The Royal Society for the Protection of Birds

GUIDE TO BIRD & NATURE PHOTOGRAPHY

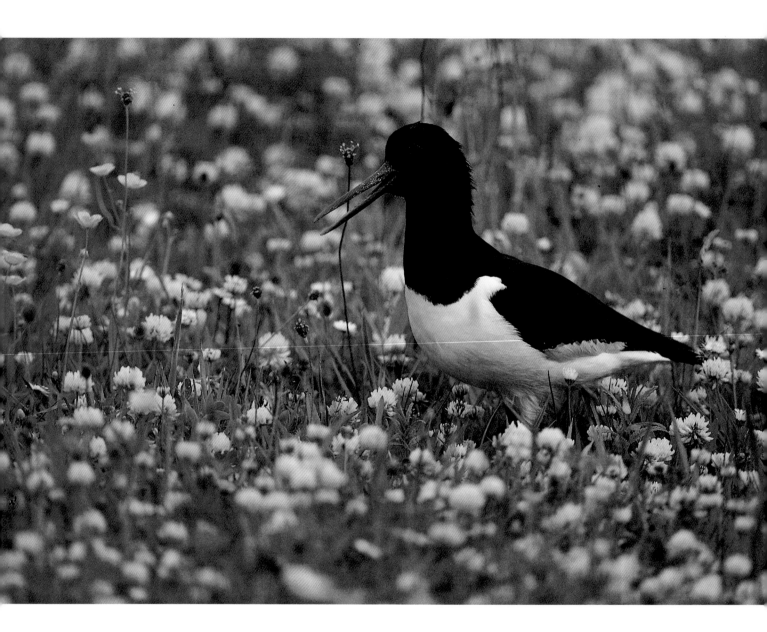

The Royal Society for the Protection of Birds

GUIDE TO BIRD & NATURE PHOTOGRAPHY

Laurie Campbell

David & Charles

To my wife, Margaret, who supports and encourages me through many long and irregular hours with much understanding and practical help.

Frontispiece **Oystercatcher.**
Page 6 **Water lily.**

The Royal Society for the Protection of Birds

The Royal Society for the Protection of Birds is the charity that takes action for wild birds and the environment.
The largest voluntary wildlife conservation organisation in Europe, it has a membership of over half a million. Members receive a free quarterly colour magazine, *Birds*, which keeps them in touch with conservation matters and developments at reserves – currently more than a hundred, owned or leased, and covering over 180,000 acres (72,000 ha). They are also entitled to visit over ninety reserves free of charge.
An annual subscription of £15.00 covers two adults living at one address, while £18.00 will also include membership of the RSPB's junior club for all children in the family. Please send a cheque or postal order (payable to RSBP) to RSPB, The Lodge, Sandy, Bedfordshire SG19 2DL.
(*Membership fees correct at time of going to press*)

British Library Cataloguing in Publication Data
Campbell, Laurie
 The Royal Society for the Protection of Birds
guide to bird and nature photography.
 1. Photography. Special subjects. Nature.
 I. Title
 778.93

ISBN 0-7153-9470-3 H/B
ISBN 0-7153-0127-6 P/B

© Laurie Campbell and the Royal Society
for the Protection of Birds 1990

First published 1990
Reprinted 1990, 1993
First published in paperback 1993

Book designed by Michael Head

Typeset by Ace Filmsetting Ltd, Frome, Somerset
and printed in Singapore
by CS Graphics Pte Ltd
for David & Charles plc
Brunel House Newton Abbot Devon

Distributed in the USA by
Sterling Publishing Co. Inc.,
387 Park Avenue South,
New York, NY 10016–8810

CONTENTS

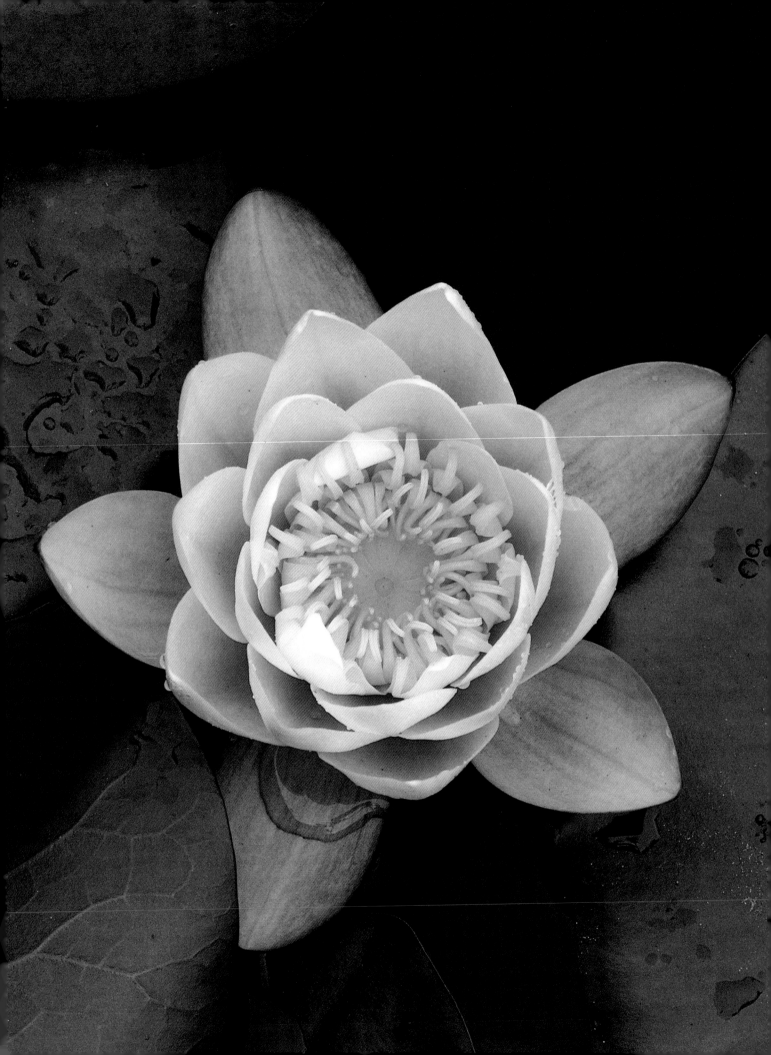

INTRODUCTION

For many years photography has played an increasingly important role in the media by stimulating public interest in wildlife and the countryside. More recently there has been a tremendous upsurge in concern over conservation matters, and this has been reflected by the rise in membership experienced by many conservation organisations. Film and television must certainly have had the greatest impact, with the regular screening of a seemingly endless supply of high quality natural history programmes. Inspired by such images, it is hardly surprising that more and more people than ever before are venturing out into the countryside with their cameras.

All of these people have one main desire: to see and photograph wildlife in close-up for themselves. The actual reasons for taking these photographs and the purposes for which they are to be used are diverse. For example, many bird photographers wish to build up a collection of slides purely for identification purposes and will therefore require a portrait-type photograph which shows clearly all the distinguishing features of a particular species. Others may choose a more artistic approach and want to portray the subject in an abstract way, possibly using techniques such as silhouetting by backlighting or by recording movement by long exposure.

Whatever the approach, each photographer will eventually develop his own recognisable style of working and theoretically there is no reason why he should not strive to produce results which are both technically and aesthetically pleasing. In practice however, photographing nature is seldom straightfoward, and it is very easy to become disillusioned when in the first few attempts the potential subject keeps rapidly disappearing in the opposite direction. Successful nature photography depends not just on having a sound knowledge of the photographic techniques involved, but more on a thorough understanding of the subject and its habits. This latter point is especially true of birds and mammals that invariably tend to be the most active, and therefore the most difficult to get to grips with—it is essential to appreciate the acuteness of their senses if we are to stand any chance of getting close to them at all.

Assuming all these points are fully understood and implemented, there is never any guarantee that the subject is going to behave, or even just appear where and when required. This uncertainty adds a whole new dimension because it includes an element of chance, which in turn adds to the challenge and enjoyment of the activity. I can think of numerous occasions when I have been waiting in a hide for a particular bird or mammal to put in an appearance when something totally unexpected happened, and I ended up photographing a different species altogether. Similarly, many of my best plant photographs have been taken as a result of coming across the ideal specimen when on my way to photograph something else.

The trick is always to be alert to any picture-taking opportunity which may present itself. However, it is worth bearing in mind that in adopting this approach it is all too easy to become side-tracked: it is best to become very selective—take advantage only of the best opportunities and always keep the original goal in mind. Generally speaking, many of the most spectacular photographs are carefully pre-planned, and follow as a result of being patient and persistent in their execution.

Whichever approach is chosen, there will always be some degree of disturbance caused when photographing certain subjects, and for this reason it is essential to appreciate the risks involved to the subject. Even the act of photographing a rare plant in a public place can have the undesirable effect of drawing attention from passers-by. No photograph is ever more important than the safety and welfare of the subject. At the end of the day, however, there is always an immense amount of satisfaction to be had when things do go well and a subject has been photographed successfully.

Although good photographic equipment alone will never guarantee results, the recent advances in their technology are beginning to open up new

possibilities. Auto-focus lenses, improved exposure meters, and better quality film have all helped to give the photographer the freedom to tackle active subjects in ways which were just not possible a few years ago. At one time, because of the limitations of his equipment, most bird photography was done at the nest, simply because it was one of the few places where the photographer could get close-up views. Over the years this has led to many species being overworked to the point where it has become increasingly difficult to produce any original aspect of this situation. With the availability of improved equipment, however, it is no longer necessary to pressurise nesting birds in this way—one photograph of a black-bird feeding its young at the nest looks very much like another.

It is far better then to use this greater freedom to concentrate on other aspects of bird and animal behaviour. When, for instance, was the last time you ever saw a good photograph of a bird pulling a worm from the lawn? There are many other such behavioural photographs just waiting to be taken, and very often it is the more common, everyday species which can provide a wealth of excellent subject matter, providing that a little imagination is used beforehand. When the individual photographer's choice of lighting, viewpoint and composition are added, the possibilities are endless.

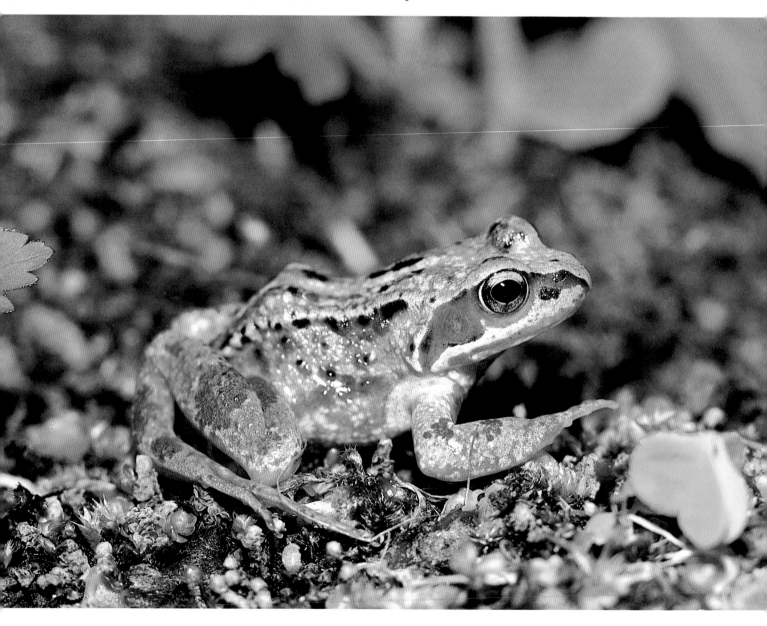

PART ONE

EQUIPMENT

For the beginner entering almost any camera shop today, the range of photographic equipment on offer must seem bewildering; and to complicate the situation, camera manufacturers are continually adding new models to their ranges which offer the very latest technology, at a rate faster than ever before. The competition between makers is intense, as each strives to produce a camera system which will outperform any rival in terms of specification and degree of automation. As a result, there has been a move away from the manually-operated mechanical cameras of the past to highly automated systems which rely almost entirely on electronics and built-in computers. In theory, this current trend towards automation would seem to be a good idea, and certainly any features which help to speed up the picture-taking process are of great benefit to anyone attempting to photograph active subjects.

It is important, however, not to be lulled into a false sense of security: do not believe that any of these camera systems is completely foolproof. No-one, for example, is ever likely to invent a camera which will realise that an exposure slightly greater than that indicated by its light meter will completely alter the mood of the finished photograph. By all means invest in automatic camera systems, but make sure that they have manual override facilities for the times when *you* want to make finer adjustments.

For the photographer to use this new technology with confidence, it is essential to learn something about the basic photographic principles involved; once these have been understood, choosing equipment becomes much easier. Begin by deciding which subjects you are likely to want to photograph, and then aim to work with the minimum amount of equipment at all times—it is amazing just how much can be achieved with only one camera, one lens and a tripod. Only add extra lenses and accessories when there is a genuine need for them; to collect too many too soon may mean that you are never sure which to take with you and which to leave behind.

Always buy good quality, reliable equipment and do consider the secondhand market carefully: you may be able to take advantage of the growing trend for trading in equipment, often which has barely been used but has been ousted in favour of the latest, updated models. Once obtained, use it as often as you can—never be afraid of subjecting equipment to the rough and tumble of conditions in the field if this is going to result in a better photograph. Familiarise yourself with its functions to the point where handling becomes instinctive, so that when good opportunities do occur, you are free to concentrate on the finer points of lighting, background and composition. Do not hesitate to spend money on good film and always be prepared to take more than one or two photographs of any given subject; however many are taken, there will always be one or two which stand out above the rest. Above all, remember that it is the results which matter most: equipment is never more than the tool that happens to be used in their production.

Many small wildlife subjects such as this common frog can easily be photographed without the use of very sophisticated equipment. On this occasion I only needed a standard 50mm lens, an extension tube and a small flash unit. Far more important in a shot like this is a basic knowledge of the techniques of lighting, exposure and composition. The positioning of the flash was critical: it was held over the front of the lens at an angle towards the subject, a facility which would have been impossible had I been using one of the many new SLR cameras with built-in flash units.

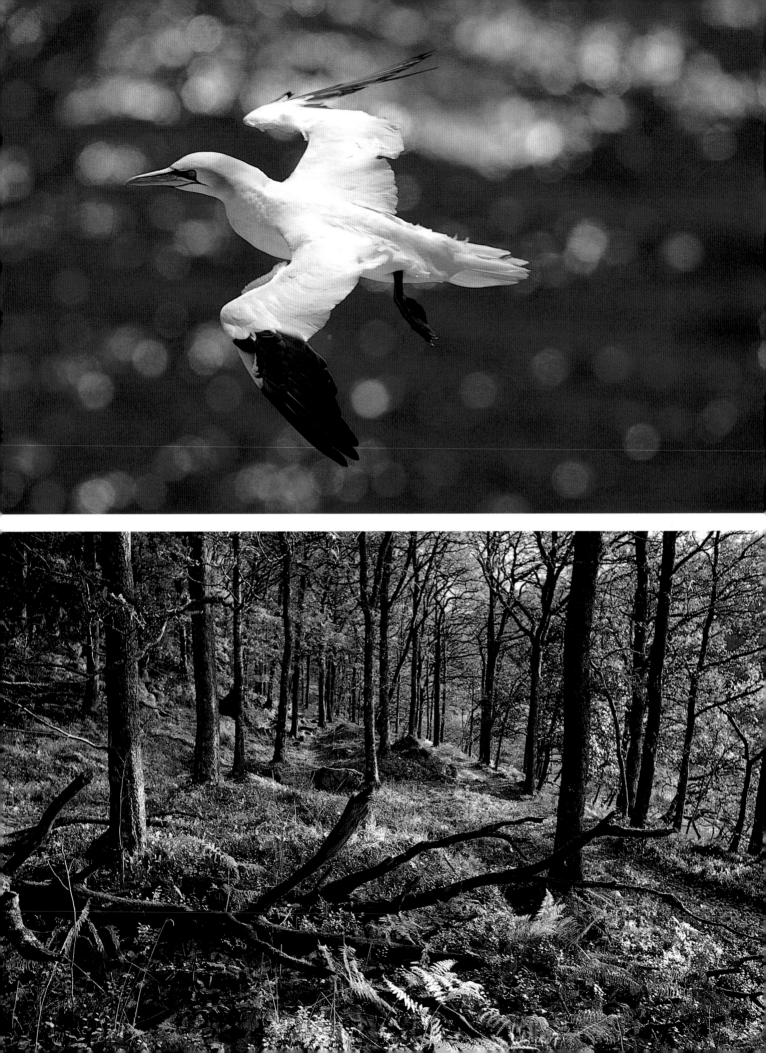

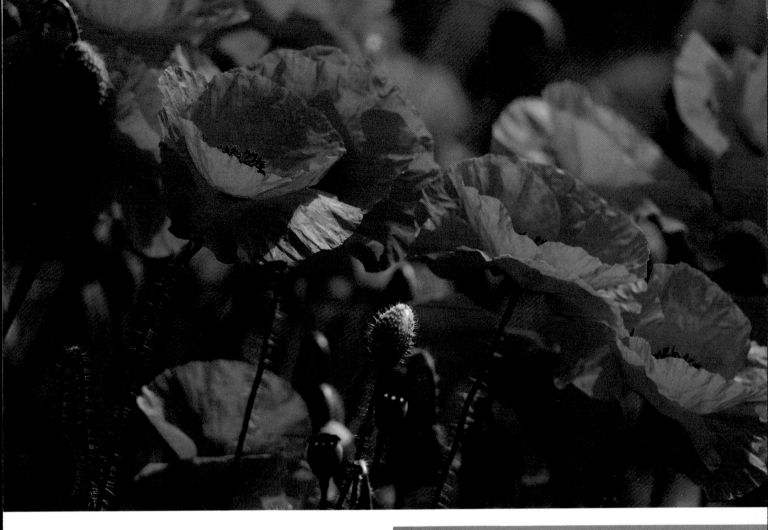

The greatest attraction of the 35mm SLR camera system is the freedom it offers to tackle a wide variety of subjects with a range of equipment which is both lightweight and quick to use. All of these subjects were photographed with items of equipment which form the basis of my working field kit.
Above left **Gannet.** 600mm lens, motordrive, tripod.
Above right **Poppies.** 300mm lens, extension tube, tripod.
Left **Sessile oakwood.** 28mm lens, 81B filter, tripod.
Right **Common blue butterfly.** 105mm macro lens, tripod.

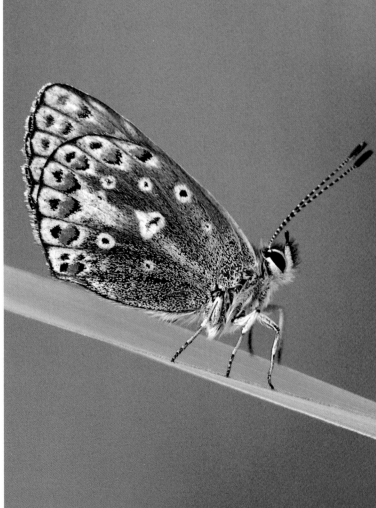

1 THE CAMERA

Throughout this book I shall be dealing with one camera: the 35mm single lens reflex (35mm SLR). As well as being the most popular camera in use today, it also happens to be the most suitable for nature photography. Its small size makes it very portable, easy to handle and quick to use; in addition, the availability and choice of film stock, lenses and accessories makes it the most versatile system by far. This facility to choose from such a wide range of lenses is most important, and for various technical reasons it is the reflex viewing system which has made this possible: 'reflex viewing' simply means that the user is able to see exactly the same image as the one which is recorded on the film. In practice, the system works in the fashion of a mini, upside-down periscope, but with two main differences: the first is that the lower mirror, which lies at a 45° angle behind the lens, casts the image upwards onto a focusing screen. The second difference is that this same mirror is hinged, and when the shutter is released it flips up, out of the way, to allow the image to be transferred onto the film behind. Once exposure is complete, the mirror returns to its original position to enable the user to compose the next photograph.

Reflex viewing is therefore the feature which all makes of SLR cameras have in common. All other controls are concerned with the mechanics of advancing the film, controlling exposure, focusing, and generally giving the user as much information as possible. The layout of these controls varies little from one manufacturer to another, but the way in which each functions can often be quite different—although between established makes these differences are often irrelevant because most are capable of producing good quality results.

When it comes to actually choosing a camera, take a long-term view and check the availability of extra lenses and accessories. You may not be able to afford or even need them right away, but it is nice to know that they are there should the need ever arise. Personal preferences will undoubtedly influence your final choice, but do make sure that particular attention is paid to each of the following features.

TTL METERING
Most SLR cameras now have their light meters built into their reflex viewing systems to give through-the-lens (TTL) metering. The fact that the meter is able to 'see', and therefore evaluate, the same scene as the one about to be recorded on film is extremely useful. However, the proportion of the area upon which these meters base their readings varies considerably. The most commonly used, and the best all-round system, is the centre-weighted one in which up to 60 per cent of the reading is taken from the centre of the frame. Alternatively, spot-metering systems, which only read from one small central area, are more precise because they allow very small areas to be read separately. With either of these systems an exposure memory button is a useful additional feature as it allows readings to be taken, then used, from any area of the frame.

As technology advances there are numerous other metering patterns being devised, and some cameras even offer a variety of modes to choose from. With care, all are perfectly usable. The readings from TTL meters are normally displayed in the camera's viewfinder by one of the following methods: liquid crystal displays (LCDs), light-emitting diodes (LEDs), or simple match-needle arrangements. The most accurate is the match-needle because it is possible to see at a glance exactly how close the reading is to the nearest marked setting, unlike many LCDs and LEDs which only show full settings. (A full account of how to use TTL meters is given in the section on exposure, see p 55.)

EXPOSURE SELECTION MODES
Exposure selection is about choosing between a combination of shutter speed and lens aperture, and the effects that each has on the finished photograph are quite different (both are described in more detail in the section on exposure, p 54). The ability to select a suitable combination or exposure from a given light reading is vital, and in response to this problem most modern cameras now offer a range of automatic and

My main difficulty in photographing this coot was in obtaining a light reading from the small area of plumage illuminated by the low-angled winter afternoon lighting—from past experience, I knew that my camera's TTL centre-weighted meter could not be relied upon to read such a small area. Therefore, to obtain a correct exposure, I had to take several photographs at settings above and below its recommended reading. In such a situation the only way of obtaining an accurate light reading directly off the subject would have been to use a camera with a spot-metering facility.

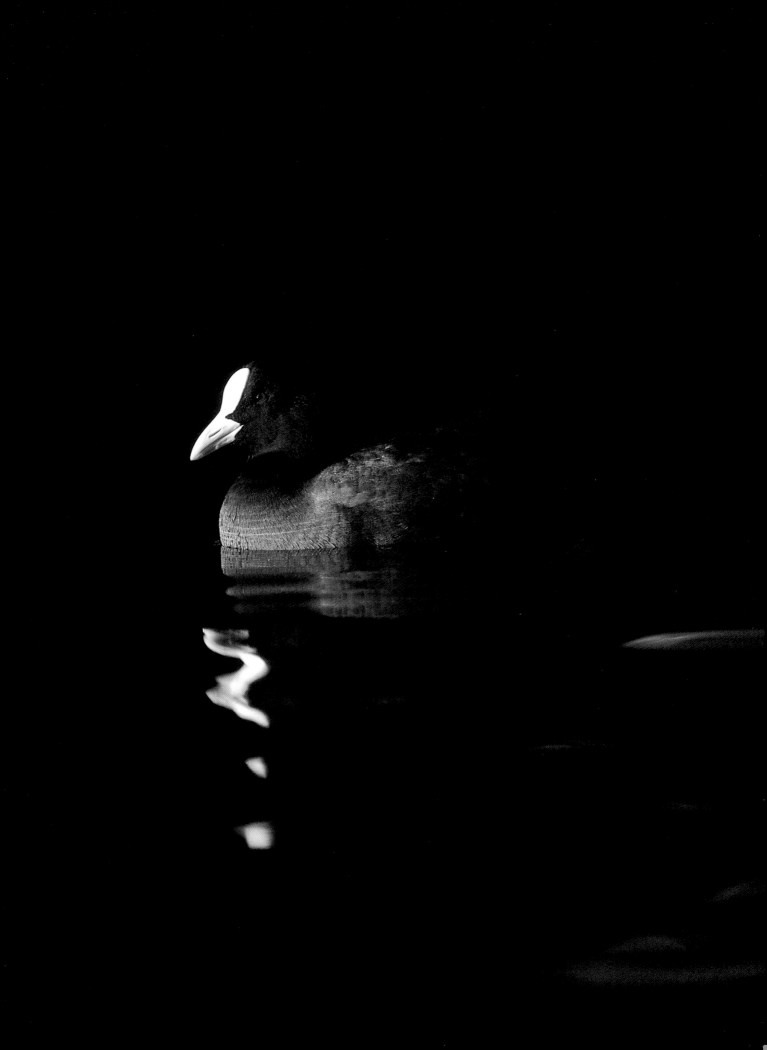

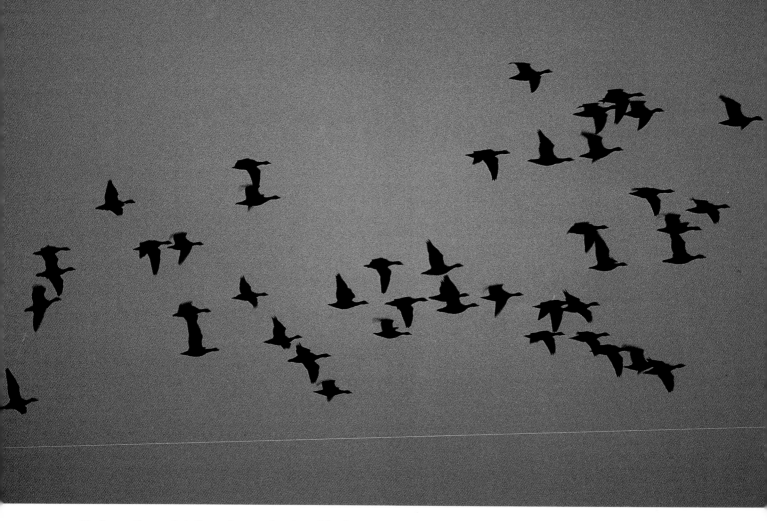

To keep these pink-footed geese in view, I had to pan my camera with a 300mm lens across a wide area of sky. From beginning to end, the brightness of the sky increased dramatically as they flew towards the sunset. To enable me to concentrate on framing and focusing, I set my lens to its widest aperture, and my camera to its aperture priority selection mode. The camera then automatically selected the fastest possible shutter speeds to match the changing lighting, and prevent subject movement and camera shake.

semi-automatic exposure selection modes. All of these systems base their selections on the readings given by the camera's TTL meter; the most sophisticated are the so-called programme modes, which automatically select both shutter speed and lens aperture. Unfortunately, unless these have a programme shift ability which allows a bias towards either lens aperture or shutter speed, then they are unsuitable, because they do not allow the control which serious work demands.

More useful by far are the semi-automatic modes, which fall into two main categories: shutter priority, and aperture priority. Shutter priority modes automatically select the lens aperture once a shutter speed

has been chosen. Conversely, aperture priority modes select the shutter speed once a lens aperture has been chosen. Therefore in using either of these modes, the photographer is responsible for deciding which to give preference to: depth of field (lens aperture), or subject/camera movement (shutter speed). And when choosing between them, it must be realised that many subjects, be it flying birds or fields of gently swaying poppies, will require a specific shutter speed to control movement—in which case the shutter priority mode is always preferable.

However, when a static subject like a landscape is being photographed, the aperture priority mode is more appropriate because it allows greater control over depth of field—specific shutter speeds can still be obtained simply by adjusting the lens aperture ring until the camera selects the corresponding shutter speed. One further advantage of many aperture priority modes is that they offer a stepless progression of shutter speeds, which means that the resulting exposures are likely to be more accurate.

With practice, either of these modes can prove to be useful for speeding up the picture-taking process, particularly when photographing active subjects. In

14

both cases, make sure that your final choice of camera has a manual override facility for the occasions when it will be necessary to bend the rules a little to obtain a certain effect.

AUTOMATIC FOCUSING

Although autofocus cameras have been available for several years, it is only recently that they have become sufficiently reliable to cope with the more demanding situations that confront the nature photographer. The implications for those interested in photographing action are obvious, and many of the present systems are now capable of focusing faster, and in poorer lighting than any equipment heretofore. There is no doubt that over the next few years we will see yet further improvements and indeed, judging by current trends, there may come a day when it will become difficult to find a 35mm SLR which does not have this facility. The cost of autofocus cameras compares well with that of good quality manual focus equipment and, at the time of writing, some manufacturers are even offering their autofocus lenses cheaper than their own manually operated equivalents, presumably to encourage more photographers to change over to autofocus.

In practice, autofocus works by employing a series of sensors within the camera's viewing system which are able to determine whether or not a subject within a certain area of the viewfinder is in focus. Because this area—like many TTL metering patterns—is near to the centre of the viewfinder, the accuracy of the system depends upon the subject being centred on this area. For this reason it is advisable to choose a camera which has a focus memory button, to allow subjects to be focused, then subsequently composed off-centre.

Actual focusing movements are carried out by electric motors which can be quite noisy on some cameras, with the result that shy animals may be impossible to photograph at close range. To overcome this problem it is necessary to have the option to switch over to manual focusing. Even then, this means of operation should be checked, since many of the focusing rings on these lenses tend to be too narrow and fiddly to use positively, particularly in cold weather when gloves are perhaps being worn. Also, most autofocus lenses do not have depth-of-field scales marked on them, and this does pose a problem when trying to determine hyperfocal distances which need to be known for a particular focusing technique (described in Chapter 11, Composition, p 86).

Despite these drawbacks, autofocus cameras are certainly well worth considering, but only if they are going to be used for a specific application; after all, why use autofocus for static plant portraits or landscape views?

FOCUSING SCREENS

Whether a camera has manual or automatic focusing, the selection of a focusing screen deserves special attention. With most cameras, the usual choice is a plain fresnel screen with a split-image arrangement within a 12mm central circle. Unfortunately this type of screen is unsuitable for two reasons: firstly, with moving subjects it is almost impossible to align the split-image sections onto the subject quickly enough. Secondly, many telephoto lenses and close-up attachments do not allow sufficient light into the camera for the split-image finder to function properly, with the result that one half of the finder tends to black out, thus rendering it unusable.

On cameras where the focusing screens are interchangeable, a plain matt, or ground glass screen will cope with most situations. If possible, a further refinement would be to have one on which the fields of view of both auto-focus sensors and light meters were marked. Focusing screens designed for architectural photography have grid lines marked on them, and are therefore particularly useful for checking that horizons are level in, for example, scenic pictures.

DEPTH-OF-FIELD PREVIEW BUTTONS

Depth of field is controlled by adjusting lens apertures, and it is the amount of any scene, from near to far, which is in sharp focus. Under normal circumstances it is impossible to see the effect of any such adjustment because the iris in the lens is always working at its widest aperture to allow the maximum amount of light into the camera for viewing and focusing. When the shutter is released, a lever inside the camera automatically closes the iris down to its pre-selected aperture for the duration of the exposure. Depth-of-field preview buttons provide a link to this same lever and therefore a means of manually closing down the lens iris in order to view the effect of any aperture setting in advance. Surprisingly, few manufacturers seem to be including this simple but invaluable control on their cameras nowadays, and it is well worth making the effort to find a model which has this feature.

MIRROR LOCKS, DELAYED ACTION RELEASES, AND CABLE RELEASE SOCKETS

SLR cameras generate a certain amount of internal

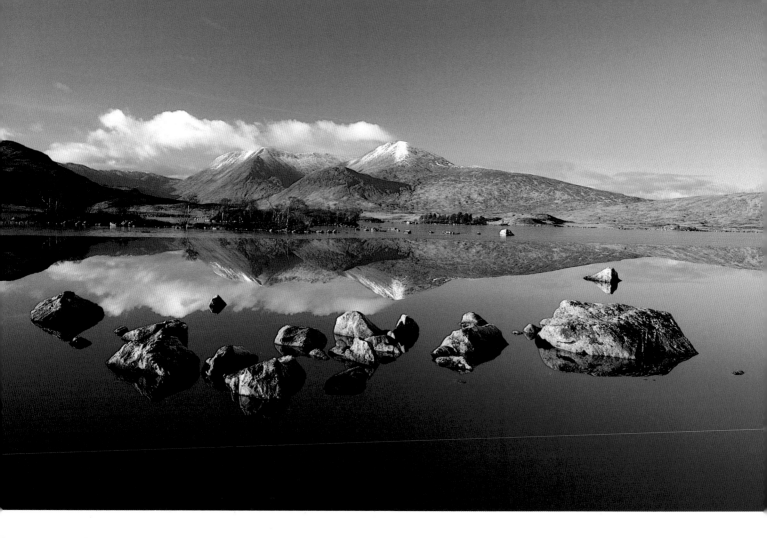

To ensure adequate depth of field for this winter scene of Rannoch Moor, Perthshire, I supported my camera on a tripod and focused my 28mm wide-angle lens mid-way between foreground rocks and the distant mountains. I then kept my finger on the camera's depth-of-field preview button, and adjusted the aperture on my lens until both rocks and mountains appeared in sharp focus.

vibration whenever the shutter is released; this is largely caused by the hinged mirror in the reflex viewing system swinging up, out of the way, to allow light to reach the film. On most modern cameras the problem has been greatly reduced by incorporating dampers into these assemblies, but difficulties can still occur when working with the high magnifications which are involved when using long lenses or close-up equipment. In such situations, the increased magnification can exaggerate the vibration to such an extent that, in poor lighting, it may be impossible to use a fast enough shutter speed to prevent it from blurring the image.

Mirror locks can prevent blurring by allowing the mirror to be locked up manually before the shutter

I came across this dead pheasant by the side of a road one rainy day. To photograph this small section from its plumage, I fitted my camera to a tripod and used a 105mm macro lens at a small aperture to obtain adequate depth of field. Because of the subdued lighting and the small lens aperture, the camera's TTL light meter indicated an exposure time of half a second. To minimise camera vibration with such a long shutter speed, I locked up the reflex mirror, then activated the 10-second delayed action shutter release and stood perfectly still until the shutter fired and exposure was complete.

I photographed this cock capercaillie displaying at its lek, from a hide just after dawn on an April morning. The poor lighting forced me to use a shutter speed of 1/8sec, even though I had my 600mm lens set to its widest aperture of f5.6. With the camera supported on a tripod, I used a cable release to prevent any camera movement when firing the shutter. Even then, I had to wait until the bird was perfectly still, and lock the camera's mirror up to be sure of getting a really sharp photograph.

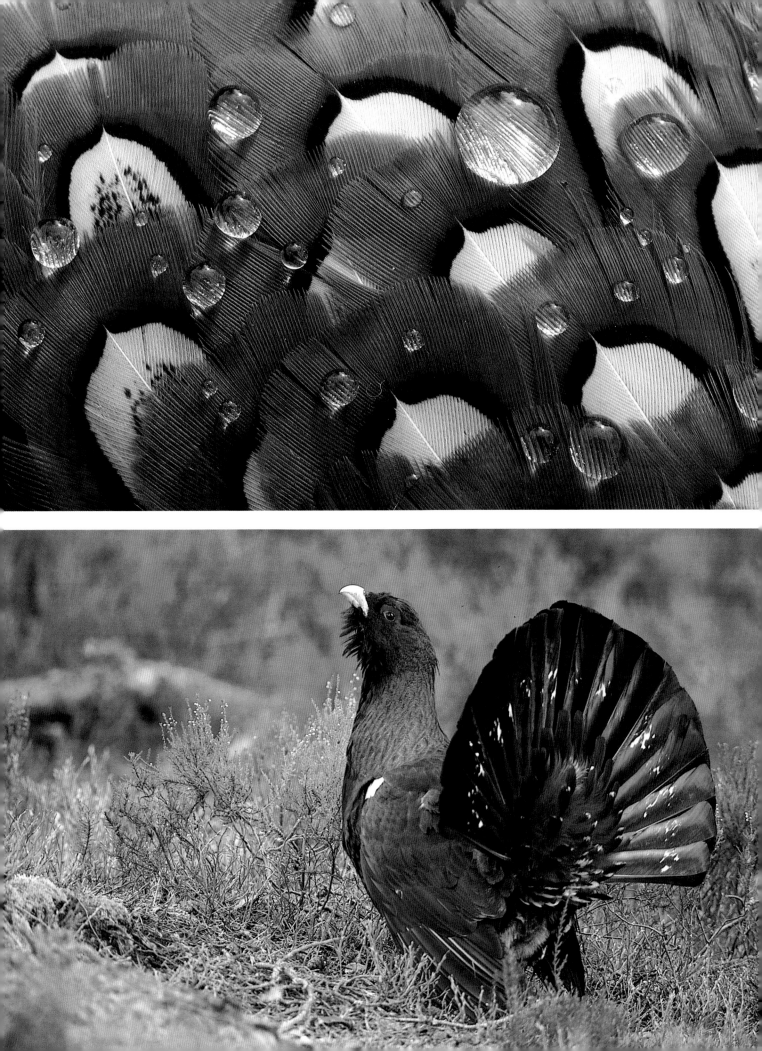

is released. They have, of course, one main disadvantage—once the mirror is locked up, it becomes impossible to see anything in the viewfinder; for this reason they are really only usable for photographing static subjects. In addition, it is necessary for the camera to be attached to a tripod and triggered via a cable release, to prevent any physical contact which could cause further camera movement. As well as reducing camera vibration, mirror locks also reduce camera noise, an added advantage when attempting to photograph shy birds and animals at close range.

Like depth-of-field preview buttons, mirror locks are not necessarily included on all cameras, and even when they are, they are often combined with a delayed action shutter release. With this combination, the mirror is automatically locked up at the beginning of the delayed action sequence, so that any initial vibration is over long before the shutter fires. Similarly, any camera movement caused by activating the release will also have had time to diminish. Unfortunately the latter combination also relies on the subject being stationary—in practice, it can be very frustrating when a previously still subject suddenly decides to walk out of the frame, just as you have triggered the delayed release.

All things considered, the first priority must be to have a camera with a socket for a cable release, followed by the option of a mirror lock or a delayed action/mirror lock combination.

SHUTTER SPEED RANGES

For quite some time, practically all SLR cameras have had shutter speeds ranging from one second to 1/1,000sec, with a 'B' setting for manually timed exposures. Whilst this coverage is perfectly adequate for most subjects, a growing number of new cameras have ranges that extend from thirty seconds to 1/4,000sec, or even 1/8,000sec—though I cannot remember when I last used even the 1/2,000sec setting on my camera, let alone wishing I had an 1/8,000sec one! At the other end of the scale, the longer speeds could otherwise be obtained by using the 'B' setting.

No doubt some photographers will find an application for each of these extremes, but the most practical development within these ranges has been the introduction of a faster flash synchronisation speed. Previously, the fastest shutter speed at which it was possible to use electronic flash, was 1/60 or 1/125sec; this has now been increased to 1/250sec, and the main benefit of this change is that there is now greater scope for using flashlight and daylight

together. A full explanation of how this can be achieved is given in Chapter 10, Lighting, p 75.

MOTORDRIVES AND AUTO-WINDERS

At one time motordrives and auto-winders might have been classed as accessories, but nowadays they are commonly built in to many of the newer cameras and it is more appropriate to discuss them as an integral feature of the camera. The main function of either type is to advance the film and re-cock the shutter each time a photograph is taken, and the difference between them is mainly one of specification; most motordrives now offer both single and continuous modes of operation, a firing rate of up to five or six frames per second, and rapid film rewinding. By comparison, auto-winders are much less sophisticated, and may only have a single-frame advance facility which fires at a rate of one or two frames per second.

All motordrives and auto-winders cause vibration and noise, and the faster the rate of fire, the worse the problem becomes. Generally, however, this situation is improving and some recent models even have special single-frame advance modes, known as 'quiet firing modes'. Electrical sockets for remote control devices are also well worth having, and where the motordrive or auto-winder is built in to the camera, they are essential, because such cameras do not usually have the conventional sockets for mechanical cable releases. Instead, a simple remote control cord provides an alternative means of firing the shutter without the risk of camera movement. There are many other subtle ways of using motordrives and auto-winders, but because these are geared to the nature of the subject, they are described in Part Three, Fieldwork.

Motordrives and auto-winders are invaluable when photographing active subjects because so much can happen in a short space of time. This otter diving into a Scottish sea loch proved to be no exception. In fact, the whole event only lasted about one second. I know this, because I had my motordrive set to take three pictures a second and these are the only ones which contained an otter!

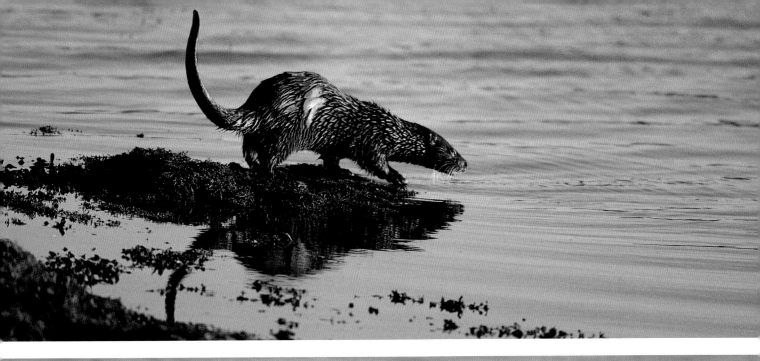

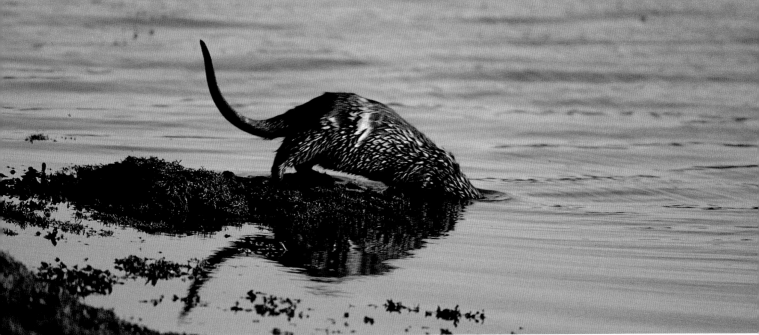

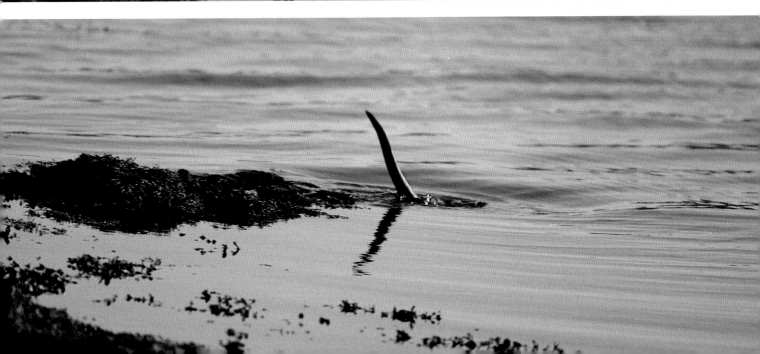

2 LENSES

In many ways, choosing a lens is much more important than choosing a camera body because, more than any other factor, it is the lens which is responsible for the appearance and quality of the final image. The very nature of many natural history subjects dictates the use of certain types of lenses—the greater the range of subjects you wish to photograph, the more lenses you will need. Knowing which ones to choose is never easy, so it is best to begin by selecting only one or two; then, once you are familiar with their properties, it becomes much easier to develop your own collection to suit the needs of your subjects. Obtaining good optical quality is extremely important, and in general, the best lenses are made by the camera manufacturers, though unfortunately these also tend to be the most expensive. Where budgets are limited, it should still be possible to obtain substitutes which are of reasonable quality from an established independent manufacturer's range.

THE EFFECTS OF FOCAL LENGTH

The first lens that most people acquire is the one which is supplied with their camera body. It is known as a 'standard' or 'normal' lens, and usually has a focal length of 50mm. All lenses are discussed in focal lengths: in basic terms, this is the distance—measured in millimetres—from the optical centre of the lens to the film when the lens is focused at infinity. Focal length determines the angle of view of all lenses; in the case of the standard 50mm lens, its 45° angle of view is equivalent to that of the human eye. Thus any subject viewed through such a lens will appear to be much the same as it would in life. Lenses with focal lengths greater than 50mm have narrower angles of view, and thus magnify the image. They are generally known as long focus or telephoto lenses and the amount by which they magnify the image is in proportion to how much greater their focal length is over the standard lens. For example, a 300mm lens magnifies the image by six times, because it has a focal length which is six times greater than that of the standard lens. Conversely, lenses with focal lengths smaller than 50mm have greater angles of view, and thus reduce the size of the image; they are known as short focus or wide-angle lenses.

Focal length also influences depth of field. When photographing from any one position, the longer the focal length, the narrower the depth of field will be at any given distance. Although there are slight variations, actual focusing movements, and minimum focusing distances are similarly affected. For example, compared to telephoto lenses, wide-angle lenses focus closer, and require less movement of their focusing rings to get from one end of their range to the other. Given that most subjects in nature are relatively small, it is always desirable to choose a lens which will focus as close as possible.

STANDARD 50MM LENSES

These lenses usually come fitted with most 35mm SLR cameras but, because they record things in much the same way as we see them, we soon tire of using them and tend to look toward the more exciting properties of wide-angle and telephoto lenses to stimulate our interest. This is a pity because, not only do these lenses have a very high optical quality, they also have fairly wide maximum lens apertures and are therefore suitable for working in low light. In practice, they may be used for photographing a wide range of subjects from landscapes to wildflowers; and when used with a set of extension tubes, they provide the basis for a versatile close-up system.

WIDE-ANGLE LENSES

Normal wide-angle lenses range in focal length from 35 to 24mm. In nature photography their broad field of view tends to limit their use to photographing landscapes or large subjects like trees. However, because they focus closely and give a great depth of field, they can be used to good effect for showing plants and animals in relation to their environment. Extreme wide-angle lenses, with a focal length of 20mm or less, need to be used with caution because the distortion they produce may dominate the picture to the point where the effect becomes gimmicky; their application is therefore considerably more limited.

When photographing from any one viewpoint it is possible to take a range of completely different photographs, simply by changing focal length. For the first photograph in this series of the River Muick, in Scotland, I used a 24mm wide-angle lens with the camera tilted slightly downwards to focus attention on the rapids in the foreground. For the photograph below, I used a 300mm telephoto and re-composed to isolate the waterfall in the background.

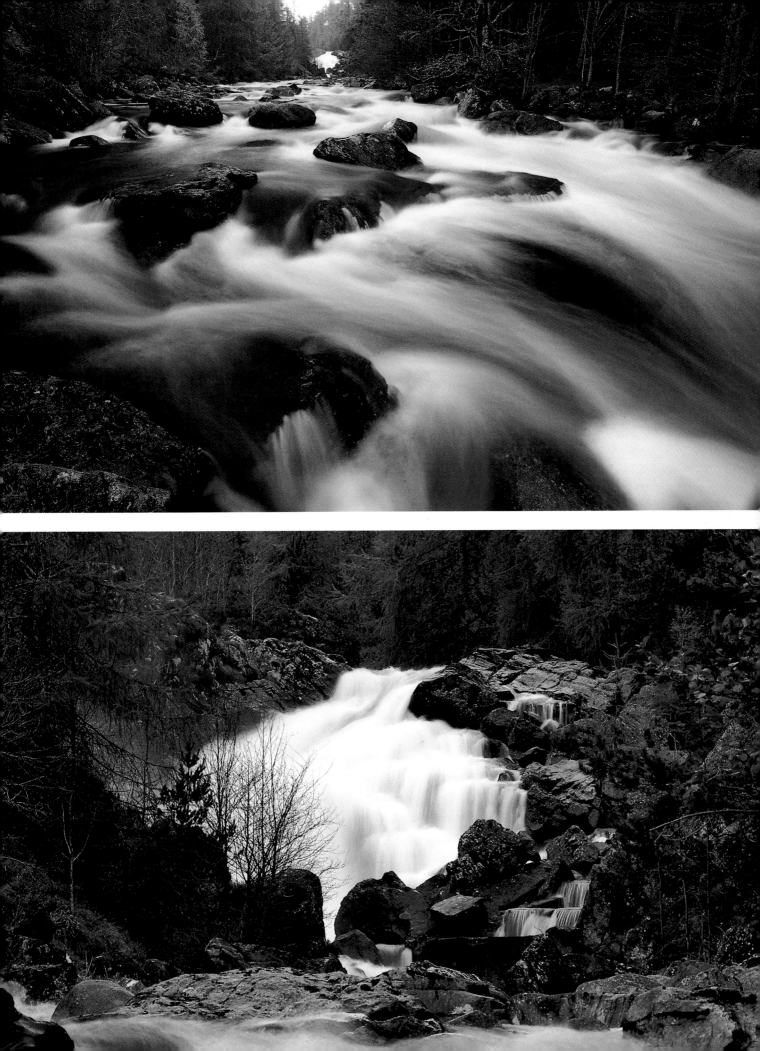

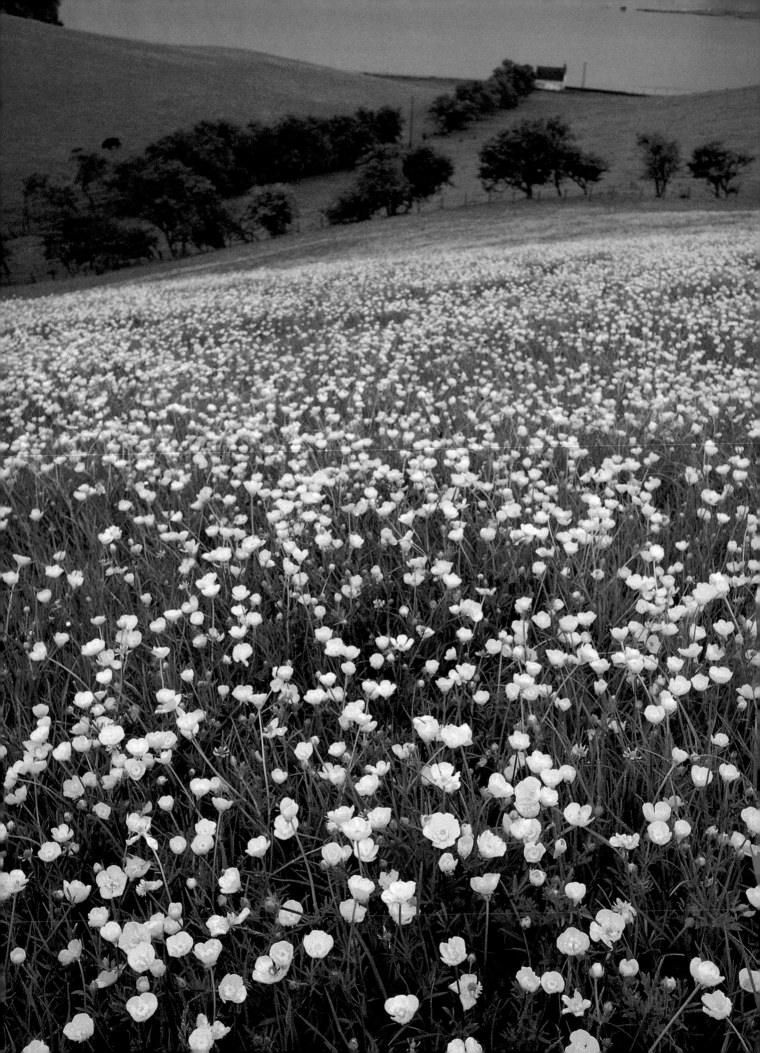

For this field of buttercups I used a 28mm wide-angle lens and composed the picture vertically to include as much foreground and background as possible. Then, by moving in close and using a low viewpoint I was able to make the flowerheads nearest the camera dominate the foreground. In contrast, the wide-angle lens has also made the distant flowerheads appear smaller and further away, thus exaggerating the depth of the photograph.

After spotting this purple sandpiper resting on a rock by the seashore, I used a harbour wall as cover to approach within 8m (25ft), so that I could photograph it with my 600mm lens. Stalking small birds in this way usually requires a lens with a focal length of at least 400mm, since it becomes increasingly difficult to get any closer, and thus get a reasonably sized image on the film.

TELEPHOTO LENSES

Telephoto lenses have the effect of magnifying the image and making things appear close, and are therefore essential for photographing a wide variety of birds, animals and insects which will not normally allow a close approach. Furthermore, their narrow angle of view makes them useful for picking out small sections from landscapes, trees and other large subjects. However, there are disadvantages, because any increase in magnification can only be gained by increasing focal length—and lenses with a focal length of 400mm or more become too long and heavy to be used without some means of support. In addition, their high magnification exaggerates camera movement and makes it more difficult to keep fast-moving subjects accurately framed.

These problems are further aggravated by the fact that depth of field, and maximum lens apertures are reduced; it may not always be possible therefore to choose an adequate combination of shutter speed and lens aperture to control subject/camera movement and depth of field. Optical quality also suffers with increased focal length, and some manufacturers have developed lenses made from special types of glass which improve definition, contrast and colour rendering. Such lenses usually have wide maximum apertures, and are offered as additional versions; as such, they tend to be very expensive.

A further development—which also adds to cost—has been the introduction of lenses which have internal focusing arrangements. They focus by moving optical parts around inside, instead of the usual method of slightly altering external length, and have the advantage that they are more compact, and can focus more quickly and at closer range than conventional designs. Shorter telephoto lenses within the 85mm to 300mm range are much less affected by the problems normally associated with increased magnification, and so are more suitable for photographing action.

MIRROR LENSES

Mirror, or catadioptric lenses have been developed in order to provide a cheap, compact alternative to a long telephoto lens. They are available in focal lengths ranging from 250 to 1,000mm or more; when compared with conventional telephoto lenses, they are at least 50 per cent shorter and lighter. To achieve these reductions whilst maintaining effective focal length, the light rays which form the image are reflected back and forth inside the lens by a series of mirrors. However, the positioning of these mirrors means that not only is the overall diameter of the lens increased, but also out-of-focus highlights are recorded as curious, doughnut-shaped rings. In extreme cases—for example, if a bird is being photographed against backlit water—the effect can be quite distracting.

More seriously, this design also makes it impossible to incorporate an adjustable lens diaphragm, with the result that these lenses must have fixed apertures. In practice, this means there can be no control over depth of field, and that exposure must be altered either by changing the camera's shutter speed or by fitting a neutral density filter. Lens apertures tend to be fairly modest, and in the case of a 500mm mirror lens it is usually fixed at f8. In poor light, such a setting gives a very dim image in the viewfinder, thus making focusing slower and more difficult. Furthermore, it may prove impossible to use shutter speeds which are fast enough to control subject movement and/or camera shake.

On the positive side, mirror lenses still represent good value for money, especially where priorities dictate savings in weight and bulk. They also focus at closer range and are slightly easier to handhold than comparable telephoto lenses.

ZOOM LENSES

Because zoom lenses have variable focal lengths, they are faster and more convenient to use than several fixed focal length lenses within a given range. In recent years the range of focal lengths that can be covered by a zoom has broadened considerably—for example, it is now possible to obtain virtually any focal length from a 28mm wide-angle, to a 500mm telephoto with just two lenses: a 28–200mm and a 200–500mm.

However, covering such a wide range demands a complex optical design, and this imposes a number of restrictions. Firstly, there is often an overall loss in image quality, because it is always more difficult to correct evenly the various optical faults throughout their entire range; so lenses which offer the widest range of focal length therefore suffer most. Secondly, the large number of individual lens elements used in their construction increases weight and bulk, although this is only really apparent when comparing the shorter end of their range with conventional fixed focal length lenses. Maximum lens apertures and minimum focusing distances are similarly restricted at their shorter focal lengths.

As lens technology advances, all these difficulties are becoming less noticeable, and in fact many of the

recent versions of the long-established 70–210mm and 80–200mm designs are capable of producing excellent results. The decision of whether or not to choose a zoom or a fixed focal length lens is never easy to make, but as a general rule, zoom lenses really come into their own when working from a fixed viewpoint such as a hide where it is often difficult to judge just how close a subject may approach. In such situations a zoom lens may be the only way of changing magnification without disturbing the subject.

MACRO LENSES

Unlike many close-focusing zooms, which are often described as having a 'macro' facility, true macro lenses are optically corrected to give their best results at close range. They usually come in focal lengths of between 50 and 200mm, and have extended focusing mounts which allow them to focus at least twice as close as conventional lenses of comparable focal length. Their ability to focus very close affects how big the image appears on the film: for example, when a typical 55mm macro lens is focused down to its minimum focusing distance of 24cm (9½in) it records an image on the film which is about half life size (1:2)—at this scale, a butterfly with a wingspan of 7.5cm (3in) would fill the entire photograph. Regardless of focal length, most other macro lenses are capable of producing similar results; many even have an optical extension tube which permits reproduction ratios up to life size (1:1).

In practice, telephoto macro lenses with a focal length of between 90 and 200mm tend to be the most useful for fieldwork because they provide a reasonable working distance between the lens and the subject. This facility is particularly important when attempting to photograph shy animals and insects which would otherwise be frightened off by a close approach. An increased working distance will also prevent overcrowding the subject, a situation which at best may simply block out too much light, or at worst might result in the disturbance of the surrounding vegetation.

Where a closer approach is feasible, the shorter 50–60mm focal length macro lenses are more appropriate because they are slightly easier to handle, especially at magnifications of life size (1:1) and greater. Most macro lenses also perform perfectly well at longer range so they are well worth considering as an alternative to comparable focal length lenses. In addition they have smaller minimum lens apertures, and this allows greater control over depth of field.

TELECONVERTERS

Strictly speaking, teleconverters are not really lenses, but optical components which may be fitted behind a lens to increase its focal length by a factor of between 1.4× and 3×. Their ability to increase magnification makes them of special interest to many bird and animal photographers who already own short telephotos in the 200 to 300mm range, yet cannot justify the extra expense of buying a long focal length lens of 500mm or more.

However, despite their obvious attraction, teleconverters have two major drawbacks: firstly, they reduce the amount of light reaching the film by the same factor at which they increase magnification. For example, when a 200mm lens with a maximum aperture of f4 is used with a 2× teleconverter, it becomes a 400mm lens with a maximum aperture of f8. Compared with a normal 400mm f5.6 lens, such an aperture is one whole setting lower and therefore less suitable for use in poor light. Obviously, this situation becomes more serious when 3× teleconverters are used with lenses with more modest maximum apertures.

Their second drawback is that they increase the risk of a reduction in image quality—not only by exaggerating any faults of the lens in use, but also by introducing defects of their own. Inevitably, this means that in order to get acceptable results it is necessary to use only good quality lenses and teleconverters together.

The best teleconverters are made by the camera manufacturers—although these do tend to be expensive, they are still relatively cheap when compared with the cost of ordinary lenses. Some manufacturers also produce models which are matched optically for certain focal lengths within their own range. Once fitted, the small size of most teleconverters often produces a compact, but deceptively powerful lens which must receive the same amount of care in handling that an equivalent conventional focal length would require. Basically, this means using an adequate means of support to avoid camera shake and, where possible, not photographing at the maximum lens aperture since this only degrades image quality and reduces depth of field.

Unlike many other factors, teleconverters do not affect the focusing scale of the lens they are attached to. As a result, minimum focusing distances are retained, with the advantage to the photographer that the longer focal lengths they produce will focus considerably closer than comparable normal focal length lenses.

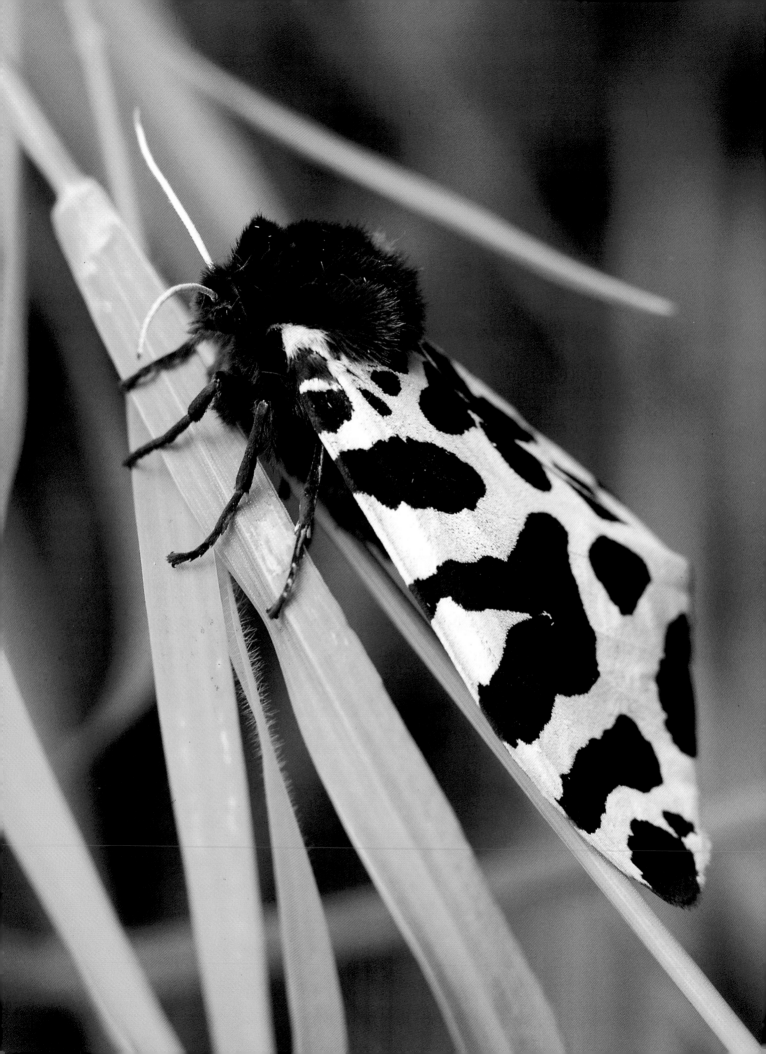

3 CLOSE-UP ACCESSORIES

The effects of most close-up accessories are described in terms of reproduction ratios, or magnification rates. Both terms refer to the relationship between the size of the subject being photographed, and the size it appears on film. To get an idea of what this means, consider the problem of trying to photograph a 36mm (about 1½in) long caterpillar with a standard 50mm lens. Most 50mm lenses only focus down to about 46cm (18in), and at this range their angle of view dictates that the area they will record on film will be about 23cm (9in) across. Because this is six times greater than the length of the caterpillar it will only occupy one-sixth the width of the 24×36mm (1×1½in) film format, therefore the reproduction ratio will be one-sixth life size (1:6). However, if the reproduction ratio were raised to 1:1 (life size on film), the caterpillar would then fill the entire width of the film format because both would then be of equal size.

Choosing equipment for close-ups is therefore all about choosing reproduction ratios to suit the subjects you plan to photograph.

EXTENSION TUBES
Most lenses focus closer by increasing their physical length. The greater the distance between the lens and the film, the closer it will focus and the higher the reproduction ratio will be. Extension tubes are simply fixed-length metal tubes which fit between the camera body and the lens, to permit the lens to focus closer. They are available in a variety of different lengths which may be used singly, or in any combination to obtain a specific reproduction ratio. A typical set from one camera manufacturer has lengths of 8mm, 14mm and 28mm which are capable of producing reproduction ratios of between 1:6 and 1:1 when used with a standard 50mm lens. A selection of reproduction ratios within this range will be sufficient to photograph a wide variety of subjects from wildflowers to all but the tiniest of insects.

It should be realised, however, that in photographing a subject at 1:1 with a 50mm lens the working distance between the end of the lens and the subject will

only be about 65mm (2½in). Longer focal lengths need proportionally greater amounts of extension to achieve similar reproduction ratios—for example, a 200mm lens requires 200mm of extension to obtain a ratio of 1:1. Such combinations are not really practical because they become too big and awkward to handle. Nevertheless, 100 to 200mm lenses fitted with extension tubes to obtain ratios of less than 1:2 (ie extensions less than 50–100mm respectively) are extremely useful for photographing butterflies and other unapproachable subjects, due to their increased working distances. Similarly, short extension tubes of between 10 to 15mm in length may be used to reduce the minimum focusing distances of long telephoto lenses when photographing small birds, etc, at close range.

Gaining magnification by adding extra extension does have its drawbacks. Firstly, the whole focusing range of the lens is restricted so that it becomes impossible to focus on distant subjects. Secondly, at high reproduction ratios, the built-in focusing travel of the lens has very little effect and focusing must be carried out by moving the camera physically back and forth. Thirdly, the amount of light reaching the film is reduced due to the extra distance it must travel. Of

Overleaf **Because the largest of these barnacles was only 7mm (¼in) across, I needed to use a fairly high reproduction ratio to obtain a reasonably sized image of even just a small cluster. The first photograph was taken with a 55mm macro lens at a ratio of 1:6; this is equivalent to the scale most standard 50mm lenses give when set at their closest focusing distance, and without any close-up attachments. For the second photograph, I added an extension tube to obtain a life-size (1:1) image on film.**

Page 29 **The secret to taking good close-ups does not always lie in getting as close to the subject as possible. In fact, photographing at high magnifications only exaggerates the problems of camera movement, and limited depth of field. Fortunately, many close-up subjects like butterflies, fungi and wildflowers rarely require reproduction ratios greater than half-life size (1:2). This section from a foxglove fell into this category. On this occasion, I mounted the camera on a tripod and used a 135mm lens with extension tubes to obtain a reproduction ratio of about 1:3. By locking the camera's mirror up and using a cable release, I was able to use a slow shutter speed and small lens aperture to get sufficient depth of field.**

Although this garden tiger moth was resting peacefully, I still had to be very careful not to disturb the grasses which supported it when manoeuvring my tripod into position. A 105mm macro lens helped the situation by allowing me to take this close-up from 36cm (14in) away.

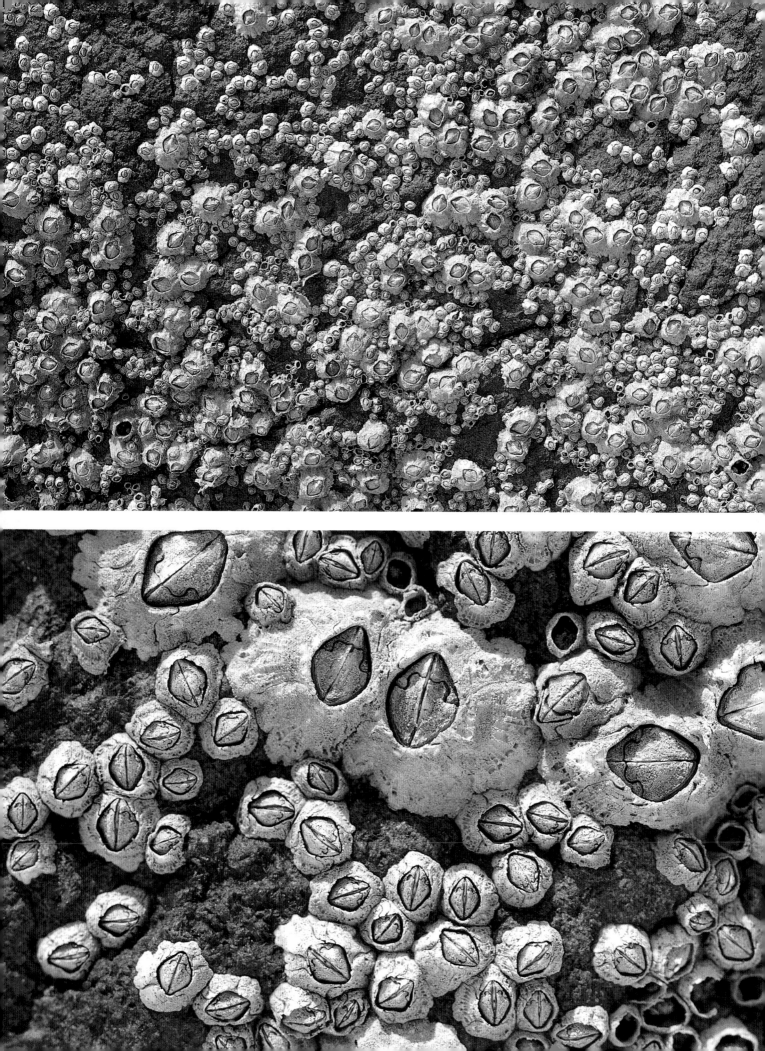

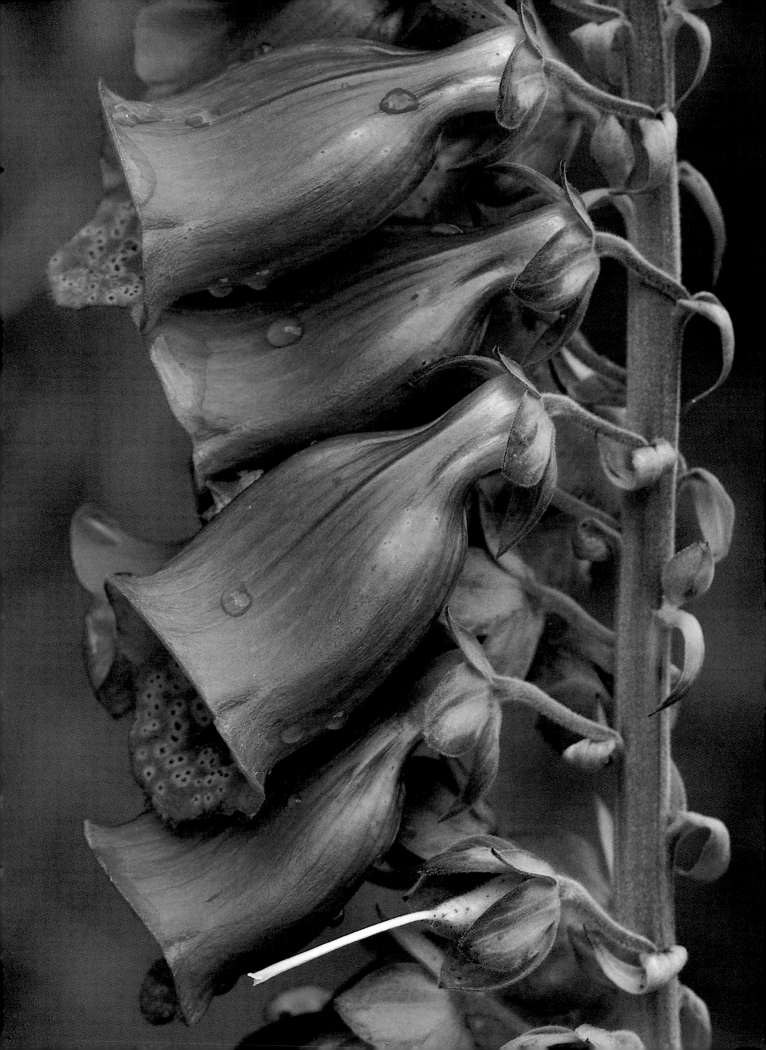

all these problems the latter is the most serious, and it is discussed in more detail in Chapter 10, Lighting, p 69.

EXTENSION BELLOWS

Extension bellows perform exactly the same function as extension tubes, except that they have greater physical lengths which are constantly variable; they can therefore be used to obtain precise reproduction ratios over a great range. When used with a 50mm lens, most bellows offer extensions which yield any ratio between 1:1 and 4:1. However, at a ratio of 4:1 (four times life size) the picture area is only about 10mm (⅜in) wide, and subjects of this size are extremely difficult to photograph in the field because of the immense amount of control needed to position and support the camera. In an effort to alleviate this problem, some models have built-in focusing rails which allow the camera to be racked back and forth.

Furthermore, unlike most extension tubes, few bellows have couplings for TTL light meters, and at best, lens apertures are controlled by a special double cable release. Consequently, adjustments to exposure are slower to make since they must be done manually, and with active subjects this is a major drawback. Despite these handling difficulties, bellows still offer the best way of taking close-ups at high reproduction ratios, particularly where precise framing is required.

REVERSING RINGS

Because most lenses are optically designed to give their best results at long distances, adding extension to make them focus closer can often lead to a reduction in image quality, particularly at ratios beyond 1:1. Reversing rings are inexpensive adaptors which may be used with wide-angle and standard 50mm lenses to restore image quality by allowing photographs to be taken with the lens mounted back to front. They also provide a means of obtaining high reproduction ratios without the need to use large amounts of extension.

Reversed wide-angle lenses yield greater reproduction ratios than reversed standard lenses. For example, a reversed 28mm wide-angle lens gives a ratio of 3:1, while a reversed 50mm standard lens gives a ratio of 1:2. By comparison, the 50mm lens would require 50mm of extension between itself and the camera to achieve a 3:1 ratio.

Of course, in using a lens in the reverse position all light meter and aperture control couplings between

Opposite **Here, a Z-ring has been attached to a reverse-mounted lens to allow it to be used at its widest aperture. This gives the brightest possible image in the viewfinder to make focusing easier, regardless of which aperture the lens is actually set to. The double cable release closes the lens down to its pre-selected aperture before firing the shutter.**

itself and the camera are lost. To regain control of the lens apertures, a special adaptor known as a Z-ring must be fitted to the back of the lens. Then, as with some bellows, a double cable release is used to stop the lens down to its pre-selected aperture and fire the shutter.

SUPPLEMENTARY LENSES

Supplementary or close-up lenses provide the simplest and cheapest method of making lenses focus closer. They consist of single element lenses which screw into the filter mount on the front of normal lenses. The power of supplementary lenses is measured in diopters and most manufacturers produce several different strengths, beginning with a +1 diopter. When a +1 diopter lens is attached to any lens focused on infinity, it shifts the focusing range so that the lens is then focused at one metre; a +2 diopter lens focuses a lens to half a metre; and so on. In each case, the built-in focusing travel of the lens may be used to focus even closer.

Still greater magnification can be obtained by adding supplementaries together, though it is best to mount the strongest (the highest diopter number) first, and never to use more than two at a time. Because supplementary lenses make all normal lenses focus closer by equal amounts, there is a temptation to use them on the longest focal lengths to achieve the greatest reproduction ratios; this is inadvisable, however, since most are designed for use with standard 50mm lenses. Even then, none is optically perfect and with diopter powers greater than +4, the contrast and sharpness of the image begins to deteriorate, particularly around the edges of the frame. Up to a point, using the camera lens closed down to a smaller aperture can help to reduce this problem. Generally though, the fall-off in image with high diopter powers restricts the use of supplementaries—with 50mm lenses—to reproduction ratios of 1:2. However, unlike extension tubes and bellows, supplementary lenses have the advantage of not reducing the amount of light reaching the film.

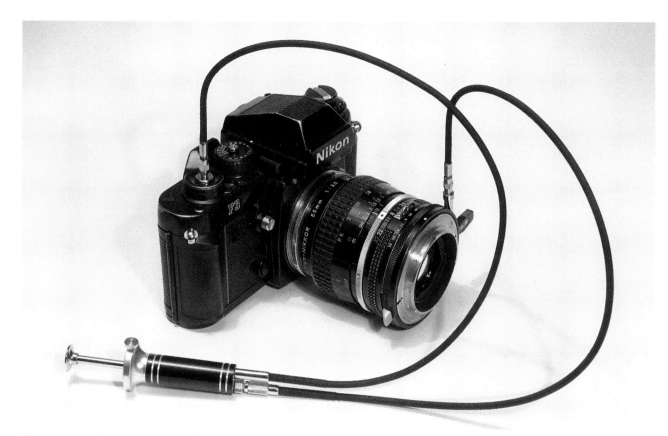

To photograph these gills on the underside of a milk-cap fungus I used a reverse-mounted 50mm lens with a 28mm extension tube placed between it and the camera. This gave me a reproduction ratio of about twice-life size (2:1): the section shown below was less than 20mm (¾in) across in real life.

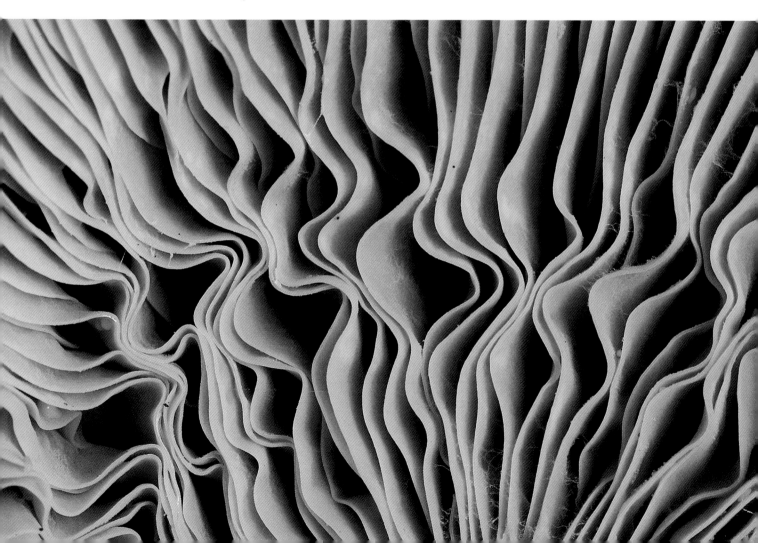

4 FILM

Statistics of film sales show that more photographers prefer colour prints to colour slides or transparencies, and that not many favour black and white or monochrome prints. Certainly so far as nature photography is concerned, the dimension of colour is often essential for communicating the sheer beauty of the subject, and to allow us to differentiate between various species. The popularity of colour negative film is easy to understand—prints are more convenient to view, and in many cases may be ready within hours of the films being handed in to a local laboratory for processing. Unfortunately, having prints made introduces another stage over which the photographer often has little or no control. In particular, it is unreasonable to expect the mass-process-

The importance of colour is most obvious in this autumnal scene of birch trees in the Spey Valley—there is no doubt as to the season the photograph was taken in. Had the scene been photographed with black and white film, the yellow foliage would have recorded as a light grey—the same tone that the fresh green foliage of early summer would render.

ing techniques used by many high street laboratories to yield prints capable of showing the subtle gradations of tone and colour necessary for accurately portraying many natural history subjects. In short, to obtain consistently good results from colour negative films they must be hand printed by a professional laboratory, and that is expensive.

Colour transparency films differ in that they have a single stage process which forms the final image directly on the film. This characteristic gives transparency film the distinct advantage of being able to record images which are sharper, and have richer colours, than those obtainable from negative films. Also, where costs are concerned, transparency film is more economical to use since there are no prints to be made. With negative film, the higher unit cost also means that even rejects are more expensive—a point worth considering in the case of action photography where only one picture in ten may be successful.

The advantages of using transparency film are widely recognised by most serious amateurs and professionals with the result that the majority of nature photographs we see published are taken on this type of film. There is, however, one major drawback to

using transparency film: it requires careful exposure—too much (overexposure) results in weak, 'washed out' colours, while too little (underexposure) leaves colours appearing dark and 'muddy'. Negative films fare better in this respect because they have more latitude for error. Where necessary, prints can be made directly from transparencies, though it is seldom possible to get a result which matches the original image; unfortunately, the problem here is mainly one of increased contrast, with light-coloured subjects in bright sunny conditions proving to be the most difficult to reproduce.

Regarding black and white films, in order to get the most out of them it is helpful to have a knowledge of the stages involved in their processing. Luckily, the simplicity of the process encourages many users to do their own developing and printing, and in many ways this is to be recommended as a great deal of control may be exercised over the contrast and exposure of the final image in the darkroom. Ultimately though, the success of any black and white photograph relies heavily on the photographer being able to judge just how the subject will record as a series of greys at the time of actually taking the photograph. Strong lighting also plays an important role by creating contrast, and so defining shapes and textures more easily.

FILM SENSITIVITY
All films consist of a flexible plastic base, coated with an emulsion of chemicals containing light-sensitive silver halide crystals. After exposure and development the crystals or 'grains' register the various tones of the subject and thus collectively form a mosaic-like representation of the image. The size of these grains determines the sensitivity, or speed, of the film. High speed, or fast films have coarser grain structures which are more sensitive to light than slow films which have finer grain structures. Film speeds are generally quoted in ISO numbers (previously ASA numbers), which double each time the film's sensitivity to light doubles. Thus, ISO 200 films are twice as sensitive to light as ISO 100 films, and therefore need only half as much light for proper exposure.

FILM SPEED AND IMAGE QUALITY
Because the small size of the 35mm format requires a high degree of enlargement to produce even moderate-sized prints, film speed—and therefore grain size—becomes an important factor to consider when choosing any film. Fast films with speeds of ISO 400 or more often have grain structures which are so coarse that they are incapable of resolving fine detail: they thereby effectively cancel out many of the advantages to be gained by using good equipment and careful working techniques. Furthermore, fast colour films never give colour renderings as accurate as those obtained from slower versions.

In practice, however, it is often impossible to use slower, finer grained films all of the time because their low sensitivity seriously restricts the choice of shutter speeds and lens apertures. For example, when photographing action in poor lighting, it is often necessary to use a film speed greater than ISO 200 to allow shutter speeds fast enough to arrest subject movement. But, when recording the fine detail of inanimate subjects like fungi and mosses under the same lighting conditions, it is feasible to use slower films of between ISO 25 and ISO 100, using a tripod to support the camera for the necessary slow shutter speeds. Moreover, the freedom to use slow shutter speeds permits the use of smaller lens apertures for greater control over depth of field. Consequently, the compromise between film speed and image quality depends largely on the nature of the subject and the prevailing lighting conditions.

ALTERING FILM SPEEDS
When light levels become too low for even the fastest of films, their effective speed may be increased or up-rated by manually doubling up their normal ISO rating on the camera's film speed selector dial. Thus, ISO 400 film may be rated at ISO 800 or ISO 1,600—this has the effect of underexposing the film which in turn must receive extra development to compensate. (Of course it should be remembered that the entire film will have to be exposed and processed in the same manner.) Despite the advantages, films should only be up-rated as a last resort because there will always be a marked deterioration in image quality, due to the increase in grain size. Up-rated colour films suffer the additional penalties of poorer colour rendering and reduced image contrast.

OTHER CONSIDERATIONS
There is no one film which will cover all eventualities, regarding speed. In fact, many experienced nature photographers who choose to cover a wide

Overleaf **Although the lighting was very dull and flat on the day I photographed this grey heron, the dark background and the contrasting tones of the bird's plumage ensure that the picture works equally well in both black and white, and in colour.**

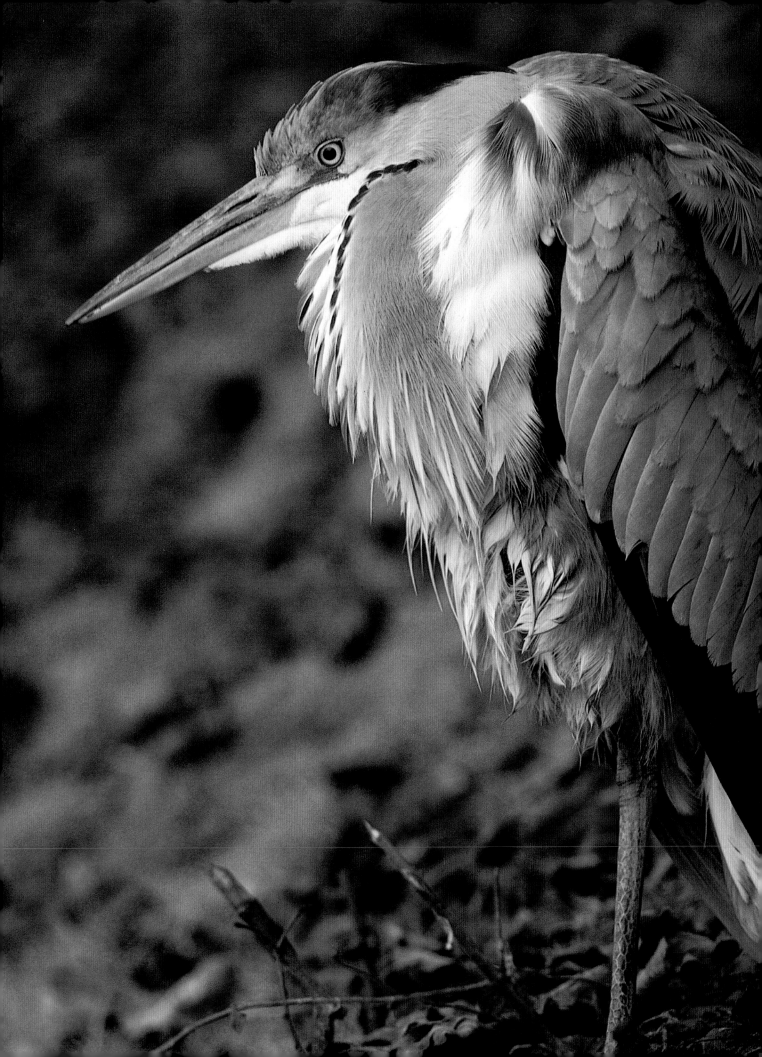

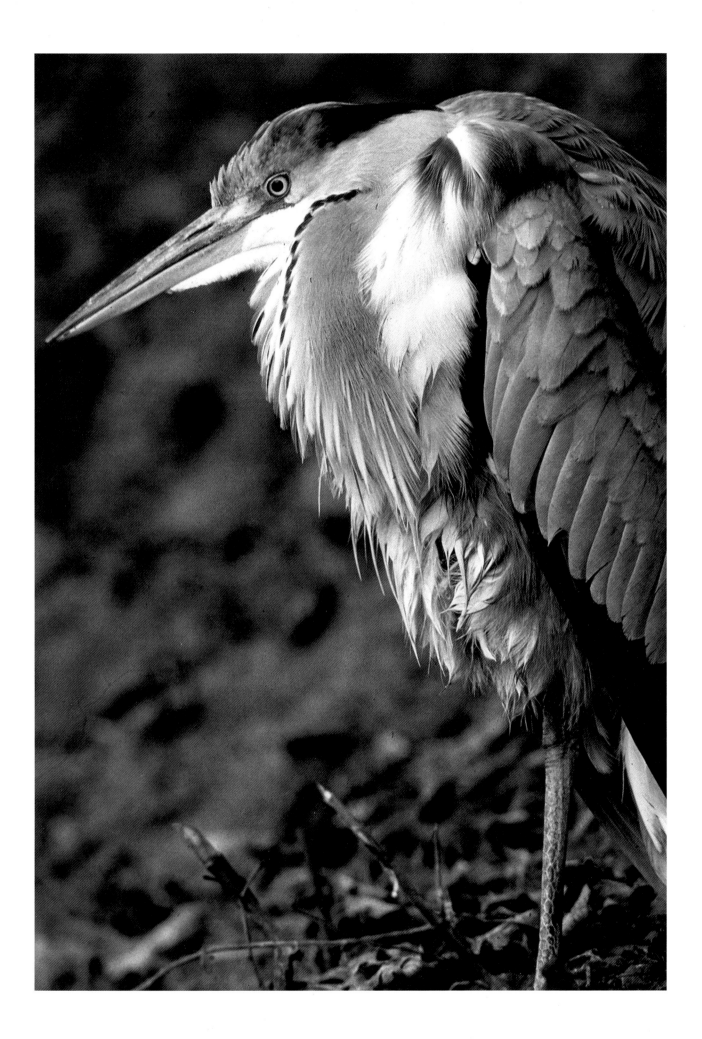

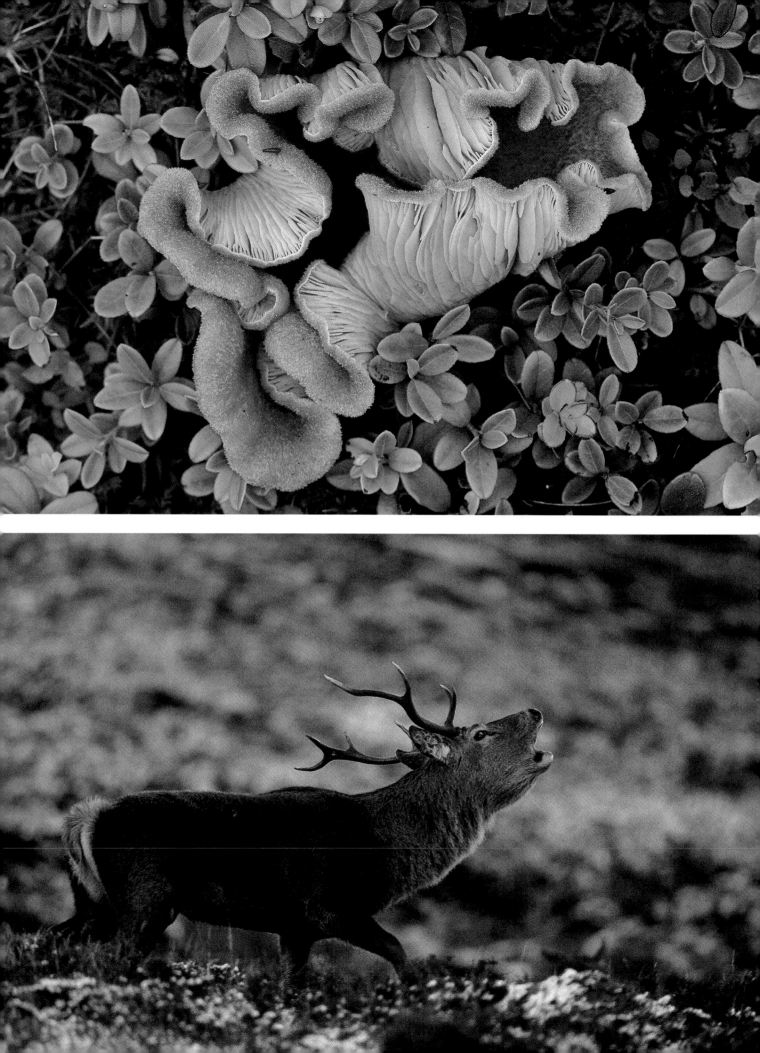

variety of subjects often attempt to solve this problem by using extra camera bodies containing different types of film. Even between manufacturers there are often subtle variations in the way colours are rendered by films of the same speed. Anyway, since most people have different ideas concerning proper colour rendering, choosing a film becomes a matter of personal preference. Begin by selecting only two or three medium speed films, and get to know their characteristics well by using each in a variety of lighting conditions—by comparing the results, it is possible to decide which ones you are going to like. Gradually, after a little more experimentation with faster and slower films, a working knowledge is acquired which may be used whenever a particular subject demands a certain approach.

5 FILTERS

In nature photography, the use of filters is generally restricted to types which will emphasise certain aspects of the subject, yet still show it accurately. The types that most people encounter first are UV and skylight filters which may be used with both black and white and colour films to reduce the effects of haze by absorbing ultra violet light. These filters are often offered by camera shops on the pretext that they should be left permanently attached to protect the front of the lens. Certainly, they are useful for this additional purpose when working in adverse conditions—such as a marine environment where salt spray is a constant problem—but otherwise, they are just another layer of glass which may degrade image contrast by increasing the likelihood of flare, particularly when photographing into the light. In fact, lens hoods are a much better investment for this purpose because they minimise flare and provide ample protection against rain, stray fingers and even abrasive qualities of undergrowth.

Polarising filters reduce haze, and also perform two other important functions: they deepen blue skies, and enhance other colours by reducing reflections from shiny surfaces. This latter property is equally useful when attempting to photograph aquatic subjects below the surface of clear, shallow water. In all instances the effect is greatest when photographing at right angles to the sun and, to some extent, may be varied by rotating the filter in its mount.

When working in overcast lighting or in shade, certain colour films often give images with a cool, or bluish cast. In these circumstances, an amber-coloured warming filter may be used to restore

The lighting was very dull and overcast on the day I found this fungus growing at the edge of a Scottish pine forest. Nevertheless, I decided to use a slow, fine-grained film with a speed of ISO 25 to show the maximum amount of detail. As always, a tripod proved to be indispensable for eliminating camera shake resulting from the slow shutter speed.

Unlike the previous photograph of the fungus, I did not have the option of using a slow film speed when photographing this red deer stag roaring in the rutting season. The dim lighting, combined with the need to select a reasonably fast shutter speed to prevent camera shake and subject movement, compelled me to use a faster film with a rating of ISO 200.

Overleaf **In addition to enhancing the blue sky, a polarising filter has enriched the yellow foliage of these birch trees by eliminating countless reflections from the surfaces of the leaves. Because the filter was adjusted for maximum effect, there was a loss of light equivalent to two shutter speed settings.**

Page 39 **I used a polarising filter to remove unwanted glare from the surface of this moorland pond. This has had the effect of increasing the contrast between the dark peaty water and the floating leaves of the waterlilies.**

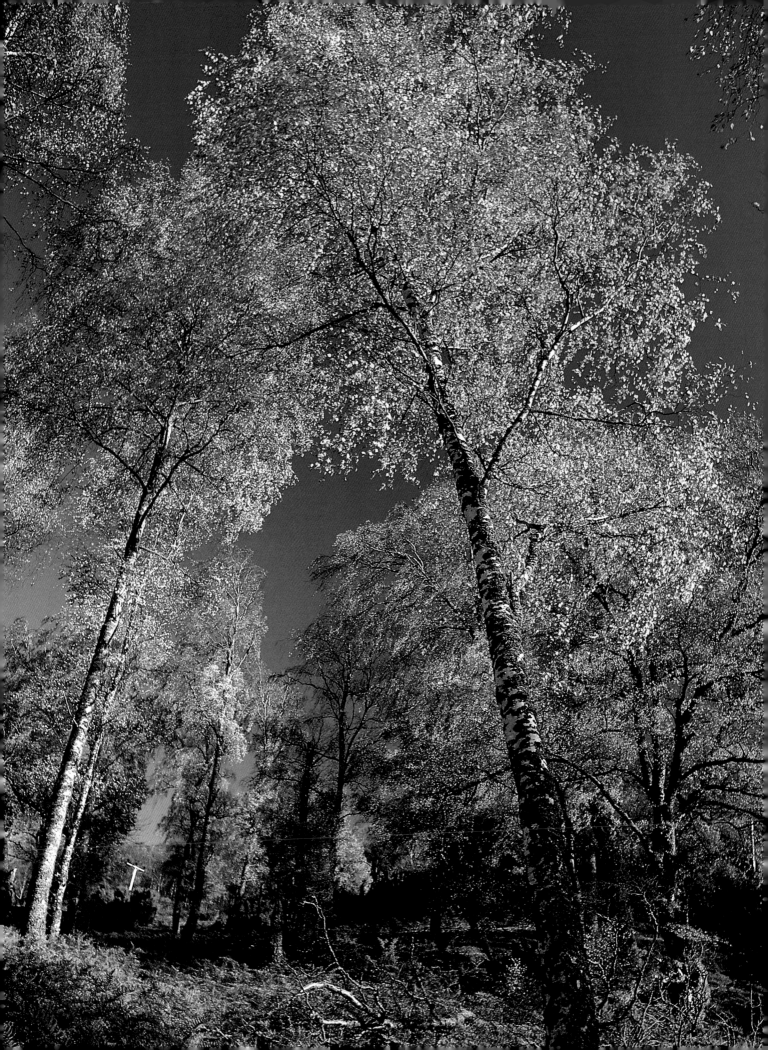

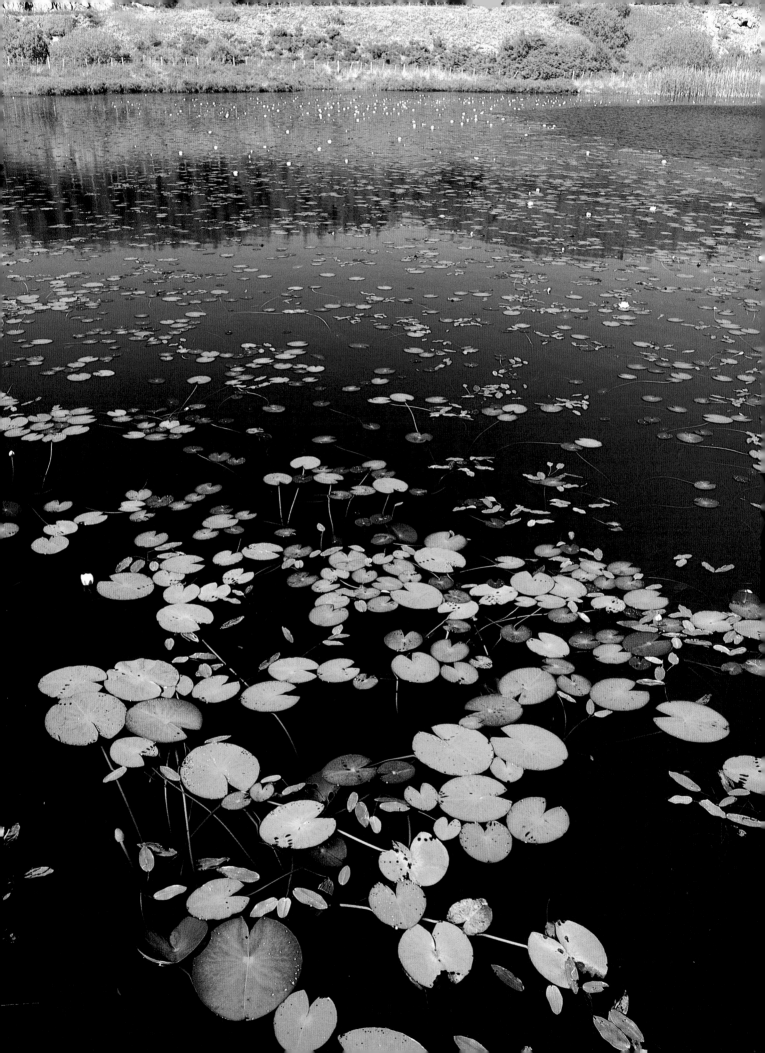

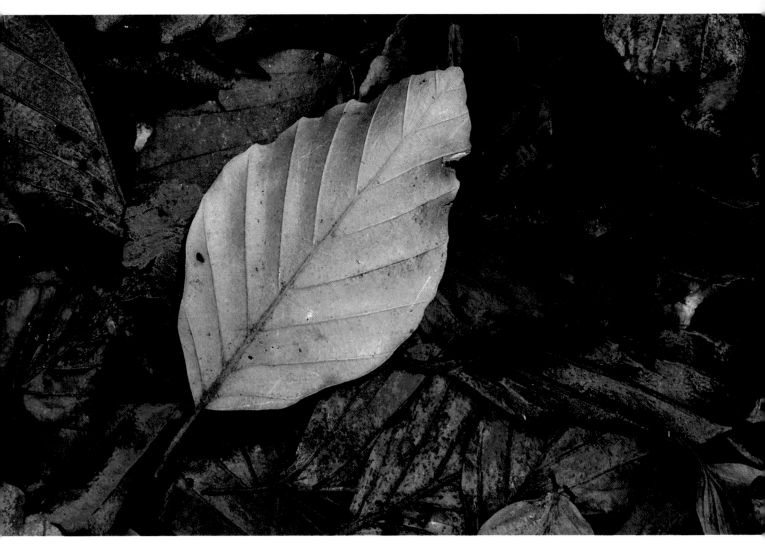

The effect of an 81B warming filter is clearly visible in these comparison photographs of beech leaves. The photograph above was taken without any filter, and though acceptable, it is not so appealing as the one on the right, which was taken with the filter. Both were photographed on the same roll of Kodachrome 64 slide film in dull, overcast lighting.

proper colour balance. As warming filters come in a variety of strengths it is vital that the photographer has an intimate knowledge of the film he is using, in order to predict which will be the most appropriate. Warming filters may also be used with poorly corrected lenses which consistently give bluish images, regardless of lighting or film characteristics.

Colour contrast filters are specifically designed for use with black and white films, and have the effect of emphasising certain colours; they achieve this by blocking out the light from colours which are complementary to those of the filter. For example, a green filter will absorb red and blue light, while allowing yellow and green to pass freely, thus green foliage may be rendered as a lighter tone on the final print. Similarly, a yellow contrast filter will darken a blue sky and make white clouds and flying birds stand out more clearly.

With the exception of UV and skylight filters, all filters work by reducing the amount of light reaching the film, and so affect the readings given by the camera's TTL light meter. In addition, there are special light-reducing filters, known as neutral density filters, which absorb all colours equally—and therefore have no effect on colour rendering—whose primary function is to allow the use of slow shutter speeds or wide lens apertures in situations where lighting levels

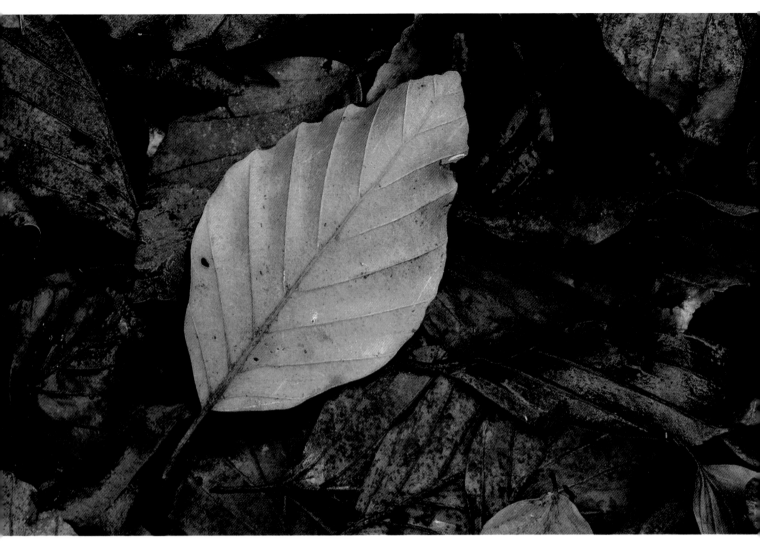

are high and/or where a fast film is being used. Graduated neutral density filters reduce the brightness toward one half of the picture area, and so can be invaluable in overcoming the difficulties experienced when photographing scenes where there may be extremes of contrast between foreground and sky.

Overleaf **To illustrate the effect a colour contrast filter can have on a blue sky, I photographed this dead flowerhead of a giant hogweed both with, and without, a deep orange filter. While the photograph on the right clearly shows the difference a filter can make, the effect could have been more dramatic had I used a red filter. A yellow filter would have given a result somewhere between the two photographs reproduced here.**

41

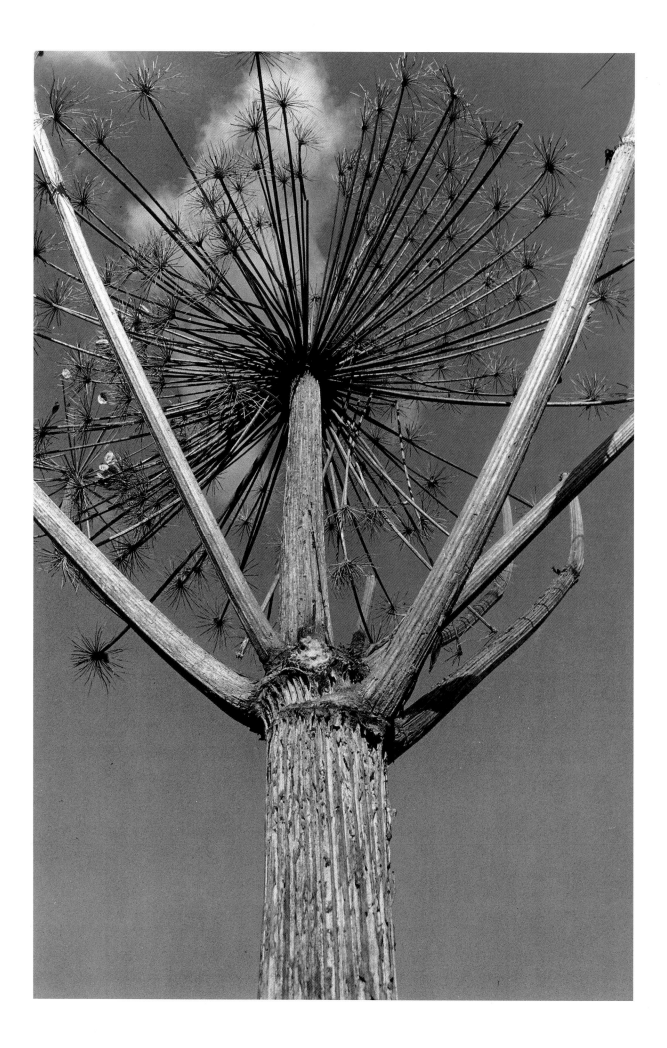

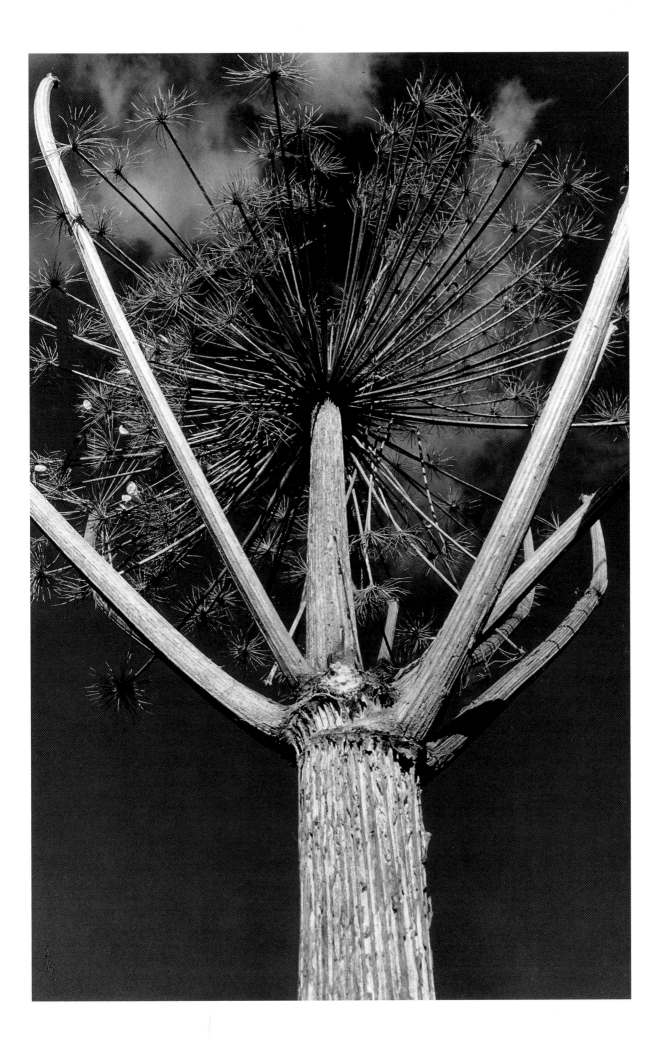

6 ELECTRONIC FLASH

The illumination from an electronic flash unit is produced by discharging a high current of electricity through a tube filled with inert gases. The power for this electrical charge is built up from low voltage batteries and stored in a capacitor; these batteries are often rechargeable and capable of providing sufficient power to expose several rolls of film with a delay of only a few seconds between each exposure. With the miniaturisation of many electrical goods, modern flash units provide nature photographers with a very convenient supply of artificial lighting.

Before choosing a flash unit it is necessary to consider the distances at which you are likely to be working from the subject. For instance, with shy nocturnal mammals like badgers, it is often difficult to get any closer than about 8m (25ft), while for most insects, it is possible to approach within 15cm (6in) or less. Working distances, or to be more precise, flash-to-subject distances, are very important because of one fundamental rule: the intensity of lighting diminishes the further the light must travel from its source. Therefore, the further the subject is from the flash, the more powerful the unit must be.

GUIDE NUMBERS

All manufacturers use a system of guide numbers as a means of quoting flash outputs; they are given in metres, and are usually calculated for film speeds of ISO 100. The best way of understanding guide numbers is to think in terms of lens apertures and flash-to-subject distances, since at all times we are primarily interested in knowing which lens aperture we shall be able to use at any given distance. To determine the lens aperture we must divide the guide number by the flash-to-subject distance. For example, when using a flash unit with a guide number of 28, at a distance of 5m (16ft), the lens aperture will be f5.6; at 10m (32ft) it will be f2.8; and so on.

Because high guide numbers indicate a powerful flash unit, some manufacturers quote guide numbers

This photogaph of a hedgehog crossing a road was taken purely on an 'opportunist' basis. To illuminate the scene I used a very small manual flash unit which I tend to keep in my camera bag at all times— just in case. Despite its limited power (GN14 metres with ISO 100), it has proved extremely useful on many other such occasions when I have wanted to photograph a subject at close range in dim lighting.

44

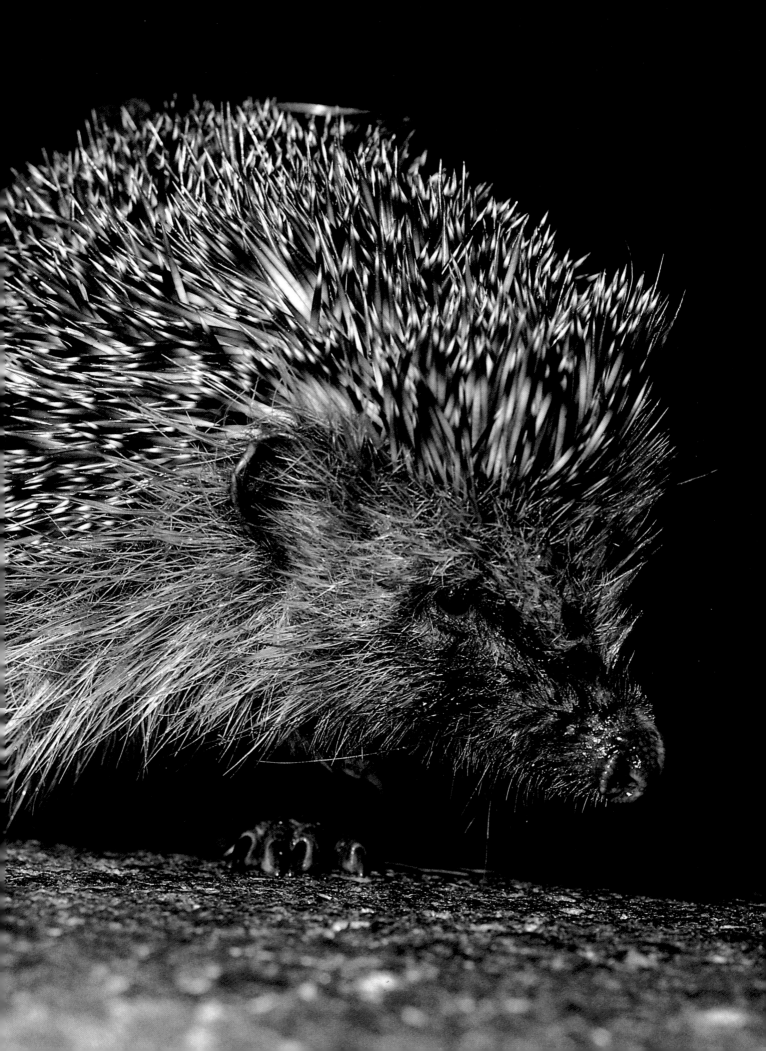

for faster film speeds to make their flash units seem more powerful. To overcome this difficulty we must work in lens apertures, because each higher setting is equal to a two-fold increase in film speed. As an example, consider the problem of using ISO 100 film, with a flash unit which is said to have a guide number of 40 with ISO 200 film. Using the above example, where the subject is 5m (16ft) from the flash, we find the lens aperture will be f8 (ie guide number of 40 divided by 5m). Because we are using a film which is half as sensitive, we must decrease the lens aperture by one setting, ie to f5.6. Thus we find that the unit has exactly the same power as the one with a guide number of 28 for ISO 100 film.

Even with the most powerful flash units the rapid fall-off in illumination with increased distance imposes severe restrictions when attempting to photograph subjects any further than 10m (32ft) away. To counteract this problem, some manufacturers offer telephoto adaptors which increase the effective guide number by concentrating the flash into a narrower beam. Each adaptor is matched for a particular focal length of lens—but effective as these devices are, they do require careful alignment if they are to illuminate the same portion of the scene which is covered by the lens.

Guide numbers really are only a guide to correct exposure, and when working outdoors they often prove to be unreliable. This problem stems from the fact that most manufacturers base their calculations for indoor use, where flash power is enhanced by light reflecting off walls and ceilings. The only way to determine the power of any unit is to actually test it in a variety of conditions. As a general rule, it is wise to increase the size of the lens aperture by one setting (use next lowest number) when working outside with manual flash units.

AUTOMATIC FLASH UNITS

Guide numbers also enable us to calculate exposures for manual units which emit a fixed amount of light. In fact few modern flash units work solely on a manual basis, and most now have the option of an automatic mode of operation, too. On some units even the manual modes are variable, in that outputs may be reduced in stages by factors of $1/2$, $1/4$, $1/8$ and so on.

Automatic, or computer modes are easier to use because they may be programmed to discharge only a measured amount of light for correct exposure with a given lens aperture and film speed. The most powerful units offer five or more different aperture settings which change with film speed. Each setting has a maximum operating range which is indicated on a chart printed on the flash unit. Computer settings work by employing a sensor to measure the light being reflected off the subject once the flash is fired. As soon as the required level is reached, the sensor cuts off the supply, thus saving part of the charge stored in the capacitor.

The speed at which this sequence of events takes place is quite incredible and the closer the unit is to the subject, the shorter the duration of the flash will be—with some units it can be as brief as $1/20,000$sec. In situations where flash is the main light source, such short durations can provide an effective means of freezing the actions of a whole range of subjects from insects to small birds and mammals. Like the TTL meters in many cameras, the accuracy of such auto-exposure systems relies on the positioning, and the angle of view of the sensor. Normally it is mounted on the flash, but with so-called TTL flash units—only compatible with selected cameras—it is positioned inside the camera. The benefits of this innovation are that the angle of view of the lens, and the loss of light caused by filters and close-up accessories, will automatically be taken into account. This is because the sensor is only 'seeing', and therefore measuring, the light which is actually reaching the film.

7 CAMERA SUPPORTS

The key to obtaining sharp, well-composed photographs often lies in having an adequate means of supporting the camera. Choice of subject matter alone may often dictate the use of long telephoto lenses or close-up equipment, either of which will increase the risk of camera shake due to the higher magnifications involved. Although using faster films will allow faster shutter speeds to eliminate camera shake, they do reduce image definition because of increased grain size. By all means use fast films to freeze subject movement in poor light but, where there is a choice, it is always preferable to take the trouble to support the camera and use a slower, finer-grained film.

TRIPODS

A good solid tripod must be high on the list of priorities for anyone beginning in nature photography, and the type of tripod required depends largely on the nature of the subjects to be photographed. Plant photographers will certainly need one which has a facility for working at low level; bird and mammal photographers will require a heavy duty model, capable of supporting long telephoto lenses when working from a hide. Before choosing a tripod

it is important to realise that there is a direct correlation between weight, stability and ultimately, cost. A flimsy, lightweight tripod which appears satisfactory when set up on the floor of a camera shop, may be totally inadequate when working in rough grass in a light breeze. If in doubt, it is always preferable to err on the heavy side—the benefits will be well worth the extra effort it takes to carry it around.

The working height of most tripods is usually governed by the number of sections contained in their legs. On compact models which have three or more sections, the last ones tend to be rather thin, and therefore make the structure less stable. Locking

The rock on which this dipper is perched was put there by myself; it was carefully sited below the bird's nest and was subsequently used regularly by each parent as a look-out post, before they flew up to feed their chicks. After introducing a hide into the area I was able to begin photography. With such a well-used perch all I had to do was pre-focus my camera and wait. A heavy tripod was essential, not just for avoiding camera-shake, but also for holding the camera in one position over long periods of time, which helped to put the birds at ease.

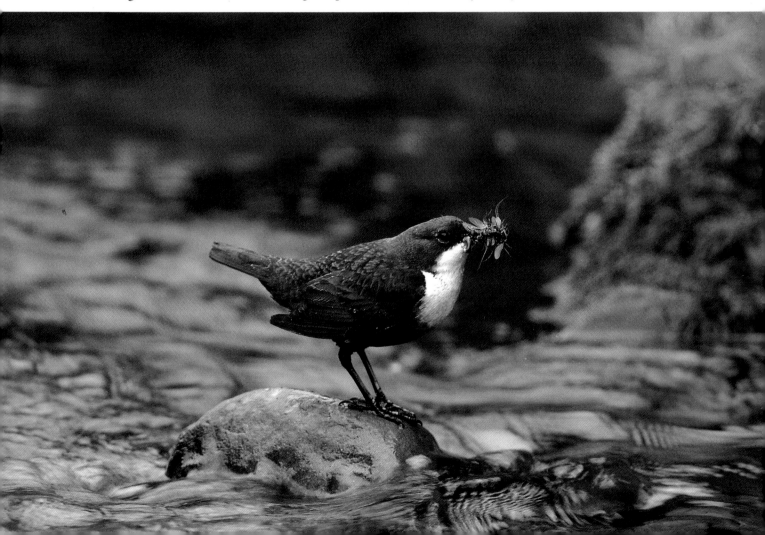

Most modern equipment is well able to produce good results, but when it comes to tripods, one make in particular seems to have been custom-designed with the nature photographer in mind: the Benbo tripod. It is available in six different versions which vary both in weight and maximum height; and the angle of the centre column, and of each leg, is independently adjustable and may be locked into any desired working position by rotating a single lever. The photograph below shows it in use at low level to photograph the close-ups of barnacles on page 28. In the photograph on the right, only the middle leg and the centre column have been extended, to form a makeshift but effective monopod.

clamps used for adjusting leg length must operate quickly and positively. The materials used in leg construction should also be checked—enclosed tubular designs are always better than the open 'U'-shaped variety since they cannot fill up with mud or sand.

Tripod heads are normally interchangeable and fall into two main categories: ball-and-socket, and pan-and-tilt. Ball-and-socket types allow more rapid adjustment but are difficult to level, and are often unsuitable for hidework because they cannot be used smoothly. Pan-and-tilt heads differ, in that they have separate handles for locking the various movements, and thus are more usable with heavy equipment.

With tripods which cannot normally be used at low levels, it is often possible to suspend the camera closer to the ground by reversing the centre column. The success of this mode of operation relies on having a tripod head which permits the camera to be used the right way up, otherwise you are faced with the near-impossible task of using it with all the controls upside down.

MONOPODS AND SHOULDER GRIPS

Although tripods can often be used successfully for stalking many wildlife subjects, monopods and shoulder grips give a much greater freedom of movement—albeit at the expense of some stability. The comments on tripod legs apply equally to monopods since they are essentially of very similar design, except that they have a retaining screw on top for attaching a long lens or camera. Shoulder grips offer less support, yet compensate by being the most effective way of handling a camera with a telephoto lens when panning with a rapidly moving subject. The best shoulder grips have cable releases or electrical cords built in to triggers in their handgrips for firing motordrives and camera shutters. When monopods and shoulder grips are used together, the resulting combination is more stable because the shoulder grip reduces the side-to-side movement of the monopod.

I spent the best part of an afternoon and used up three rolls of film photographing puffins flying to and from their breeding grounds, trying to obtain a good shot of this individual returning to its burrow. Using a rifle grip proved to be the only practical way of supporting the combined weight of my motorised camera and 50–300mm zoom lens whilst panning with such fast-moving subjects.

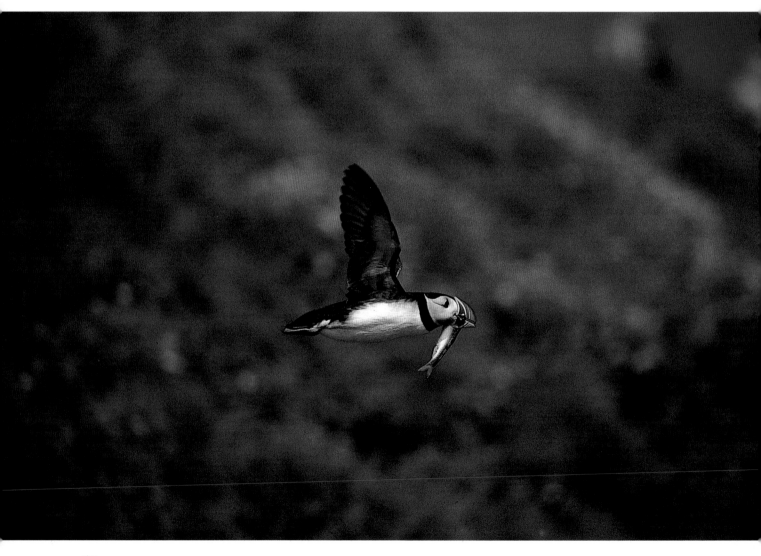

8 REMOTE CONTROL DEVICES

To be effective, all remote control triggering equipment must be used with a motordrive or auto-winder to allow the film to be advanced automatically after each exposure. Indeed, where sensitive subjects like nesting birds are being photographed, motorised cameras are imperative. Over short distances, air releases provide the simplest and cheapest way of operating cameras which may be triggered via a cable release socket. They consist of a 4–5m (13–16ft) long plastic tube with a rubber bulb on one end, and a threaded plunger on the other. Their range is limited, and their greatest drawback is the time delay between squeezing the bulb and the plunger actually firing the shutter.

A more satisfactory method of triggering a camera is to do so electrically, using devices which fit into the remote control sockets which are present on most motordrives and auto-winders. There are three main systems: radio control, infra-red flash and electrical cables with hand switches. The first two devices—which tend to be rather expensive—consist of two units, a transmitter and a receiver. With the infra-red flash system, a pulse of light fired from the transmitter is picked up by a photo-electric sensor, which in turn fires the camera. Operating distances are usually limited by the power of the flash, to a range of about 60m (200ft), though at this distance extreme care must be taken to align both units accurately.

Although radio controlled systems allow even greater operating distances, very few are legal, and all are subject to accidental misfire from other sources. Most cable switches function by completing an electrical circuit. By exploiting this principle it is possible to extend, and adapt short cables to accept simple homemade systems of pedal triggers and trip-wires which will allow subjects to photograph themselves. Some electrical hand switches have a two-stage mode of operation. Depressing the switch fires the shutter, and releasing it winds the film on. Since the latter causes the most noise, it is possible to regulate disturbance when photographing say, nesting birds, by waiting until the parent leaves the nest before advancing the film.

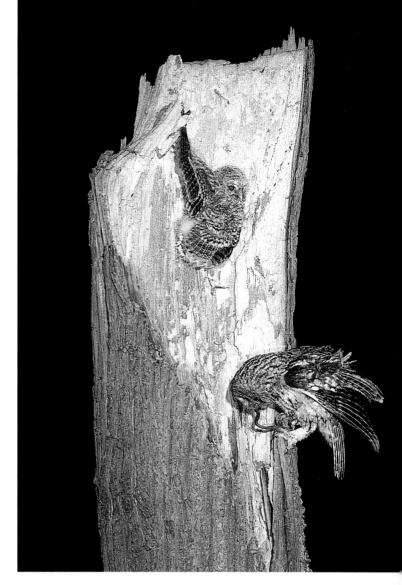

I discovered this nest of young tawny owls in the rotted limb of an ash tree 15m (50ft) above the ground, while returning home after an evening spent badger watching. On returning to survey the site in daylight I decided not to introduce a hide since the tree was close to a well-used public footpath. Instead, I nailed a single wooden board onto the branch of a neighbouring tree which overlooked the nest; the following evening I returned and clamped my camera with flash units onto the board. Then, after connecting a homemade electric cable release to a socket in the motordrive, I was able to trigger my camera from the comfort of a sleeping-bag on the ground beneath the tree.

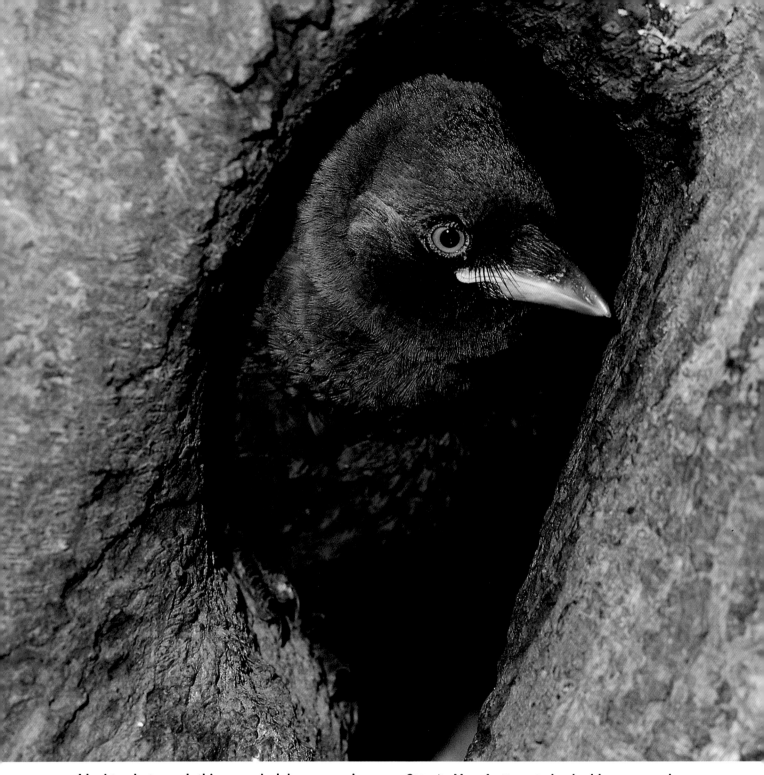

I had to photograph this young jackdaw, preparing to leave its nest, by remote control because it was impractical to introduce a pylon hide in time to coincide with its departure. Instead, I clamped a motordriven camera and flash units onto a ladder placed against a nearby tree and retreated behind a hedge some 40m (130ft) away where I was able to fire the shutter via an infra-red flash trigger. I wrapped a pullover around the camera to muffle the sound of the motordrive.

Opposite Here I attempted a double exposure by photographing the moon and its reflection separately on the same piece of film. This involved photographing the moon first at the top of the frame, then, while mentally noting its position, making the second exposure having tilted the camera downward onto the reflection, so that one would be superimposed above the other. Using ISO64 film and a lens aperture of f5.6, I found the correct exposure time for the moon to be 1/125sec, and 30 seconds for the reflection.

PART TWO

TECHNIQUES

9 EXPOSURE

Exposure is the term used to define the amount of light which is allowed to fall onto the surface of the film. To achieve consistent results from a film of a given sensitivity or 'speed', we must ensure that it receives only a strictly measured amount of light. To regulate exposure we use two basic controls: lens apertures, and shutter speeds. Lens apertures, or 'f stops' as they are more widely known, control the intensity of the exposure by altering the size of the opening in the lens iris. On most lenses they are marked as a series of steps usually beginning at f2.8 (a large aperture), and ending with f22 (a small aperture). Shutter speeds, which control the duration of the exposure, are graded on most cameras from a slow speed of one second duration through to a fast speed of 1/1,000sec. The faster the shutter speed, the briefer the exposure, and the less time light has to reach the film.

Both shutter speeds and lens apertures have what is known as a 'one-stop' relationship. This means that for each higher setting (or stop) selected on either scale, the amount of light allowed to reach the film is halved. Conversely, for each lower setting chosen the amount of light is doubled. As the two scales are fully interchangeable, choosing a higher setting on one must be compensated for by choosing the next lowest setting on the other. For example, an exposure of 1/125sec at f11 lets just as much light onto the film as 1/250sec at f8, or 1/60sec at f16. In each case there are many possible combinations, and knowing which one to select depends on understanding the effects that both have on the subject. This last point is especially relevant when using cameras with auto-exposure modes which often choose settings without being able to interpret the effect of their selections. In fact, for the beginner, with such a camera, the best way to learn about exposure will be to spend time with the camera switched over onto a manual mode. The following discussions are based on this recommendation.

SHUTTER SPEEDS
Shutter speeds dictate a certain effect on both camera, and subject movement—the faster the shutter speed, the greater the ability to arrest subject movement. And the effect of shutter speed on camera movement should never be underestimated as it is probably the foremost cause of blurred pictures. The ability to hold a camera steady varies not only from person to person, but also according to the focal length of the lens in use. Longer, higher magnification lenses require faster shutter speeds because they are always more difficult to hold still.

The general rule is that the shutter speed in fractions of a second should equal that of the focal length of the lens in millimetres. Thus a 50mm lens should not be hand-held at speeds greater than 1/50sec, while a 500mm lens will require a speed of 1/500sec. Of course, when the camera is supported by a shoulder grip or a monopod, these speeds may be reduced by one or two settings. When a tripod is used, far greater reductions are possible, but remember that this will ultimately depend on the stability of the tripod.

The other factor to consider when selecting a shutter speed is subject movement. With plant life it is generally only necessary to arrest movement on windy days and even then, by using a tripod it is often possible to work with speeds as low as 1/15sec or more by waiting for a lull in the wind. Similarly in the animal world, wading birds, butterflies, or deer will all usually pause momentarily, allowing the picture to be taken when the subject is still. Deciding just how 'still' a subject needs to be for a given shutter speed is largely a matter of experience.

There are, however, instances when faster shutter speeds must be used in order to freeze movement. In the case of flying birds, for example, the direction of flight, frequency of wing beats, and proximity of the subject to the camera, all come into play. Because this is a more difficult and specific subject, advice on selecting shutter speeds is given later in Part Three, Fieldwork, p 105.

LENS APERTURES
Lens apertures control depth of field, and depth of field is the section of any scene, from near to far, which appears to be in sharp focus. To increase depth of field it is necessary to 'stop-down' to a smaller aperture, while to decrease depth of field the lens must be 'opened up' to a larger aperture. Another important factor is the proximity of the lens to the subject. In extreme cases where long telephoto lenses are focused at their minimum focusing distances, the depth of field can be very narrow—even when the lens is stopped down to its smallest aperture. This also applies in the case of close-up photography where at a reproduction ratio of 1:1 the depth of field

may only be measured in millimetres. In either situation this effect is due entirely to the magnification of the image on the film. Thus, with a given lens aperture, all lenses will show the same depth of field providing that the subject remains the same size in the viewfinder. For how to use depth of field effectively, see Chapter 11, p 86.

COMPROMISES BETWEEN LENS APERTURES AND SHUTTER SPEEDS

With any given exposure value there is only a limited allocation of light available from which to derive a ratio between lens aperture and shutter speed. In extreme lighting conditions this choice can be severely restricted, and it may prove necessary to change film speed, use neutral density filters, or better methods of camera support in order to widen one's options. When choosing between them, the golden rule is to eliminate both camera and subject movement. After that criterion has been fulfilled, the remaining allocation may be used to stop the lens down to increase depth of field. In practice no two situations are the same and, because of the number of variables involved, combinations of speed and aperture need to be tailored to suit the subject. For example, it may prove more effective to use a slow shutter speed to blur the background and create an impression of movement when panning the camera with a running deer. Again, there are instances when a limited depth of field might be desired in order to isolate a subject from a distracting background. Overall, it very much depends on how the photographer wishes to see the finished photograph.

MEASURING THE LIGHT

Today, almost all 35mm SLR cameras come complete with built-in, through-the-lens (TTL) light meters. Although these meters have many advantages, all are designed with one or two inherent features which make the process of measuring light in certain conditions much less straightforward than it seems at first. It is particularly important to be aware of these potential problems when using automatic cameras, because these are normally designed to give best results from average lighting conditions. To use these meters accurately requires an understanding of the way in which they work.

With TTL meters two main points must be considered. The first is that their readings are based upon the amount of light being reflected by the subject. In practice this means that the tone of the subject influences the exposure value worked out by the meter.

For most average subjects of neutral tone this system works well, since the meter is calibrated to give exposure values which will record average tones. However, when confronted with a predominantly dark or light subject it will still try to record the 'average' tone, thus resulting in a false exposure value.

The other important point about TTL metering concerns knowing what proportion of the composed scene the meter is actually 'seeing'. The most practical and widely adopted system is the centre-weighted one, in which the meter is progressively more sensitive to the brightness of the subject in the centre of the viewfinder—it assumes that the photographer is composing his or her pictures in the centre of the viewfinder. Difficulties can therefore occur when attempting to take a reading from a small subject that has been composed off-centre and against a background of a contrasting tone: the meter will be influenced more by the tone of the background it finds in the centre than that of the off-centre subject.

Neither of these difficulties need pose too much of a problem. The best way to overcome them is to familiarise yourself with your meter's response to awkward lighting situations, anticipate the difficulties and make the correct adjustments.

COMPENSATING FOR DIFFICULT LIGHTING

In the following examples of commonly encountered TTL metering problems it has been assumed that a centre-weighted system is being used. In each case the amount of compensation required depends both on the brightness of the weather conditions, and on precisely which tones we wish to record. The greatest adjustments are required in bright and sunny weather because of the increase in contrast. However, in extreme cases, and due to the limitations of the film, it may prove impossible to record a complete range of tones from certain scenes. In such situations it is best to obtain an exposure value that will record just a hint of detail in the highlight areas at the expense of some detail in the deeper shadows.

Overleaf **The effects of changing shutter speeds are shown in these two photographs of a section from a waterfall. The one on the left was taken at 1/500sec to 'freeze' the droplets of water in mid-air. The photograph on the right was taken at a slower speed of ½sec to create a blurred effect. To obtain the slower speed I was obliged to use the smallest aperture of f22 on my 50mm lens, plus a polarising filter to reduce exposure even further; the filter has also eliminated the glare from the wet rockface.**

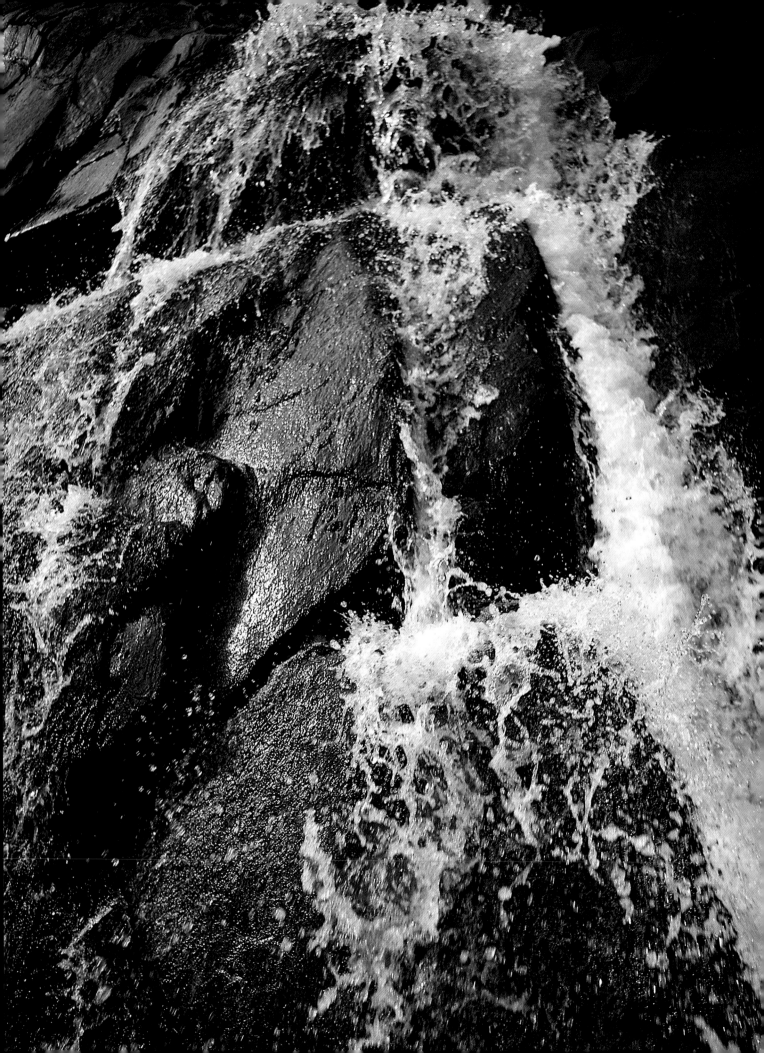

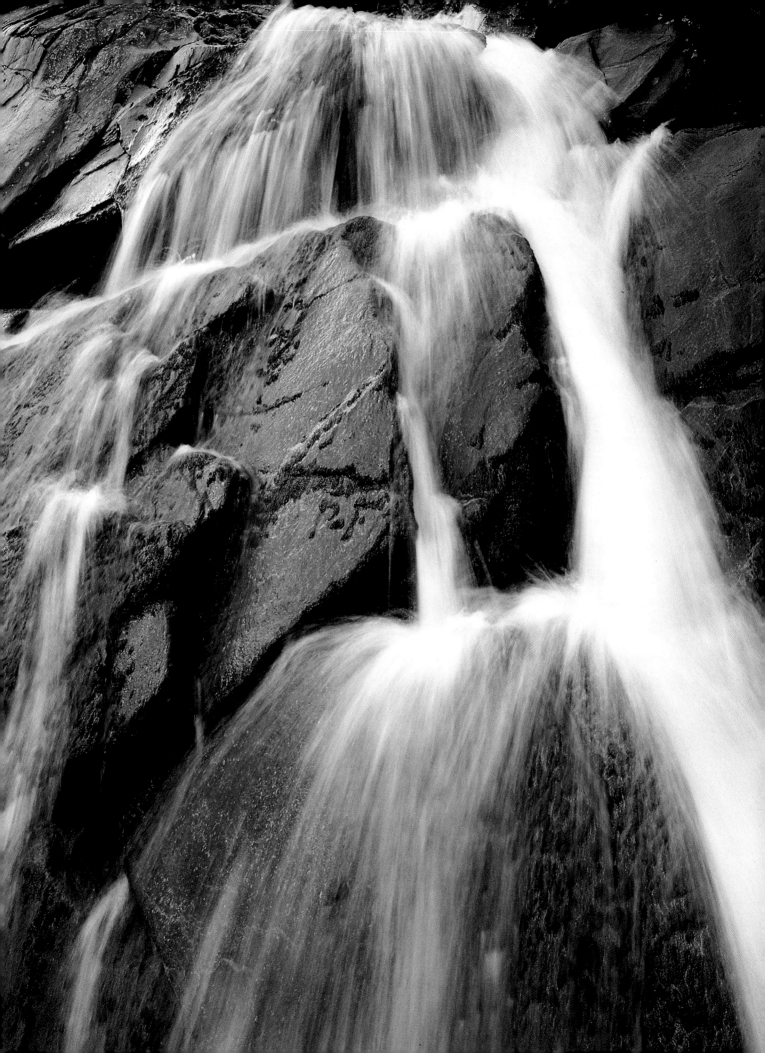

Pages 58/9 **These photographs of snowdrops well illustrate the effect of closing a lens down to a smaller aperture to obtain a greater depth of field. In each instance a 28mm wide-angle lens was used with the camera mounted on a tripod. The photograph on the left was taken with the lens opened up to its maximum aperture of f2.8, while for the one on the right, it was closed down to its minimum aperture of f22.**

Below **This photograph of a great tit is typical of a situation in which a compromise must be reached when choosing between shutter speed and lens aperture. A light meter reading on this bright and sunny day gave an exposure reading of 1/125sec at f8 with ISO 64 film. Because I was working from a hide, I already had my camera with 300mm lens supported on a tripod, therefore camera shake did not present a problem. However, the movements of this active little bird did, and in order to ensure a**

sharp photograph, I selected a higher shutter speed of 1/250sec. To compensate for the loss of light caused by this faster speed, I was forced to open up the lens by one more stop to f5.6. In turn, this had the effect of restricting the depth of field even further, so I was having to continually re-focus the lens to keep the bird in sharp focus.

Opposite **This photograph of a red deer stag was taken on a wet and overcast day when the lighting was very soft. Deciding which area to take a light reading from posed very few problems, as the whole scene was equally composed of neutral tones. However, because of the low lighting levels and the slow film speed (ISO 64), I was forced to use my 600mm lens at its widest aperture of f5.6, with a shutter speed of 1/15sec. To avoid camera shake with such a slow shutter speed I rested my camera on a conveniently positioned boulder which I had initially used as cover when stalking the stag.**

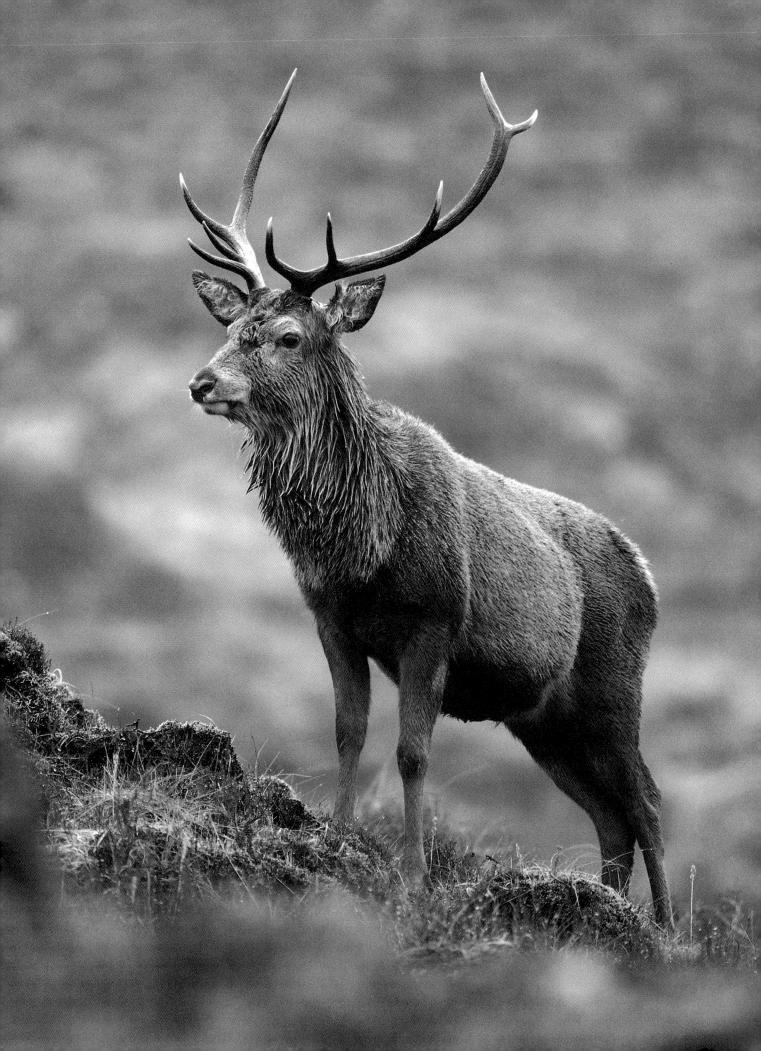

DARK SUBJECT/LIGHT BACKGROUND

Two typical examples of this problem would be a pheasant on a snow-covered field, or a hawk hovering against a light, cloudy sky; in both cases it would be desirable to show detail in the plumage of the bird. If either subject appears small in the frame the light meter will give a reading based on the brightness of the background; this would be too low for the bird which will therefore appear too dark (under-exposed). To prevent this happening we need to redress the balance in favour of the bird by giving it extra exposure. To ascertain how much extra exposure the bird needs, a light reading must be taken from a larger subject of similar tone, and in the same lighting to that of the bird—in practice, this may involve directing the meter at a neutral-coloured rock or tree-trunk.

LIGHT SUBJECT/DARK BACKGROUND

In many ways this problem is similar to the previous one. In the case of, say, a group of primroses against a patch of dark-coloured leaf litter on a woodland floor, the meter will be influenced more by the tone of the background, and the reading will therefore

I photographed this grey heron, from a hide, at its daytime winter roost site on a snow-covered field. Even with my 600mm lens, the bird only occupied a small part of the viewfinder. Though the lighting was very dull, the light meter gave a reading of 1/250sec at f5.6 with ISO 64 film, because of the amount of light being reflected by the snow. To obtain a more reliable reading from a subject of similar tone to the bird, I tilted the camera upwards to centre the viewfinder onto the out-of-focus trees on the horizon—this gave an exposure value of 1/125sec at f5.6, which I then used to photograph the bird.

For this silhouette photograph of black-headed gulls at dusk I needed to take a light reading based exclusively on the brightest portion of the sky. In order to prevent the dark clouds influencing the reading, I directed the camera to an area of clear sky that was just to one side of this scene.

be too high for the flowers. If this exposure value were used, the resulting photograph would leave the flowers appearing much too light (overexposed), and without any detail in their petals. In such an instance, the exposure must be reduced and the technique used to do this depends largely on whether or not the subject is moving. If it is, to obtain a more accurate reading the camera must be directed at a larger, static subject of similar tone in the same lighting. If the subject is static, it is possible to take a reading directly off the flowerheads by moving the camera in close until they fill the viewfinder; the resulting exposure value can then be used from the original viewpoint.

In taking a reading in this manner it is important not to focus the lens closer since this would increase extension, and alter exposure. The techniques described above may also be used for metering dark coloured subjects against light backgrounds.

VERY LIGHT OR DARK COLOURED SUBJECTS

As already discussed, because light coloured subjects reflect so much light, normal TTL meters tend to give readings which are much too high, and exposures based on such readings always result in the subject being underexposed—thus snow-scenes, or close-ups of white birds, often appear grey in colour. To rectify this problem, the exposure must be increased, and this will involve taking a meter reading off a neutral coloured subject in the same lighting conditions. If this is not possible, an alternative would be to estimate the exposure by selecting a slower shutter speed or larger lens aperture—in most situations a difference of one or two settings will usually suffice. Similar problems can occur when photographing very dark subjects at close range, in which case the meter is likely to give a reading that is too low and which, if used, would result in overexposure; for

When photographing this grey seal pup on the Farne Islands off the Northumbrian coast, I chose to include a large area of background to emphasise the bleakness of its surroundings. However, with the pup composed to one side of the picture it did not fully occupy the portion of the viewfinder where my centre-weighted meter would base its reading. Anticipating this problem, I re-composed, and took a separate exposure reading with the pup in the centre of the viewfinder. Then, by engaging the exposure memory button on the camera, I turned back to my original position and took this photograph.

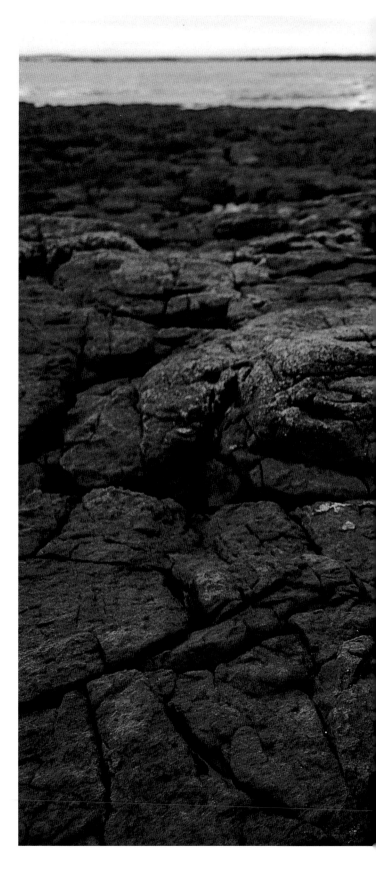

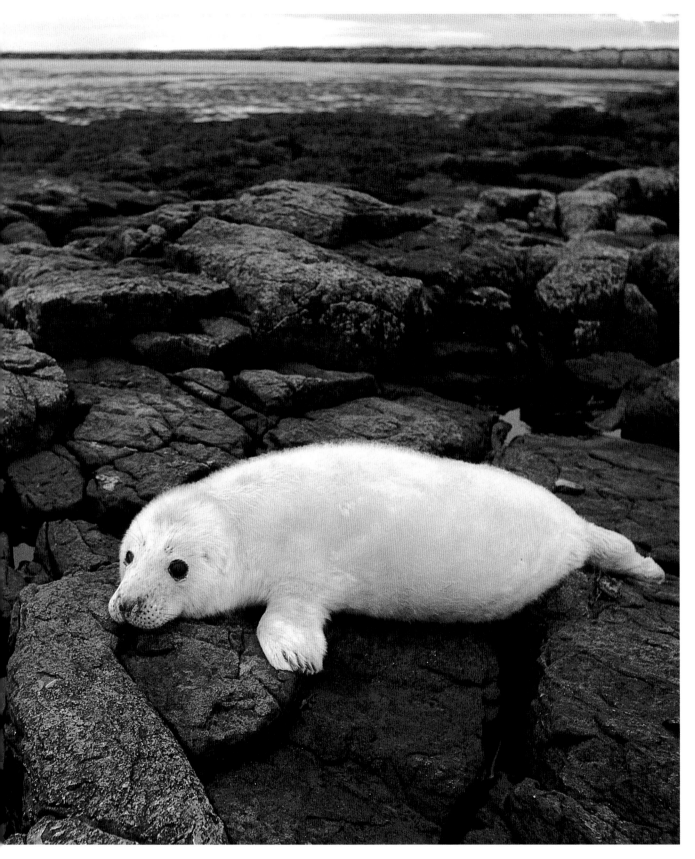

Exposure measurement always becomes more difficult when photographing into the light, and this backlit sycamore leaf proved to be no exception. To be sure of obtaining a meter reading which would not be influenced by the dark background, I changed to a longer focal length lens so that only the leaf filled the viewfinder. Then, after taking a light reading and calculating the exposure, I changed back to my original lens and took this photograph.

In photographing this male black grouse at its spring-time lekking ground, the main problem was how to arrive at an exposure reading which would show the detail in its dark plumage. Normally in such a situation I would take a reading off a more neutral coloured subject such as a rock, or a tree; however, at that time none was available, and even the grass was white with frost, so I had to rely on an estimated exposure. This involved taking a reading off both grass and bird, then using a setting mid-way between the two readings.

A reading with this mute swan's back filling the viewfinder indicated an exposure of 1/500sec at f11 with my ISO 64 film. This reading was far too high because of the amount of light being reflected by the white plumage. If it had been used, then the bird would have appeared grey in colour. To arrive at a more likely exposure for the bird, I took a separate reading from a nearby patch of green reeds which I estimated to represent a neutral tone. The reading that was obtained by this means gave an exposure of 1/250sec at f11, and when used on the swan, the detail in both the plumage and the bill was retained.

67

example black subjects like ravens often appear too light, and lack detail in their plumage. Again, the solution would be to take a reading off a neutral coloured object; except that for an estimated exposure, a faster shutter speed or smaller lens aperture must be used.

BRACKETING
In all difficult lighting situations—including those mentioned above—it is advisable to 'bracket' exposures where possible; to take one or two additional photographs at settings above and below the estimated reading. The amount by which we need to bracket depends on the type of film used; with negative films it is generally necessary to move at least one whole stop either way before there is any noticeable difference. Yet with transparency films, which have less exposure latitude, this may be too much and an adjustment of one half, to two-thirds of a stop will be more appropriate. On most cameras there are two ways of obtaining an intermediate setting: either by using the exposure compensation dial, or by manually positioning the lens aperture selector ring between marked settings when working in a manual mode. On cameras which do not have a compensation dial, a similar effect can be had by changing the film speed selector dial. For example, to underexpose ISO 200 film by half a stop, simply set the speed selector to ISO 300; to overexpose by half a stop, set it to ISO 150.

MAKING FINER ADJUSTMENTS
So far, we have been concerned with obtaining an exposure value that will ensure that our photographs will be neither too light nor too dark. For some scenes, however, there is often no 'correct' exposure and it may prove beneficial to slightly over-, or underexpose in order to create a more moody result. Misty views of woodlands often look better slightly overexposed, since tones and colours become lighter and more delicate. Conversely, underexposing scenes like sunsets will result in a more sombre and brooding effect. Slightly underexposing colour transparency film will enrich as well as darken colours and, for this reason, many photographers routinely underexpose by between one third, and one half of a stop. All of the above suggestions apply primarily to the treatment of colour transparency films. With negative films, subtle differences in brightness are traditionally controlled at the printing stage.

RECIPROCITY FAILURE
Very occasionally it may prove necessary to use a shutter speed of one second or more to photograph, say, a wildflower in deep shade on a dull day, or a landscape just after dusk or before dawn. In such situations the reciprocal arrangement between shutter speeds and lens apertures fails, and the resulting photograph appears too dark. To compensate for this it is necessary to increase exposure; the exact amount required varies, both with film speed, and the length of the exposure time. As an approximate guide, with ISO 100 films, 1 to 4 second exposures require a 50 per cent increase, while 8 to 16 second exposures should be doubled. Since increasing exposure times will only worsen the problem, corrections are best made by choosing a wider lens aperture. Using abnormally long exposure times also interferes with the ability of colour films to render colours properly. Colour balances are said to 'shift'—usually towards a crimson colour, with faster films undergoing the greatest changes. As this problem varies considerably between different types of film, each manufacturer will have his own recommendations on which types of colour correction filters to use in a given situation.

10 LIGHTING

Lighting is a crucial factor in every type of photography, and this is especially true of nature photography where the photographer nearly always has to make the most of whatever lighting conditions are available. An appreciation of the different effects of lighting is essential because it allows us to anticipate when conditions will be suitable to photograph a subject. Even throughout the course of a single day, natural light is continually changing, not just in intensity and direction, but also in colour. When the sun is low to the horizon at dawn or dusk, its rays are weaker because they must travel through an extra layer of the earth's atmosphere. In turn, this has the effect of absorbing most of the ultra-violet and blue radiation, so making the light appear more red.

Daylight colour films are balanced for the bluer midday sun, which explains why photographs taken then often display strong yellow or reddish colour casts. On many occasions, this warming effect can be quite pleasing as it establishes an air of tranquillity. However, where precise colour rendering is required to show, say, the plumage of a bird or the hues of a wildflower, this effect is false, and may be removed by using a pale blue colour correction filter.

In sunny weather, the lighting is at its best in the hours just after dawn and before sunset. At these times of day, colour casts become less noticeable, yet because the sun is still shining at a fairly low angle to the ground, long shadows are cast which accentuate shape and form.

In late autumn, winter and early spring the sun never climbs very high in the sky, so we have the benefit of this low-angled lighting for the best part of the day. The main advantage of working with low-angled lighting is that its effect on the subject may be varied simply by changing the position of the camera in relation to the sun.

Frontal lighting, where the sun is directly behind the camera, is traditionally thought to be the best form of lighting to work with because it gives the

The warm colour-cast in this photograph of a red grouse was caused by the low angle of the sun on this winter afternoon. Although a pale blue filter would have reduced this effect, I chose to leave it uncorrected as it aptly conveys something of the mood present at the time of day the photograph was taken.

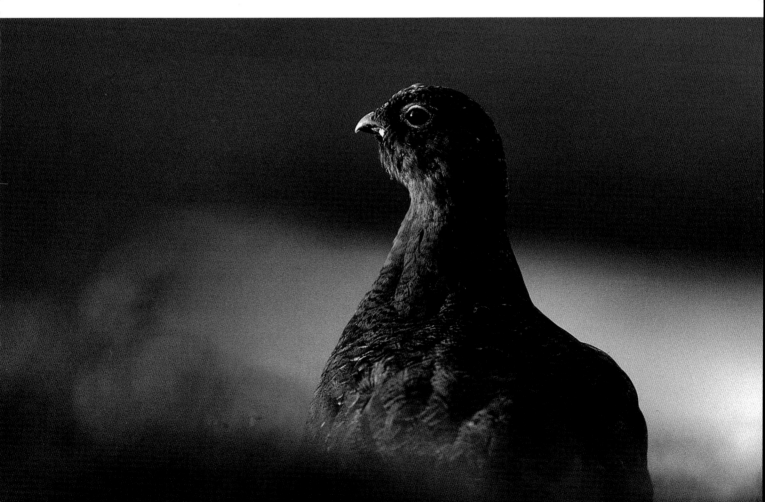

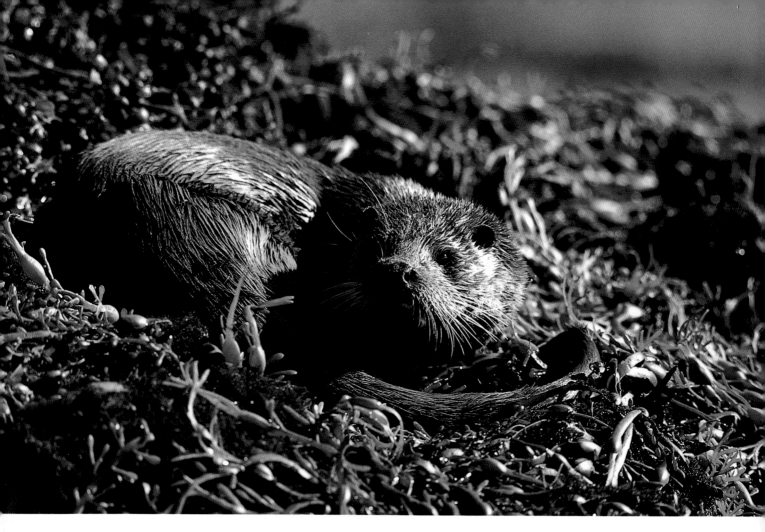

Getting close to this otter on the seashore involved a long and difficult stalk. Having to use available cover, and remain downwind, meant that I had no choice over the direction from which I could approach. As a result, I had to work with the sun shining to one side of the camera. Fortunately the contrasting low-angled side lighting proved to be ideal for showing the texture of the animal's wet fur, and for recording a highlight in its eye.

Opposite I would probably not have photographed this male mountain fern, had it not been for the low-angled backlighting shining through the freshly opened fronds. By using a telephoto lens I was able to isolate the subject against the shaded side of a large boulder. To increase contrast further, I got a friend to cast a shadow over the front of the lens to reduce flare—the difference was immediately apparent through the viewfinder.

most even illumination. However, because any shadow falls directly behind the subject, the picture appears rather two-dimensional, since depth and texture are completely lost. Conversely, sidelighting restores form and enhances texture by casting long shadows to one side; with harsh sidelighting, textures become really pronounced and contrast often reaches an unmanageable level. Under these conditions, a reflector, such as a handkerchief or a piece of white muslin, is useful to bounce light back into the shadows when photographing small inanimate subjects.

Backlighting is equally rewarding, but more difficult to work with because of the increased risk of stray, non-image-forming light striking the surface of the lens and causing flare. The most effective way of avoiding this problem is to choose a viewpoint where the shadow from a large object such as a tree will be cast over the camera. If this is not possible, and the subject is static, mount the camera on a tripod and cast your own shadow over the front of the lens, using a cable release to fire the shutter. Similarly, when working from a vehicle or a hide, move further inside so that the roof acts as a giant lens hood.

When photographing these meadow buttercups against the light, I deliberately made no attempt to shade the front of the lens. The resulting flare has lowered the image contrast, and thus subdued the colours to create this subtle misty effect.

Opposite This arctic tern was photographed on a hot midday in July when the sun was shining from directly overhead. Fortunately, the hazy atmosphere softened the light sufficiently to reduce the contrast between the bird's head and breast. However, the flat overhead lighting made it more difficult to obtain a satisfactory highlight in its eye—an absolute necessity with black-headed birds. The only solution was to wait until the bird moved its head into a suitable position for a strong catchlight to form. Using a tripod allowed me to concentrate on the subject without having to worry about camera-shake, while a motordrive secured a series of photographs at precisely the right moment.

Although dull and overcast weather may be initially discouraging, it can provide a beautiful soft lighting since the rays from the sun are greatly diffused. In fact, it was on just such a day that I photographed this male ptarmigan high on a Scottish mountain. The uniformity of the lighting has ensured no detail is lost to shadow, and that each feather marking is clearly visible.

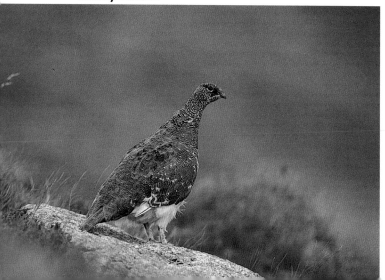

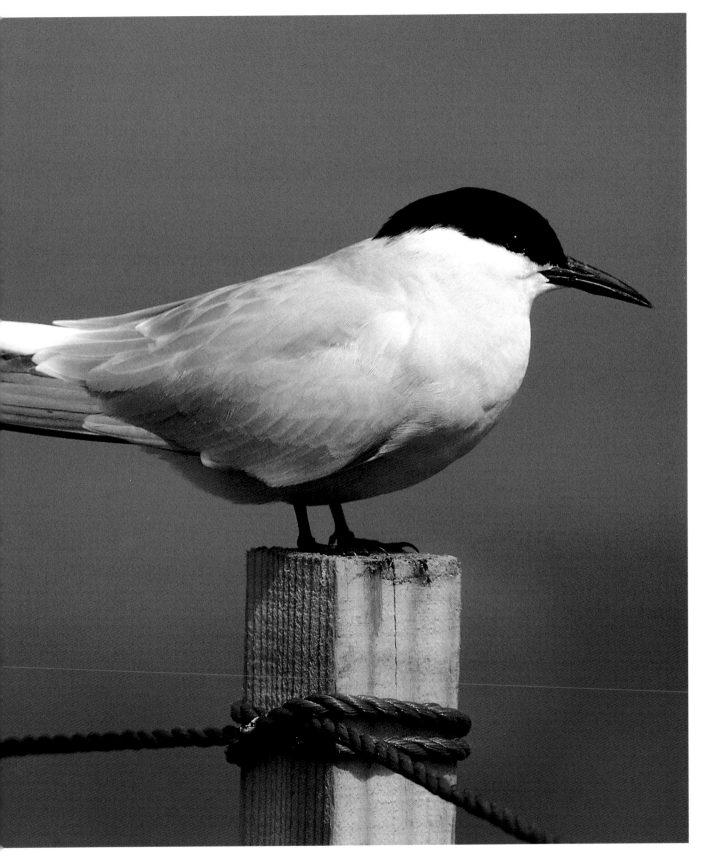

Reducing flare increases image contrast and makes colours appear richer. It also makes dark backgrounds appear even darker so that the backlit outlines of hairy plant stems or furry animals stand out more clearly. Again, where small inanimate subjects are being photographed, a reflector placed near to the lens will help to show detail in the shaded areas facing the camera. Where translucent subjects like flowerheads or leaves are being photographed, backlighting will have the effect of making them glow, as if lit from within.

By midday in the summer months, shadows become shorter as the sun reaches its highest point in the sky. At these times, natural lighting becomes very intense with the result that exposure measurement becomes more difficult due to the increased levels of contrast. With the sun almost directly overhead, it also becomes more difficult to capture the highlight in the eyes of many birds and animals, so that they often end up looking dull and lifeless. Flight shots of birds against the sky can prove equally problematical, because the detail of their undersides is often lost in their own shade.

An overcast sky will always produce a more soft and even lighting, regardless of season or time of day. Shadows become indistinct or non-existent, with the result that fine details, which would otherwise be hidden in shade, are revealed. Soft lighting also reduces contrast and so makes very dark, or light subjects easier to photograph. In fact, for subjects of contrasting tone such as black and white birds, or light coloured flowers against dark backgrounds, using overcast lighting may be the only way of recording detail evenly. Surprisingly enough, dull conditions

All three unmistakable qualities of electronic flash are evident in this photograph of a blue tit leaving its nest in a dead elm tree. The harsh lighting, dark background, and action-stopping effect are all typical of the sort of result which can be expected when a single computer flash is used near to the subject.

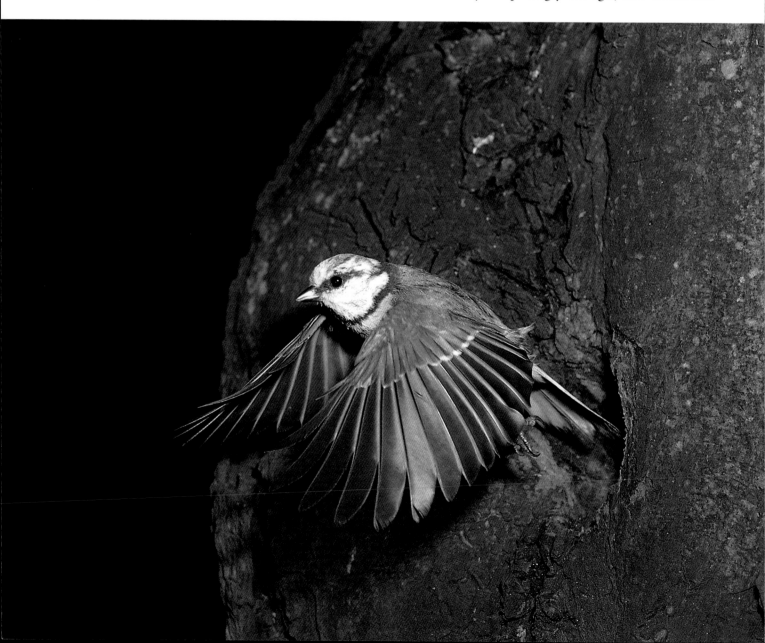

actually make the colours of many subjects appear richer and more saturated, due to the reduction of surface glare.

ELECTRONIC FLASHLIGHT

Although it is always preferable to use natural lighting, there are many occasions in nature photography where it will be necessary to use flash. With nocturnal subjects like owls and badgers, for example, there is often no alternative simply because light levels are too low. Even in daylight hours, flash may be required, either as a primary lightsource to freeze movement or to allow smaller lens apertures to be used for greater depth of field, or as a secondary lightsource to fill in shadows cast by strong sunlight. To use flash competently in any of these situations requires practice and methodical working techniques, because this is a lightsource which is largely of an unpredictable nature.

All SLR cameras provide some form of electrical contact to ensure that the firing of the flash coincides as precisely as possible with the opening of the shutter. This is known as flash synchronisation. On many cameras this connection is made when the flash is attached to its 'hot-shoe', while on others it is achieved via a cable which plugs into a coaxial socket. Due to the design of their shutters, and the difficulty of arranging synchronisation at faster speeds, all SLR cameras have a maximum speed at which it is possible to use flash. Usually this is limited to 1/60 or 1/125sec, but with many of the newer cameras it may be as fast as 1/250sec.

In situations where flash is the main lightsource, the necessity to abide by this setting presents no difficulty because exposure will be controlled solely by the size of the lens aperture. Nevertheless, problems can occur in situations where natural lighting levels are high and the subject is in motion. Here, an unpleasant 'double image' may result, due to the natural lighting recording the movement of the subject, after the flash has fired. This situation becomes more acute when slow shutter speeds are being used, since there is a greater time delay between the flash firing and the shutter closing. To prevent 'double images' forming we must decrease the exposure by using a smaller lens aperture. An approximate idea of which aperture to use can be reached by using the camera's light meter to obtain a reading which will underexpose the subject by at least two stops. After setting the appropriate aperture the power of the flash must be increased accordingly. This may involve reducing the flash-to-subject distance.

CONTROLLING FLASH

The lighting produced by a portable electronic flash unit is of a much harsher quality than that of natural lighting from the sun. Furthermore, its effect on the subject is more difficult to predict simply because it is not from a continuous source. Yet in order to learn how to control flash the photographer must first understand how natural lighting works and then it becomes easier to devise techniques which will allow a convincing imitation of virtually any natural lighting effect.

The positioning of the flash is the first and most important point to consider. Simply mounting a small unit onto the hot-shoe provided on top of the camera will invariably produce a very flat, uninteresting frontal lighting, just as if the sun were shining at a low angle from behind. By using an extension cable, the flash can be removed from the camera, and it is then possible to vary its angle and thus simulate natural side, back, or overhead lighting. In each instance, however, the characteristic appearance of flash will be evident due to the harshness of the shadows. To some extent this can be avoided, with a white handkerchief placed over the front of the flash, helping to diffuse the light and soften the shadows—though this will also, of course, reduce the light output. While automatic flashes will take this into account, manual units cannot, and the size of the lens aperture must be increased in order to compensate.

In semi-controlled situations, such as where birds are expected to land on a perch by a bird-table, for example, it is possible to arrange more elaborate lighting set-ups. Here, a second weaker flash may be used to fill in the shadows cast by the main light. Generally, the weaker flash should be positioned close to the camera and set to provide one quarter the power (two f stops lower) of that of the main unit. This technique is standard practice among many bird photographers who choose to work their subjects at the nest; the resulting photographs are easily identified by the presence of two or more highlights in the eye of the subject.

Additional flashes may also be used to lighten dark backgrounds which are so often caused by the fall-off in illumination with increased distance. Where more than one flash is being used, synchronisation may be achieved either by linking the flashes together with extension cables and a three-way connector, or by using a photo-electric trigger known as a 'slave' unit. The latter is especially suitable for fieldwork as it allows independent operation.

Opposite **This is my most tried and tested configuration for photographing small mammals and birds by flash. The flash on the left is the most powerful and is tilted at a 45° angle down and to one side of the subject. It provides most of the light and when working at a distance of 2 metres, the basic exposure outdoors on a manual mode is f22. The second smaller flash on the right is placed near to the camera axis to fill in the shadows cast by the main flash. When set to a manual mode under the same conditions it provides sufficient light for an exposure of f11—exactly two stops lower than the main light.**

FLASH EXPOSURE

As outlined earlier, there are two methods of obtaining correct exposures when working with flash: either by using guide numbers with a manual unit, or by relying on a sensor with an automatic mode. Unfortunately neither of these modes of operation is completely foolproof. When working with manual units for example, very light or dark coloured subjects will each require some degree of compensation, ie exposure must be decreased for light subjects and increased for dark subjects. In each instance, the amount of adjustment required must be estimated, and may only be in the region of one half, to one whole stop, though this will depend on the tone of

the subject. Fine adjustments such as these may be made in several ways, the most usual being to change the size of the lens aperture, or to alter the flash-to-subject distance.

Further complication may arise when auto-exposure modes are being used to photograph a subject which appears small in the frame and against a distant background. Under these circumstances, the sensor may not be sufficiently influenced by the small amount of light being reflected off the subject, with the result that the flash will be misled into illuminating the background—thus overexposing the subject. There are two possible solutions to this problem: either to move the flash closer, or to introduce a false background, such as a leafy branch just behind the subject.

Similar difficulties can occur if the subject is small and against a background of a contrasting tone. Here, the sensor will be influenced more by the tone

I used the lighting set-up shown in the previous photograph to illuminate this pied wagtail's nest on a dull day. As always, the short duration of the flash proved invaluable for arresting the rapid movements of the ever-hungry chicks. Exposure was especially simple due to the neutral colour of the subject and the surrounding drystone wall in which the nest was located.

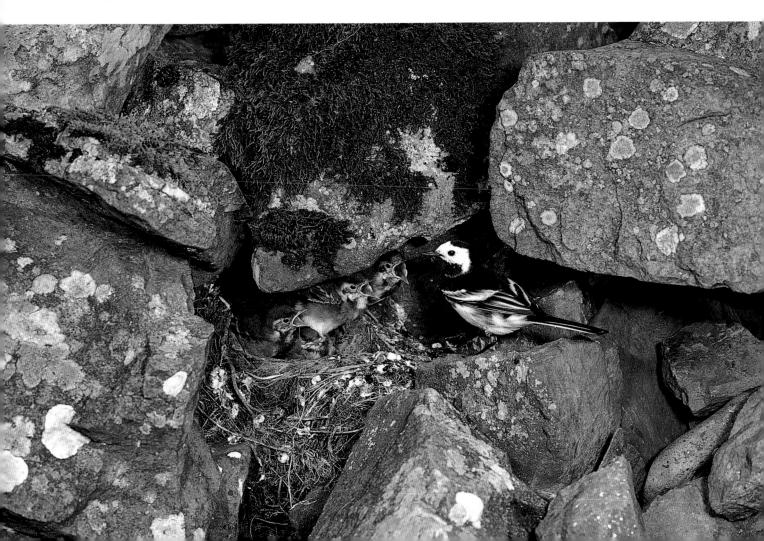

of the background, with the result that again, the subject may be wrongly exposed. To correct this problem we must either move the flash closer, or adjust exposure by changing the lens aperture, except in the case of TTL flash units where the camera's exposure compensation dial must be used.

Many of the disadvantages of using automatic flash units bear some resemblance to those encountered when using TTL light meters. In fact, many TTL flash units behave in much the same way as the camera's centre-weighted TTL light meter because the same sensor is used to control exposures by flash and by daylight. Overall, the best way of arriving at correct exposures with flash will be to get to know how a particular unit may react in a given situation. In this way it becomes possible to develop constant lighting set-ups, and anticipate potential problems in advance.

FLASH WITH DAYLIGHT

In most situations where flash is being used to provide extra illumination the effects of natural lighting are completely overwhelmed. More often than not this will also mean that if the background is distant, even by just 2 or 3m (6½ or 10ft), it will appear too dark due to the fall-off in illumination, and the fact that we are only exposing for a given distance. Although this 'night-time' effect is perfectly acceptable for nocturnal subjects, it is completely false where plantlife or birds and animals which are nor-

After spending two months baiting this dead tree trunk with suet in a local wood, I finally succeeded in tempting the resident great spotted woodpecker down to within 2m (6½ft) of my hide. Unfortunately, the lighting conditions were far from ideal, due to the woodland canopy blocking out the sunlight. The first photograph in this sequence shows the best result I could achieve with a daylight-only exposure of 1/125sec at f5.6. Setting the camera to its synchronisation speed of 1/60sec and using my standard flash set-up for the second photograph proved to be no solution either—with the lens aperture and main flash output set at f22, the background appeared grossly underexposed, since at a distance of 25m (80ft) it was much too far away to be affected by the flash. By returning to my original daylight exposure value of 1/125sec at f5.6, I calculated that I could stop the lens down to f11 and still use a shutter speed of 1/30sec. With this exposure and the flash output reduced by two stops to f11, I was able to take the third photograph, which resulted in both bird and background being evenly lit.

mally active by day are being photographed. In some situations a second flash can often be used to lighten the background, though this will only work if the background is reasonably close and the subject is not against the sky. Under these conditions the only alternative may be to arrive at an exposure which will allow both flash and daylight to be recorded on the film—ie flash for the subject and daylight for the background.

However, as already discussed, there are three main restrictions to working in this way: firstly, the subject must be static to avoid double images forming at slow shutter speeds; secondly, natural lighting

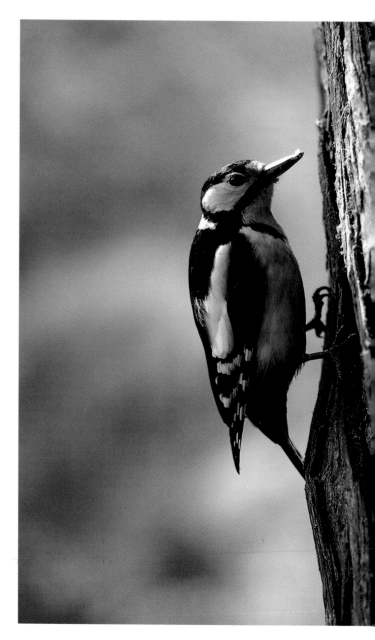

levels must be reasonably high; and thirdly, shutter speed must be no faster than the maximum flash synchronisation speed. To put theory into practice we must first use the camera's light meter to obtain an exposure reading for the background. From this a lens aperture is selected, which will give sufficient depth of field for the subject, but will not mean using a shutter speed that is faster than the camera's flash synchronisation speed. In low lighting, however, the resulting shutter speed may be too slow to eliminate the risk of double images forming when photographing, say, a wildflower which may move in the middle of the exposure. In such a situation it will prove

necessary to compromise depth of field by selecting a larger lens aperture to allow a faster shutter speed to be used.

Once the aperture is decided, the ratio of the flash can be calculated, though this will depend on both the desired appearance of the subject, and on the amount of light which is already falling on it. Where the subject is in deep shade—for example, a bird beneath a tree on a sunny day—then the flash exposure must equal the one for the daylight at the edge of the wood; so if the daylight reading suggests an aperture of f8 for the background, then the flash must also be set to expose for f8. Alternatively, if the bird is

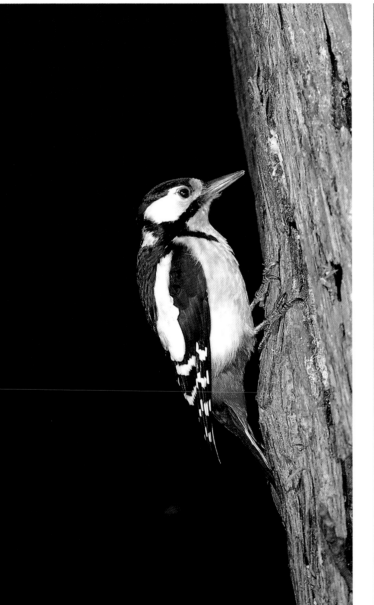 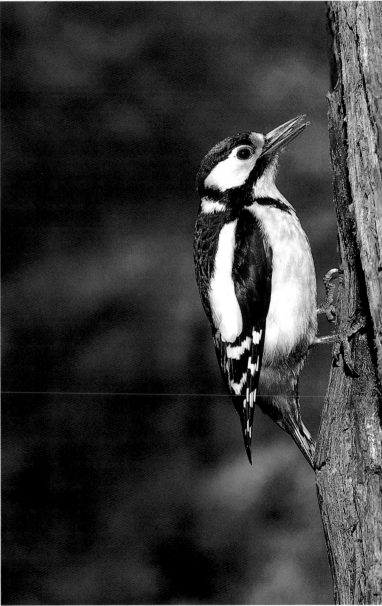

partially lit by sunlight, the flash exposure could be halved by setting the unit to underexpose by one stop (f5.6 in the above situation). Reducing the flash exposure by two stops will have a more subtle effect, since the balance is then shifted in favour of the daylight exposure.

The most effective use of ratios this low will be in bright sunlight, where harsh shadows may be lightened or 'filled in'. The small flash units which are now being built in to many cameras are ideal for providing fill-in illumination since they are often of too low a power to be effective as a main light at longer ranges.

LIGHTING FOR CLOSE-UPS

All the principles involved in using natural and artificial lighting at longer ranges apply equally when photographing in close-up. In fact, with close-ups, the relatively smaller size of the picture area means that we can more easily use reflectors, diffusers, and flash to control and refine the quality of the lighting falling on the subject. However, the decision to work in close-up will inevitably involve getting to grips with a number of technical problems which will become more difficult to solve the closer we choose to work. In one way or another each of these problems will be related to the loss of light caused either by extending the lens to make it focus closer, or by selecting a smaller aperture to increase depth of field.

Consider the problem of using a hand-held camera to photograph a 50mm (2in) wide butterfly with a 55mm macro lens at a distance of 24cm (9½in): at this range, the butterfly will occupy two thirds of the photograph and the reproduction ratio will be 1:2 (half life size). To achieve this magnification the lens will need to be extended by half its focal length, but this will reduce the amount of light reaching the film by half—thus all of the lens aperture settings are effectively one setting lower. With the lens set to f5.6 (effectively f8), the depth of field will only be about 2–3mm (1/10 in) deep; since this may be insufficient to show all of the butterfly in focus, the lens may need to be stopped down further to f22 (effectively f32), to extend this range to 9–10mm (2/5in). To compensate for loss of light caused by such a small aperture the shutter speed must be slowed down considerably—thus increasing the risk of a blurred image due to subject movement or camera shake.

Using a fast film to allow a faster shutter speed would not help, since the whole point in photographing in close-up is to show the maximum amount of detail in the subject. In such a situation the only alternative would be to use flash, both to provide additional lighting, and to freeze the movement of the camera and subject.

Clearly, there are many other instances where similar difficulties are likely to occur. Small mammals, reptiles, amphibians and practically all insects rarely keep still for any length of time, and even when they do, they are unlikely to remain long enough to allow a tripod to be set up. On the other hand, inanimate subjects impose fewer restrictions and may often be photographed by natural lighting.

From these discussions it can be seen that most close-up subjects may be divided into two categories: those which will require to be lit by flash, and those which will not.

CLOSE-UPS WITH NATURAL LIGHTING

When faced with the above difficulties there will be a temptation to use flash regardless of whether it is really necessary to do so. Sadly, many photographers are doing just this, with the result that we see far too many photographs of fungi and wildflowers where the atmosphere created by natural lighting has been completely destroyed. The best solution to obtaining consistently sharp photographs of inanimate subjects by natural lighting will be to use a good solid tripod. In this way, we are free to use the necessary slow shutter speeds required for fine-grained films and, most importantly, we will be able to work in almost any lighting.

Dull and overcast lighting is probably the most under-estimated type of natural lighting there is. In fact, had the sun been shining when I came across this tempting patch of wood sorrel, the contrast between flowers and leaves would have been too great for the film to have recorded evenly. However, as things turned out, the shadowless lighting on this damp spring day proved ideal for showing the maximum amount of detail—right down to the last raindrop!

I first spotted these mosses growing on top of a crumbling wall on some waste ground, but their awkward position meant that I was unable to photograph them exactly where I found them. By carefully removing the rock they were attached to, I was able to transport them home to a sunny, south-facing window-sill, where I photographed the delicate stems and capsules by backlighting. Taping a double layer of black velvet to the lower part of the window created the dark background, while a sheet of white card placed beside the camera acted as a reflector to provide fill-in illumination.

Generally, the best times for taking close-ups outdoors will be on still days when there is a thin layer of cloud to diffuse the light. Under these conditions the softness of the light is ideal for showing subtle colours and, since there are no harsh shadows, intricate details become more obvious.

On the other hand, bright sunlight produces high levels of contrast which must be toned down to permit the film to record detail evenly. Even where side- or backlighting is being used to emphasise an outline or a texture, it will often prove necessary to use a piece of white card or a handkerchief as a reflector to bounce light into the shadows. For a more pronounced effect a silver-coloured space blanket, or weak fill-in flash may be used. A more drastic course of action will be to diffuse the lighting by hanging a sheet of translucent white cloth between the sun and the subject.

CLOSE-UPS WITH FLASH

The most suitable flash units for close-up work are the small manual types with guide numbers of between 10 and 15m (33 and 49ft) with ISO 100 film. Units of this size provide ample illumination to use small lens apertures for maximum depth of field since flash-to-subject distances are minimal. In addition, all will have a flash duration of at least 1/500sec, and will therefore be ideal for eliminating subject and camera movement when working with a hand-held camera.

Automatic flash units are less flexible because their outputs can rarely be set to expose for apertures smaller than f11 with slow-speed films. One solution to this problem is to trick the flash into producing extra light by taping a neutral density filter over its sensor. Similarly, on models where no override switch is provided, black insulating tape can be placed over the sensor to convert the flash to manual operation. Ultimately though, the usefulness of any

A small electronic flash unit supported on a homemade bracket provided me with sufficient illumination to photograph this common lizard. Although the lens aperture was set to f11, the effective exposure was actually f22—two stops lower, due to the loss of light incurred by extending the lens to obtain a reproduction ratio of 1:1. Purely out of curiosity, I later calculated the daylight exposure time with this same aperture to be 1/8sec. Had this exposure been used, it would have been very difficult, if not impossible, to obtain a sharp photograph whilst stalking the lizard with a hand-held camera.

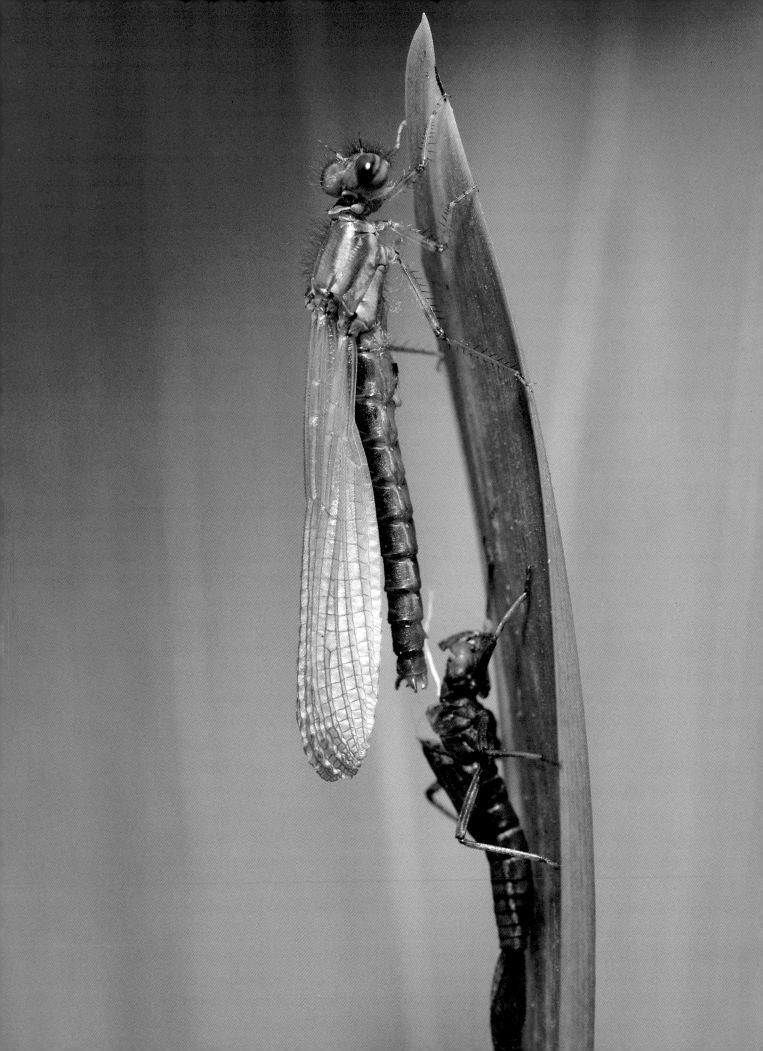

automatic flash for close-up will be determined by the location of its sensor. The best arrangement is to have a flash where the sensor is built in to the camera (TTL flash), or is detachable and may be angled toward the subject. Where the sensor is fixed below the flash tube, inaccurate exposures are likely since at close range the area illuminated by the flash may be quite different from the one read by the sensor.

Calculating exposures for using flash in close-up is especially difficult due to the loss of light incurred by extending the lens to make it focus closer. While TTL flash will automatically take this into account, all other units cannot, and allowances must be made manually. The best way of dealing with this problem is to devise a constant lighting set-up where the position of the flash is fixed at a given distance from the subject. First, arrange some sort of bracket to hold the flash at an angle which will ensure that the quality of lighting falling on the subject is satisfactory. Then, after adding the necessary extension to obtain the desired reproduction ratio, make a series of test exposures at different lens apertures, of a neutral coloured subject. Providing careful notes have been kept, the aperture setting for the correctly exposed test photograph can be identified and retained for future use. This process may be repeated for a range of different flash positions and reproduction ratios.

Having the exposure and flash positions pre-set in this way will allow more time for the enjoyable tasks of getting close to, and composing, the subject within the frame. In using the above method, however, do not adjust the focusing ring on the lens since this will alter the exposure—instead, focus by moving the camera back and forth.

The harsh quality of lighting normally associated with flash at longer ranges becomes less noticeable when small flash units are placed very close to the subject. This phenomenon is due to the flash effectively becoming a larger lightsource as it approaches, or exceeds the size of the subject; generally it will only apply when the subject is no more than 30cm (12in) from the flash. At this range the best position for the flash is directly above the subject; at slightly greater distances, a single flash placed above the lens and angled downwards is preferable since the shadows will be shorter and will fall behind the subject. Where two flash units of equal power are being used on a bracket either side of the lens, a handkerchief placed over one will reduce its output so that it may be used to fill in the shadows cast by the other.

More complicated set-ups involving the use of reflectors or extra flashes are possible, though are usually too cumbersome to use effectively in the field, particularly when working with hyperactive subjects in dense cover. In any situation, however, the worst position for the flash will be on the camera's hot-shoe because of the risk of the front of the lens shading the subject.

Opposite **I collected this newly-emerged damselfly from my garden pond by gently cutting through the iris leaf it was resting on. After supporting the leaf in a soil-filled flowerpot I brought it indoors and introduced several more leaves to form a false background. The whole set was then surrounded by a screen of white tissue paper and lit by two flashes which were placed at a 45° angle, either side of the camera.**

Right **I needed to work at a reproduction ratio of just over twice life-size to capture this portrait of a housefly perched on a daisy. To get the insect's head in focus it was necessary to close the lens aperture down to f22 in order to obtain a depth of field of only 2–3mm. Using electronic flash proved the most practical way of coping with the loss of light caused by using such a small aperture and the resulting lens extension.**

11 COMPOSITION

Composition is the way we visually arrange and balance all the key elements from a given scene within the picture frame. Exactly what goes into making a good composition is a difficult concept to define, because there are so many different factors to consider and no set way of doing things. Generally, a successful composition will be one where all the main elements work together to capture the attention of the viewer. One of the most effective ways of achieving this is to have one main centre of interest upon which the eye can settle. In many instances this may consist simply of one whole, or one part, of a single bird, animal or plant, while in others it may be the way a particular lighting effect emphasises an unusual texture pattern or reflection. Brightly lit areas always attract the eye, while shadows will reveal shape and form and so add a third dimension.

Colours are important, too—subtle colours or contrasting tones of the same colour can often be blended together to create moods and harmonies. Strong, vibrant colours automatically attract attention, especially where complementary colours such as yellow and blue are included together. Lastly, lines, which may be real or implied—as in the case of

Opposite above **The low-angled lighting of an early autumn morning tempted me to stop and take this close-up of a dew-covered sycamore leaf. On passing the same spot two hours later I noticed that the textures were completely lost, due to the higher position of the sun in the sky.**

Opposite below **I spotted this flock of starlings silhouetted against an autumn sunset whilst driving home one evening. As the light was fading quickly, I had no time to set up a tripod, so instead, I supported the camera with 300mm lens over the car roof and exposed for the background, to reduce the scene to the simple outlines which had first attracted my attention.**

Below **Though they often take a little more effort to find, many subjects in nature form their own 'ideal' natural compositions; to my mind, these primroses fall into this category. Obviously, the chances of coming across such a group are increased in instances where the subject is found in abundance. Had I been photographing a rare species where my choice would have been limited to perhaps one or two plants, I would probably have had to settle for a less satisfying 'record shot'.**

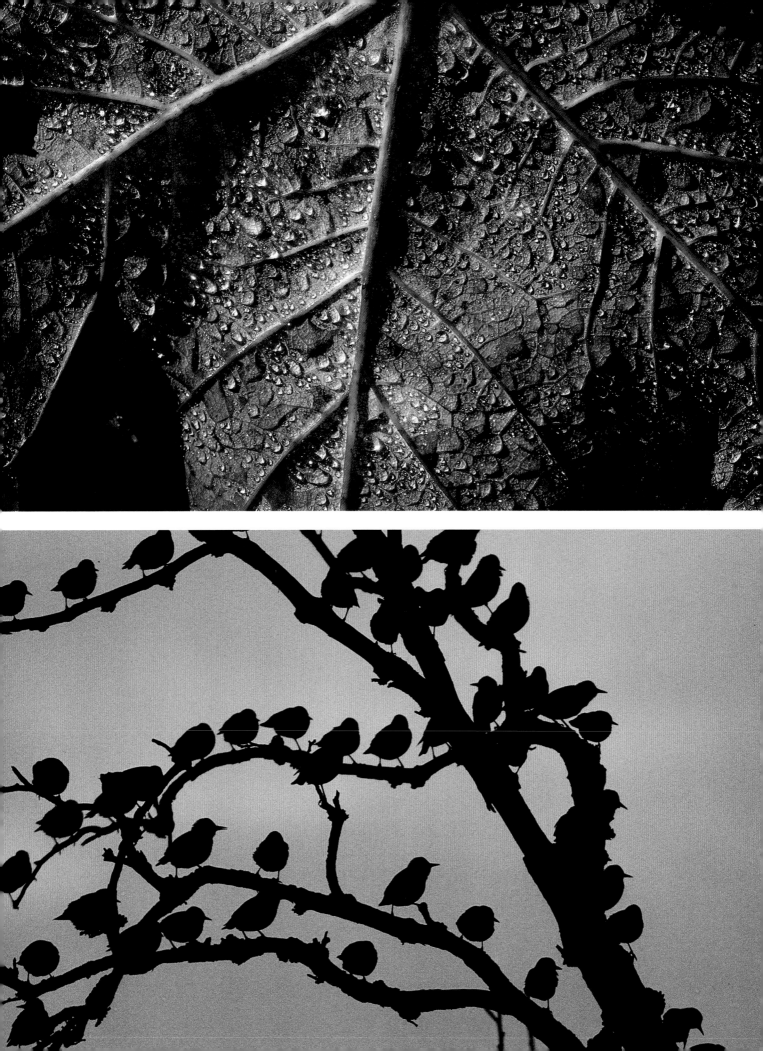

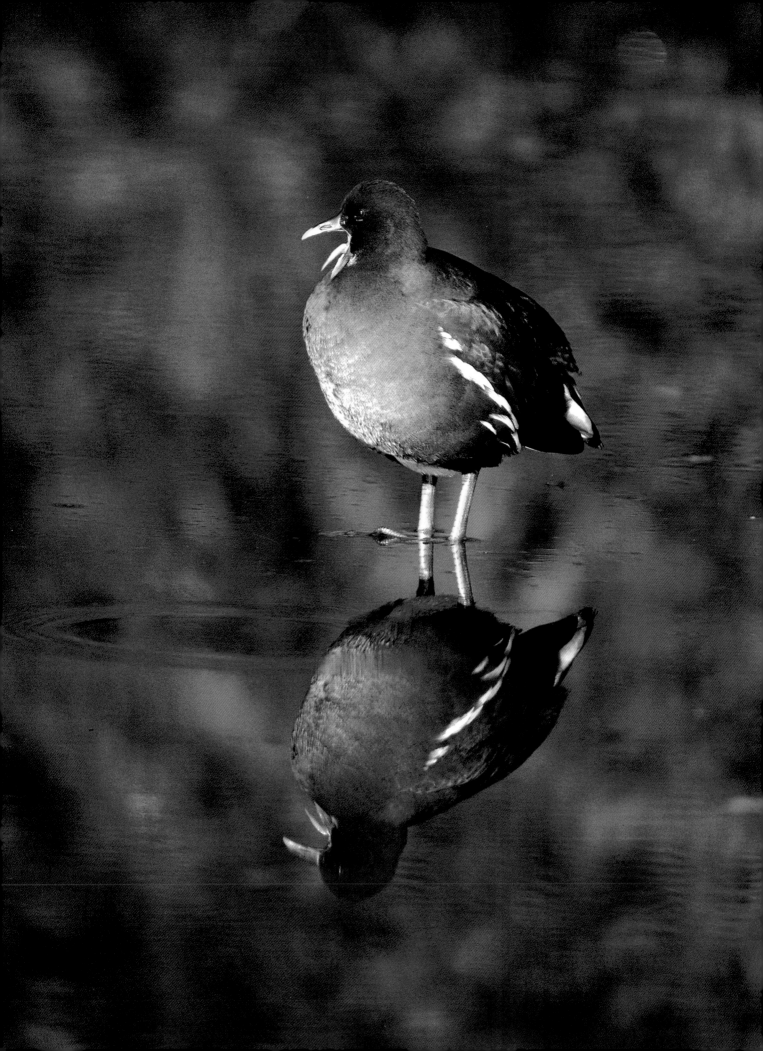

Although I had often photographed the moorhens on this ornamental pond in a local park, I was especially lucky on this occasion to come across this individual perched on a rock just below the surface. With the bird surrounded by water, the calm weather and frontal lighting ensured a near-perfect mirror image. Composing the picture vertically also allowed me to include the out-of-focus reflections from the bright red berries of a nearby cotoneaster bush.

The blue colour-cast in this photograph has been caused by the particles of water in the air filtering out the red light. The photograph also serves to illustrate how contrasting tones of the same basic colour can be used to convey both mood and depth.

the likely flight-path of a bird—are also useful for leading the eye to the subject, and for relating one part of a scene to another.

Although it is important to learn to recognise and use these compositional elements it is rarely advisable to try to include too many. Indeed, the simplest approach will invariably be the most effective, and with practice it should be possible to know instinctively which aspects to concentrate on. However, even when these have been decided, there are still a number of other decisions to make long before we should contemplate releasing the shutter.

CHOOSING A VIEWPOINT

Many nature photographers often ignore or overlook the importance of selecting a suitable viewpoint in their rush to secure a record of the subject. This is a great pity, because the angle at which we choose to photograph our subjects can greatly influence the impact of the final composition. The first step should be to choose a vantage point which will provide the most appropriate background and lighting. This should be fairly easy with static subjects like plants, because there will usually be plenty of time to move around and explore the various possibilities. With birds and animals, however, there may be less choice and the line of approach will often have to be carefully pre-determined.

Having chosen the direction of view, the next step will be to decide whether a high or low viewpoint is required. Simply holding the camera at eye-level and tilting it at an angle to photograph a small subject on the ground seldom produces a result which conveys any real sense of drama or proportion. A more satisfactory approach would be to crouch down, or even lie next to the subject, with the camera supported a few centimetres above the ground. From this position even small animals and plants can appear more imposing because they will dominate the foreground.

After taking the first photograph (below) of this snow-laden beech tree, I decided to move the camera closer, and to a position 5m (16ft) to the right. The second photograph (opposite) shows a dramatic improvement in the composition since the grey trunk and lower limb of the tree are no longer obscured by the low branches. The new viewpoint has also made the background more interesting by revealing several larch trees which were previously hidden behind the trunk.

A low viewpoint will also allow more of the distant background to be included which, with short focal length lenses, may be brought into focus to show small subjects in context with their surroundings. Alternatively, where long focal length lenses are being used from a low viewpoint—such as when stalking animals or birds—a distant background can be thrown out of focus to isolate the subject. Another method of simplifying the composition is to photograph tall subjects such as trees against the sky by choosing a viewpoint directly below.

Though high viewpoints can also produce some very interesting pictures, there are likely to be restrictions on the availability of suitable vantage points. In any case, much will depend on the size of the subjects being photographed. Unusual patterns formed by groups of many small subjects from mosses to seashells can often be revealed simply by standing directly above and pointing the camera downwards. Larger subjects, like masses of aquatic plants for example, may sometimes require a viewpoint which is considerably higher than eye-level, such as the top of a steep riverbank or a bridge. Again, large flocks of grazing geese or herds of deer must be photographed from an even greater elevation if each subject is to be shown separately—and the only solution here may be to use the opportunity to also take some exercise and climb a nearby hillside. Cliff-tops at seabird colonies can provide ideal vantage points for taking near-aerial views of birds on land, sea, and in the air.

Overleaf **The first photograph of this clump of stag's horn fungus was taken with the camera supported on a tripod 15cm (6in) above the ground. To obtain the 'worms-eye' view for the second photograph, I placed the camera directly on the ground, facing the subject from the opposite direction. As well as exaggerating the stature of the fungus, the second viewpoint also allowed me to include the shaded side of a nearby log to obtain the dark background.**

Page 93 **These mute swans were feeding on corn which was being washed into the river via a drain from a nearby granary. Although they were very approachable I chose to work with a telephoto lens from the top of a harbour wall in order to record this 'aerial section'. As well as illustrating the depth of the flock, the high viewpoint also meant that I could use a fairly wide lens aperture and fast shutter speed, since depth of field was automatically improved by tilting the camera so that the film plane was almost parallel with the subject.**

PERSPECTIVE

Perspective is a subject that is often mentioned in discussions about viewpoint and focal length. Basically, it is the term used to describe the relative size and position of objects which are at different distances from the camera. To give a clearer idea of what perspective means, imagine photographing two tame mute swans with a 50mm lens where one is 4m (13ft) behind the other: from a distance of 20m (65ft) both birds will appear about the same size and fairly close together; at a range of 2m (6½ft) however, the perspective will have changed and the bird nearest the camera will appear larger, while the distance separating the two will seem greater.

This change in perspective is caused entirely by the difference in the relative distances between the birds and the camera. Using a wide-angle or a telephoto lens from either viewpoint would only affect how much of the scene appeared in the frame because only the angle of view would be different. Thus, perspective changes only with viewpoint and not with focal length alone. However, if a wide-angle lens were used at a distance of 1m (39in) to allow the nearest bird to appear as large as it did when photographed with the 50mm lens at 2m (6½ft), then the perspective would appear quite different. Due to the closer viewpoint, there would be an even greater difference in the relative distances between the birds and the camera—ie the nearest would seem closer, while the furthest would appear more distant. Thus, the perspective is said to have been 'expanded' and an illusion of increased depth is created.

Conversely, if a telephoto lens were used at a distance of 40m (130ft) to allow the nearest bird to appear the same size as it did when photographed with the 50mm lens at 20m (65ft), then the perspective would appear different again. This time, the difference in the relative distances between the birds and the camera would be less significant and they would appear much closer together. Thus, the perspective would be 'compressed' and the depth of the picture would be reduced.

Because both of these types of distortion affect the apparent position of the various elements within the composition, it is essential to decide the perspective you require when choosing both lens and viewpoint. For example, if you wish to exaggerate how densely packed a field of wildflowers appears when viewed from a distance, then use a telephoto lens from a distant viewpoint. However, if you wish to emphasise sheer numbers, use a wide-angle lens from a close viewpoint. Composing the picture with several flowers in the foreground and using a wide-angle lens will emphasise depth because these flowers will appear larger than those in the distance.

With extreme perspective distortion, the appearance of individual subjects will be affected: for instance, if a long telephoto lens is used to photograph a head-on view of a deer, then the fore- and hind-legs of the animal will appear much closer together than we know them to be. Similarly, a wide-angle lens used very close to a single flower will render the petals nearest the camera disproportionately large. To a lesser extent, this latter effect will also occur when taking close-ups with standard 50mm lenses. A 100mm lens will allow the same magnification at twice the distance and will therefore give a better perspective. Because long telephoto lenses make backgrounds appear more prominent, distant features such as the sun at sunset can be made to dominate the picture by contrasting strongly with the silhouettes of foreground subjects.

FRAMING AND SUBJECT PLACEMENT

After choosing viewpoint and perspective the next step towards composing a picture should be to decide how much of the scene is to be included. To some extent this can be controlled by the focal length of the lens, though in practice the small size and unapproachable nature of many birds and animals often rules out the possibility of obtaining frame-filling images. In many instances this may not be such a bad thing, since it will allow the subject to be shown in relation to its environment. To achieve the best results from such an approach, the positioning of the various peripheral elements must be given careful consideration. Many less experienced photographers fail to do this, with the result that distracting elements often creep in from the sides, or potentially interesting features are left out, or are even cut off mid-way, at the edges of the frame; the overall effect therefore destroys the balance of the whole composition.

The positioning of the main subject also deserves attention, regardless of how big—or small—it appears in the picture. Simply positioning a single distant gull on the seashore in the centre of the frame, for

Although these beech trees appear to be growing closely together they are in fact several metres apart. I obtained this foreshortening effect by using a 600mm lens from a vantage point at the end of the 400m (1,300ft)-long avenue. A tripod was essential for allowing me to compose this tightly cropped scene with such a long lens.

94

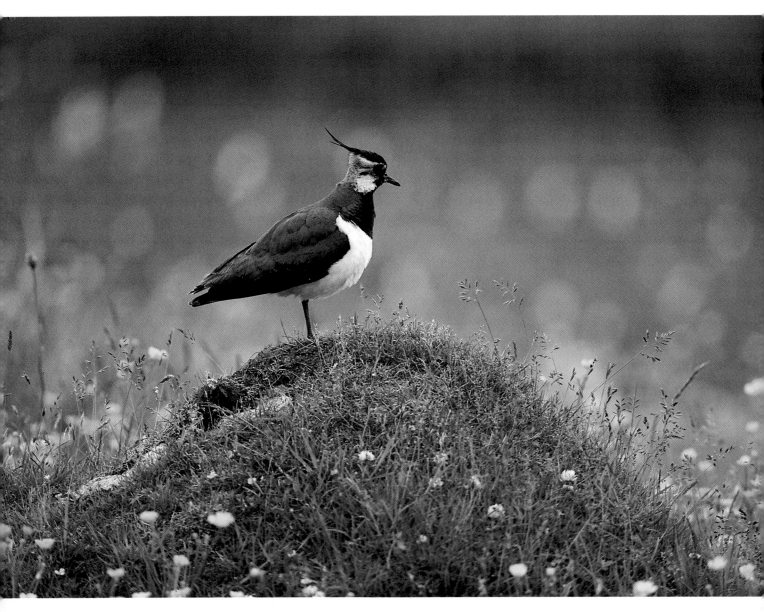

This photograph of a single beech tree against a winter sky shows how a wide-angle lens can produce an entirely different type of distortion to that seen in the previous shot of the avenue of trees. By choosing a low viewpoint close to the base of the trunk and tilting the camera at a 45° angle, I was able to create this converging effect, and thus make the tree appear taller.

I deliberately chose not to photograph this lapwing with my longest telephoto lens because I wanted to include both the mound it was standing on, and the surrounding buttercups. With the bird small in the frame, it was especially important to compose the picture with the subject to one side, and facing into the resulting empty space. Arranging the scene in this way makes the picture appear more dynamic since the likely flight-path of the bird is suggested.

To show the fine detail of this horse-chestnut leaf
I decided to move in close and concentrate on one
small section. Positioning the tip of the leaf stem
just off-centre has strengthened the composition by
emphasising the radial pattern of the individual
lobes.

Despite its precarious position, this feral goat is well
adapted for living on this sea cliff on the island of
Rhum off the west coast of Scotland. Composing the
picture vertically and positioning the subject high in
the frame allowed me to emphasise the difficult
environment in which these animals survive.

98

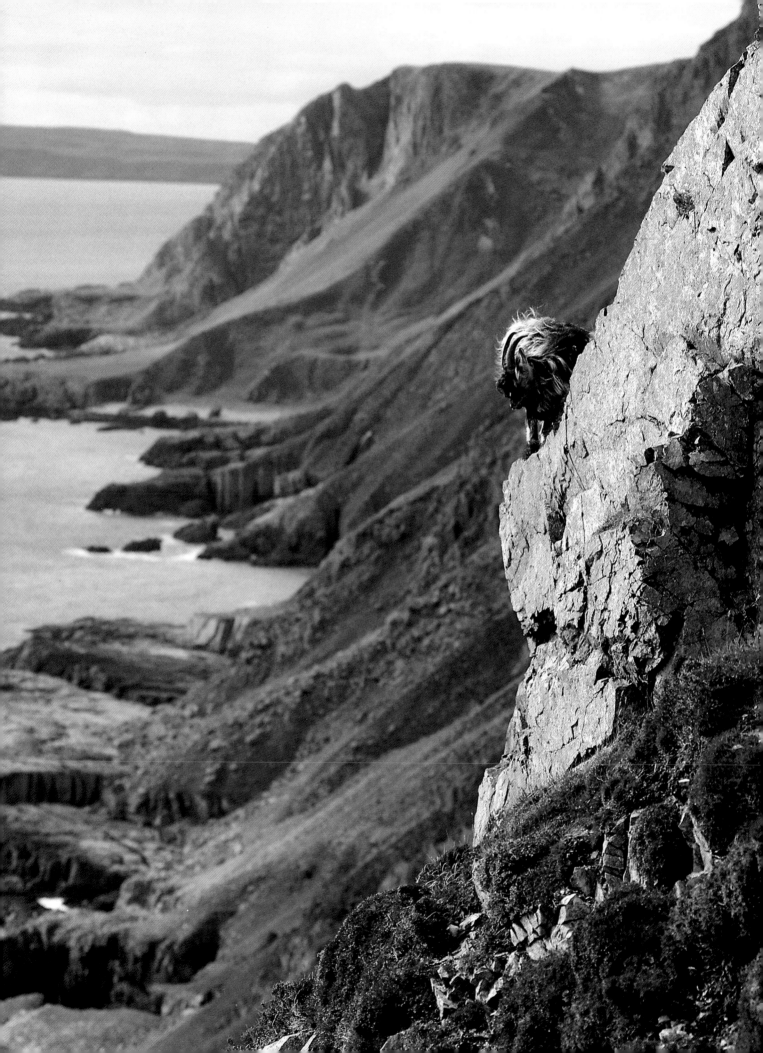

example, will tend to produce a composition which is static and uninteresting. One way to avoid this is to use the compositional law known as 'the rule of thirds': this involves mentally dividing the viewfinder up into thirds, using four lines—two horizontally, and two vertically. If the gull is positioned on any one of the four points where these lines cross, the law maintains that the composition is then at its strongest and most effective. Ideally, the point to choose is the one where the bird will end up facing into the greatest area of empty space—this positioning implies action, because the bird now has space to 'move into'.

Strong lines, such as those of horizons, will also benefit from being placed along the lines themselves; a bias may be given to either sky or foreground and it will be up to the photographer to decide which is more important. A bias toward the foreground, for example, could give the picture a greater sense of depth by allowing a nearby subject to contrast with a distant background. Either way, remember that the points and lines of the rule of thirds also apply when the camera is tilted on its side to give a vertical format. Even the choice between a vertical and a

Many butterflies are quite inactive on dull days or in the early morning, and may therefore be photographed using natural lighting and slow shutter speeds. However, on the day I discovered this fritillary butterfly, a gentle breeze prevented me from using a shutter speed any longer than 1/60sec. This restricted my minimum lens aperture to f8, which in turn meant that the depth of field was extremely shallow. Faced with such a situation, I had to be very careful to ensure that the camera was positioned parallel to the subject.

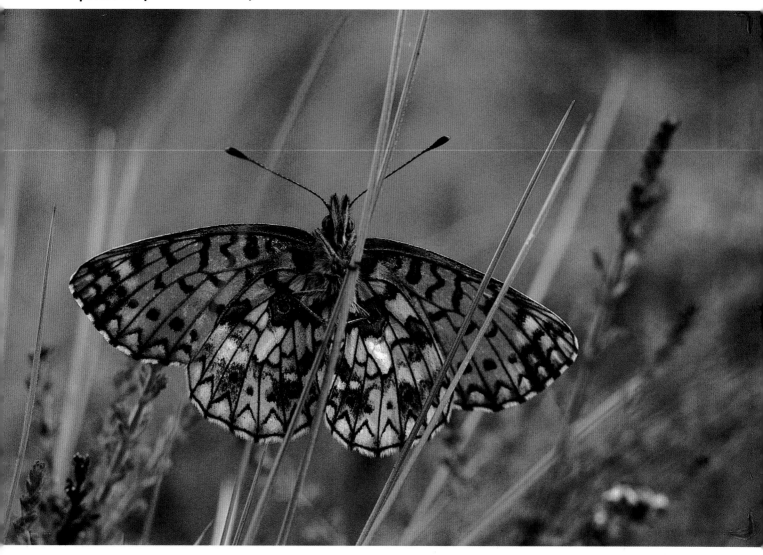

horizontal format should not be overlooked, though in general, the shape of the subject or the position of the elements will often dictate which to use.

With awkward subjects, such as a close-up of a round flowerhead for example, the best course of action may be to move in close and only show one small section. Again, the composition could be improved by positioning the centre of the flower one third from one side with the petals radiating out towards the edges of the frame.

In instances where very precise framing is required, using a good solid tripod will help immeasurably because it will eliminate the risk of misalignment due to camera movement. This is especially true where long telephoto lenses are being used, or the camera is tilted for a vertical format. Using a tripod also makes the whole process of composing a picture more deliberate, in the sense that it is easier to spend more time checking the various details in the viewfinder. Of course, where action is being photographed this will be impractical and the scene must be composed quickly, with the shutter being fired at the precise moment the subject falls into place.

FOCUSING AND DEPTH OF FIELD
Learning to control depth of field is vital because it is yet another method by which we may enhance the

A spell of very cold weather froze most of the surface of a local duck pond and concentrated all the resident waterfowl onto the one small area of water which was free from ice. After taking one or two general views with a wide-angle lens, I decided to isolate this greylag goose by using the narrow depth of field given by my 600mm telephoto lens at its widest aperture of f5.6.

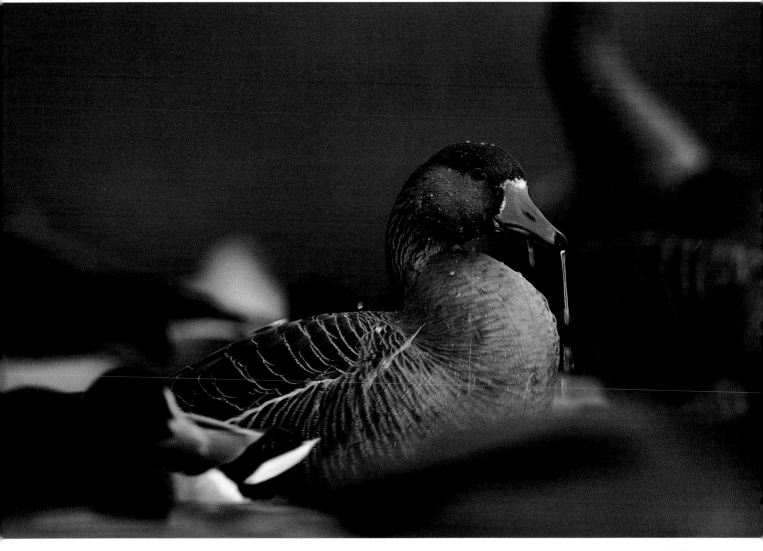

101

appearance of our photographs. Controlling depth of field involves a two-stage process: focusing the lens along the plane of the subject which is considered to be the most important, then using lens apertures to alter the zone of sharpness which extends either side of that plane. In average conditions where large subjects are being photographed at moderate distances with short focal length lenses, the normal range of lens apertures will allow plenty of choice over how much, or how little, depth of field it will be possible to obtain.

At high magnifications, however, such as when using long telephoto lenses to photograph small birds and animals at close range, or when working in close-up with tiny plants and insects, the depth of field becomes very narrow and it will be critical to focus the lens very carefully. In such situations it is also important to align the camera back parallel with the plane of the subject. This will ensure maximum depth of field because the distance between the film plane and the subject will remain constant all the way across the frame.

This technique is sometimes known as 'plane focusing', and is also worth remembering when deciding on a line of approach to photograph subjects which would not tolerate a change in final camera position. Imagine, for example, stalking a resting wading bird at high-tide on the seashore with a long telephoto lens. A head-on view would probably only allow sufficient depth of field to show the bird's head and bill in focus, whereas a side-on view from the same distance would render all or most of the bird in sharp focus, because it would then be parallel with the camera back.

Alternatively, there are many instances where it may be an advantage to use a very shallow depth of field to isolate a subject from a distracting background. The aim here will be to select an aperture which will be small enough to show the main subject in focus, yet sufficiently large enough to throw the background completely out of focus. Again, parallelling the camera back will give the maximum depth of field for subjects which are spread over one plane, while using a depth-of-field preview button will prove the most effective way of judging which aperture to use. Selective use of depth of field can also be used to blur foreground vegetation etc, when photographing animals in deep cover, or when working from a low viewpoint.

There will, of course, be other occasions when you may want to obtain the maximum depth of field to show, say, a foreground subject in context with its surroundings. The main problem here will be in deciding the most suitable plane upon which to focus the lens. Simply focusing on the foreground subject—which may be only 1 or 2m (3¼ or 6½ft) away—may not allow the distant background to be sharply defined, even supposing the smallest aperture on the lens were used. To find the optimum focusing distance—or hyperfocal distance, as it is more often known—means using the depth-of-field indication lines marked beside the focusing scale on the lens. These lines correspond with the different apertures, and show the extent of depth of field on either side of the plane upon which the lens is focused.

To set the hyperfocal distance, the lens must be focused so that the infinity setting is beside the furthest indication line for the smallest lens aperture. From then, the distance beside the nearest indication line can be read off and the camera moved to that same distance from the subject in the foreground. Thus, all of the elements within the scene will fall between the two indication lines, and will appear in focus so long as the smallest lens aperture is used. This technique will work best with wide-angle lenses because with longer focal lengths, the closest distance at which it is possible to position the camera from the foreground becomes progressively greater.

Because the flowers in the foreground were so close, I was unable to use the hyperfocal distance focusing technique to render all these wood anemones in sharp focus. Instead, I closed the lens down to its smallest aperture and focused on the flowerheads in the middle distance. Then whilst using the camera's depth-of-field preview button, I was able to re-adjust the focus until the flowers nearest the camera appeared sharply defined in the viewfinder.

Overleaf **By resting my camera on a conveniently-placed flat rock I was able to use a slow shutter speed to photograph this thorn moth on a dull and overcast day. Although I could have used my tripod to obtain a slightly higher camera position, I deliberately selected the low viewpoint so as to include only the distant background which would thus be out of focus. This would in turn have the effect of making the moth stand out more clearly.**

103

PART THREE
FIELDWORK

Undoubtedly, one of the greatest attractions of photographing nature is simply being out of doors and experiencing the thrill of encountering all manner of living things. In practice, however, the difficulties of finding and getting close to many subjects will demand just as much attention as any of the technical aspects described so far. The first step will be to learn as much as possible about the subjects you plan to photograph. Where wildflowers are concerned, for example, it is important to know when the peak flowering times will be and in which types of habitat the chosen species are likely to occur. Though much of this information can be gained from reading fieldguides and textbooks, it is equally important to spend time in the field observing the effects of different lighting and weather conditions so you will be able to decide on the best times to photograph a particular species.

These comments also apply when photographing birds and animals, but their movements are governed by a whole range of other factors including the weather and the time of year, and the necessities of finding food, shelter, and a mate; all of which dictate

This curlew was photographed at its high-tide winter roost site on a rocky seashore. The most difficult part of the operation was deciding where to build my semi-permanent hide with rocks, driftwood and seaweed. Too far up the seashore could mean that the birds would be out of range, too close could leave me with wet feet. After several preliminary visits I chose a site among some large boulders just above the high water mark. After checking the tide timetable in a local newspaper, I waited for a day when there would be a high-tide at noon so that I could work when the winter sun would be at its best.

how tolerant a subject is of human presence. Many wading birds, for example, breed inland in the summer months, then move to the coast in the winter where they can feed freely on the seashore without the risk of having their food supply cut off by snow and ice. While on the coast their daily feeding cycle is controlled by the rise and fall of the tides; at high tide they may be photographed at specific locations, where they congregate to roost in large numbers, waiting for the tide to fall and uncover their feeding grounds.

The first priority for most migrating birds on reaching land is to replace the fat reserves expended during the long journey; consequently, large flocks can often be found feeding on berry bushes near the

I came across this chaffinch with its feathers fluffed up against the cold after a heavy fall of snow, a member of a large flock which was concentrated around a farmyard, feeding on spilt animal feed. The severity of the weather and the easy availability of food meant that the birds were reluctant to leave, so I had little difficulty in approaching to within 4m (13ft) with a 300mm lens to take this photograph.

coast on their arrival. Prolonged spells of cold weather may cause food shortages which will weaken many birds and animals, and so make them more approachable. While this can create some good opportunities, it is essential that the photographer avoids disturbing them so that they take flight. This could considerably reduce their chances of survival by forcing them to use up valuable energy.

Past experience, or the lack of it, is yet another important factor which influences how tolerant a subject may be of a human presence. In early summer, for instance, fox cubs and other young animals begin to gain their independence at a time when they are perhaps a little too confiding for their own good. Some species of birds are persecuted in the

This wooden post from an old breakwater by a harbour wall proved very popular with a number of birds, including this cormorant. Since they were accustomed to seeing the local fishermen coming and going, I had no difficulty in stalking this individual to within 20m (65ft).

countryside, but are generally tolerated in urban environments and are therefore likely to be more approachable in parks and gardens because they will not associate people with danger.

The activities of birds and animals prior to their main breeding season can also provide some good opportunities for nature photographers. From late winter and early spring many garden birds can be photographed singing from regular 'song posts' which they use to loudly proclaim their territories; while in autumn, male deer may be so much engaged in competing for leadership and establishing hierarchies that they don't notice a careful approach by a photographer.

Time of day is just as important as time of year in determining when animals will be active: early morning and evening is the best time to look for shy animals like deer, whereas reptiles—which are cold-blooded—may not be seen until after mid-morning, when they can be found warming up their bodies in the sunshine. On dull days, many species of winged insects are more difficult to find because they tend to remain motionless on plants, waiting for the weather to improve.

From these few examples it is clear that there is usually a time and a place when it will be easier to photograph any given subject. Understanding behavioural patterns is the vital key to anticipating where and when these opportunities may occur, and how they can be used to best advantage. Spending time in the field is therefore vital, regardless of whether or not you succeed in actually taking any photographs—simply being there will ensure that you are accumulating knowledge which may lead to a better understanding of the subjects and their lives.

I photographed this young rabbit by its warren in a large, but well-visited public park. It was impractical to use a hide, so I made do with lying prone and very still on the ground at a distance of 10m (32ft) from one of the main burrow entrances. The technique worked well with the younger, inexperienced animals, but their elders were always more wary— one old buck in particular ended many an evening's photography alerting the others of my presence by thumping his hind feet on the ground.

108

12 COPING WITH ADVERSE WEATHER CONDITIONS

A change in the weather not only affects the behaviour of many subjects, but also the quality and quantity of natural lighting, and for many photographers the unpredictable nature of the weather is often considered to be a major drawback when working outdoors. Yet by using a little imagination, and taking the trouble to solve the practical difficulties, even the worst conditions can usually be put to good use.

Wet weather is probably the most discouraging because of the low light levels and the risk of moisture damaging equipment. However, most exposure problems can be solved by using slow shutter speeds, wide lens apertures, and fast film speeds, while many cameras are fairly watertight and can withstand brief periods of exposure to light rain or drizzle. For prolonged sessions it is advisable to carry several polythene bags, both for kneeling on when working close to the ground, and for laying over equipment. In really heavy rain the most satisfactory solution is to place the camera inside a large clear bag and then secure the open end around the lens hood using an elastic band.

The most effective use of rainy weather is in close-range photography, where water droplets can be shown clinging to the plumage of birds or the fur of animals. For delicate subjects, such as wildflowers or spiders' webs, the best times to work will be on windless days after a shower, or in a fine drizzle, because the calm conditions will leave more raindrops suspended and allow longer shutter speeds to be used. A plant sprayer from a garden centre can provide a convincing supply of artificial 'raindrops', and also has the advantage of being usable in sunny weather, when it can be employed to produce an attractive sparkling effect.

When telephoto lenses are used over longer ranges in misty or rainy weather the particles of water in the atmosphere between the camera and the subject will reduce the clarity of the image, depending on distance. However, colours are rendered as delicate pastel shades and the overall effect can be very pleasing when photographing, say, a flock of geese on a mudflat, or a distant hedgerow tree.

Very hot, dry weather will produce heat haze which again, over long distances, can impair image quality; and because of the distortion produced by the shimmering effect, the results are usually less attractive than those given by mist or rain. The only answer is to work at shorter ranges, or at different times of the day when air temperatures are lower. However, sunsets are often more spectacular in hot weather due to the increased amount of dust particles in the air—on many occasions the sun may appear as an orange ball when near to the horizon and, in fact, may be safely viewed and photographed with the naked eye. An effective approach at these times will be to make it appear larger by using a long telephoto lens, then to incorporate it into a silhouette scene.

When working by water it is worth remembering that a cool evening preceded, or followed by, a warm day can sometimes result in mist rising from the water surface, be it of river, lake or stream. This phenomenon is most likely to occur at dawn and is particularly attractive when photographed by backlighting, especially if waterfowl are included in the picture.

Hot weather can affect the colour rendering of film, and steps should be taken to keep it cool and avoid prolonged exposure to direct sunlight. When working away from home carry only what you may use in one day, leaving the main stock indoors or in an insulated picnic box left somewhere shady.

Working in cold weather creates very different

In an effort to keep my camera dry, I chose a viewpoint beneath an ancient Scots pine from which to photograph this group of trees on a grey and rainy winter's day. Because I was working from a fixed position I used a zoom lens to allow me to frame the picture accurately. With the camera supported on a tripod I could easily use an exposure of ¼sec at f11 with ISO 64 film. This setting was one whole stop more than the one indicated by my meter, and was deliberately chosen to over-expose, and therefore enhance the misty effect caused by the rain.

I used a tripod and a 105mm macro lens to photograph these beech leaves trapped in the ice on this frozen puddle. To maximise depth of field with such a flat subject I chose an overhead viewpoint and kept the camera back parallel with the surface of the ice.

110

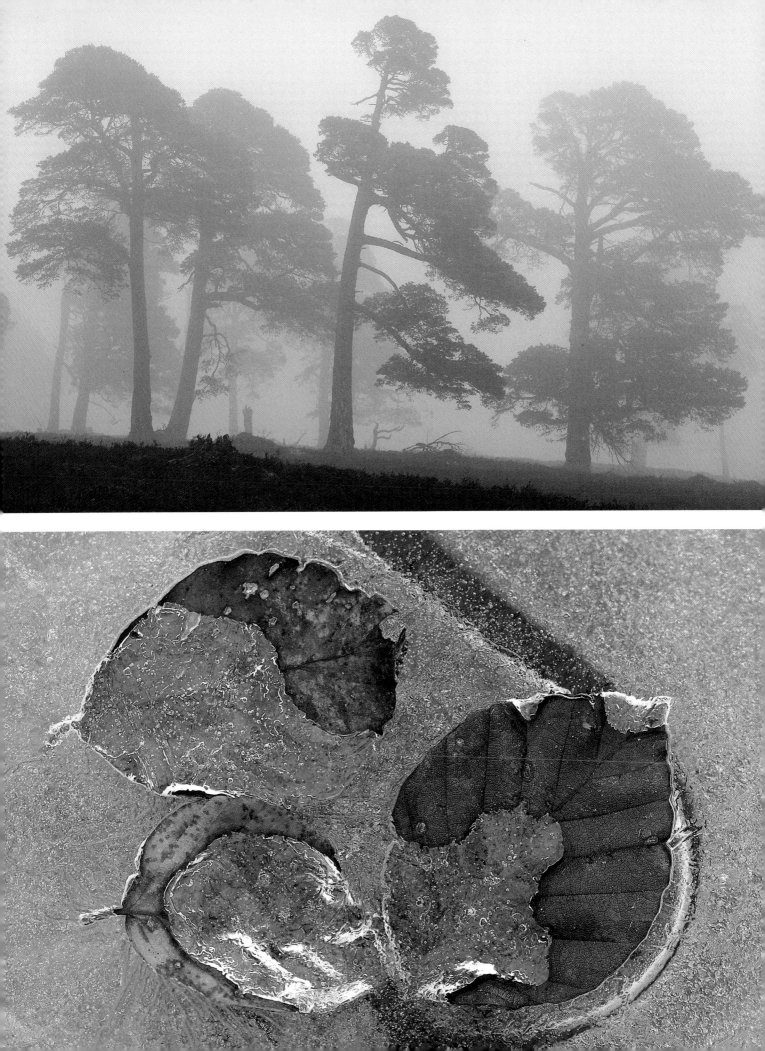

sorts of problems; the most serious of these is the fall-off in the electrical power given by the tiny batteries inside cameras. Since most cameras are dependent on these batteries to power TTL light meters and electronic shutters, it is sensible to insulate camera bodies which are not in use beneath a jacket, and to carry spare batteries in a warm place such as a shirt pocket.

Condensation is yet another problem associated with low temperatures, as moisture forms on the surface of films and equipment once they are brought into a warm environment. At worst, this can cause fungal growths on lens coatings, the formation of rust inside cameras, or drying marks on film emulsions. The most practical solution is to seal equipment into a polythene bag which has had most of the air expelled so that condensation will then form only on the outside of the bag.

The advantages of working in cold weather are well worth the inevitable discomfort. Heavy falls of snow, for example, can create exceptionally good lighting conditions by illuminating the undersides of many subjects by reflection, while early morning frosts will enhance any close-up of fallen leaves or grass stems. Ice covering shallow puddles will also create interesting abstract patterns, and water splashing onto vegetation by streams may freeze and build up into fascinating formations of icicles.

Windy weather is one of the most difficult of all conditions to cope with due to the increased risk of subject and camera movement—close-ups of plants, in particular, become almost impossible unless they are photographed by flash, or are enclosed in some sort of white translucent tent. Even when attached to a tripod, long lenses may still require fast shutter speeds because of the constant buffeting of the wind. In extreme conditions it is usually necessary to work low to the ground and in the lee of a solid obstacle such as a wall. Carry a metre-long piece of cord or rope—the stability of a lightweight tripod can be greatly improved by suspending a rock or other heavy object between its legs.

Windy conditions can be advantageous too, however—in woodlands or long grass the rustling of windblown foliage will mask the sound of your progress and so make birds and mammals easier to stalk. When stalking large birds it is always best to approach with the wind at your back, because they are always likely to take off into the wind—ie towards you—to gain extra lift. Furthermore, the progress of many birds when in flight will be slowed down by high winds, and this may allow extra time for focusing and framing.

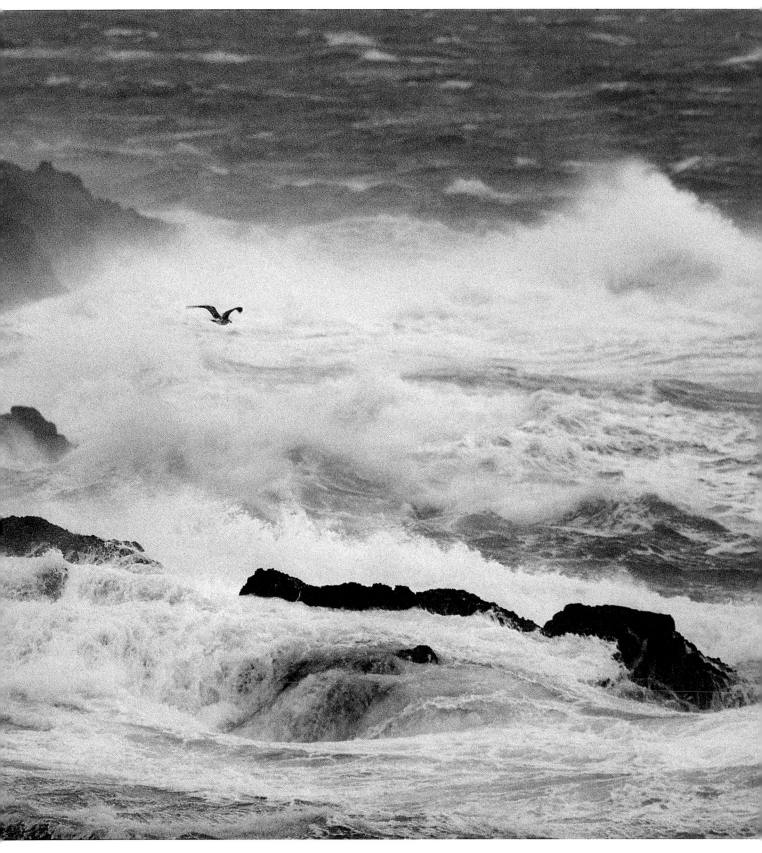

13 WHERE TO BEGIN

By far the best way to start photographing nature will be to begin on home ground with subjects that are easily accessible. Most gardens, for example, are likely to be visited by a constant stream of small birds, while many public parks in towns and cities will have populations of squirrels and ornamental ponds containing waterfowl. Many of the subjects found in either of these locations will be very approachable due to their familiarity with people—they will be accustomed to being fed. Wildflowers, too, can be found growing just about anywhere, and for the close-up photographer, even the most unlikely areas of 'waste ground' can yield a never-ending supply of interesting subject matter.

The main advantage of beginning with common species in familiar surroundings is that you will have plenty of opportunity to practise handling your camera and to learn how best to compose and light your photographs. Beginning in more exotic locations with rarer subjects will inevitably mean that experience will be gained more slowly, simply because good picture-taking opportunities will be fewer. Furthermore, when mistakes are made, it will be more difficult to go back and try to find out where you went wrong.

As your ability and confidence grow, select just a handful of wilder areas near to where you live. Then, with the permission of the owner, visit them repeatedly until you know the range of subjects they support. Get to know when and where these may be found, and keep a diary of the times and conditions in which each was seen; this will help enormously when planning return trips.

Remember, too, that many birds and mammals can be located indirectly either by their calls or by the signs they leave behind. Footprints in mud, sand, or fresh snow present the most obvious clues—though the differences between those of a fox and a medium-sized dog are very subtle and need an experienced eye to tell apart. Badger footprints are somewhat easier to distinguish, as are the setts where they live. Stripped cones found lying beneath pine trees will indicate that squirrels are present, while the scolding calls of a blackbird may lead the way to a roosting tawny owl.

Another way of finding your subjects will be to enlist the help of any local naturalist, farmer, forester, or other like-minded individual. In return, a print of the end result will always be appreciated and will go a long way towards showing that your motives are genuine. The more information you can gather about the subjects found in the areas you choose to cover, the easier it will be to think of ways to begin photographing them.

Seabird colonies are also good places to visit, particularly in June or July when most of the adult birds will be busy feeding their young. For the beginner, however, the sheer numbers of birds at many sites can often make it difficult to know where to start; this is especially true of colonies on islands which must be reached by boat and where time is limited. The best approach is to spend the first few minutes looking around to assess where the lighting will be at its best, which groups are set against the most suitable background, and so on. Having found the best subject, spend a bit more time observing its behaviour and deciding exactly what it is you wish to show. Only then should you begin to take photographs.

Covering a single subject really well, and only moving on when you are quite sure that you have the pictures you want, is much more satisfying than trying to divide the same amount of time and film between a greater number of subjects. Indeed, this is the method that most experienced photographers use, regardless of location.

Pages 112/13 **Stormy weather often provides good opportunities for photographing seascapes and waves breaking on exposed coastlines. On this occasion I parked my car on a headland in such a way that it would shelter my tripod and camera from the worst of the wind. Though a motordrive improved my chances of capturing both gull and waves in the correct position, I still had to wait for over an hour before I was confident of getting the pictures I wanted. Once back inside the car my first task was to remove all traces of salt spray from camera and lens with a damp cloth.**

Robins are among the most confiding of all the small birds to be found in parks and gardens. I photographed this individual one spring morning with a 300mm lens from a distance of 4m (13ft) as it paused whilst feeding on the insects, worms and grubs I had disturbed when weeding a flowerbed.

Birds such as this starling are frequently attracted to fruit-bearing trees and shrubs in parks—or in this instance, a botanical garden—from early autumn onwards. As the winter progresses and the weather deteriorates, migrant species including redwings, fieldfares and waxwings can sometimes be photographed at close range, particularly on weekdays when there are fewer human visitors.

14 STALKING

One of the most frequent misconceptions held by many non-nature photographers is that long telephoto lenses will solve the difficulty of getting a decent-sized image of a small subject over a great distance. Sadly, this is just not so. Even when using a 600mm lens, for example, a bird the size of a woodpigeon must be photographed from a distance of 10m (33ft) if it is to fill two-thirds of the width of the photograph. Though longer focal length lenses are available, the technical problems involved in using them become too great. In short, the most satisfactory solution will be to reduce the distance between yourself and your subject.

Although there are several ways of doing this, the most exciting and challenging method will be to stalk your subject, using techniques similar to those devised by hunters; success will largely depend on being unnoticed and your chances will be greatly improved if you appreciate, and make allowances for, its finely tuned senses. As a general rule, most mammals have highly developed senses of smell and hearing, so great care must be taken to ensure that they are approached quietly and from downwind. If you do have to pause for any length of time, then try climbing a tree to take your scent above their level. Their sight is more variable, and though it can be excellent in deer, rabbits, and foxes, it is often poorer in those that are strictly nocturnal, or spend much of their lives in water. If in doubt, it is best to regard it as being at least as good as your own.

Most birds have a poor sense of smell and tend to rely on hearing and sight. Apart from certain nocturnal species, daytime vision is exceptionally good and since most have their eyes positioned toward the sides of their heads, their field of view also tends to be very wide, thereby making them difficult to approach without cover.

To remain unseen and unheard in the field it is important to think carefully about the way you dress. Avoid materials which rustle loudly when rubbed together or when drawn against undergrowth. The colours you select should enable you to blend with your surroundings—dark browns or greens are a good all-round choice, although a pair of white overalls worn over your normal clothing will be more appropriate when working in snow. If you have a pale complexion then it is wise to cover your hands and face by wearing gloves and a balaclava, or a hat with a veil of netting. If you are really enthusiastic then try smearing these exposed areas of skin with special camouflage paints or even mud. To complete your disguise the reflective parts of photographic equipment should be covered with dark coloured insulating tape, or painted with matt black paint.

The equipment you take with you should always be kept to a minimum. Too much may create extra noise by rattling together, and will tend to slow you down, particularly in the final stages of your approach. If you are out for a long walk and have a wide selection with you, then choose only what is necessary and leave the rest hidden in a safe place. Try to manage with only one camera body and load it with a film which is appropriate both to your subject, and the prevailing lighting conditions.

Take a good supply of film, and in exceptional circumstances, always consider wasting the last few frames of a partially exposed roll so that you can reload and start your stalk with a fresh one. In many situations it will be very difficult to change films later when you are close to your subject, quite apart from the fact that you are likely to miss good opportunities while doing so. You can also save time by taking a light reading off a suitable subject beforehand, then pre-setting the exposure.

While motordrives and auto-winders are invaluable for capturing action, the noise they make will scare many subjects away. One method of deciding whether they will be usable is to fire them once from a distance and note the reaction of the subject. Small birds, for example, usually react quite favourably and will accept the noise becoming louder if they are photographed at intervals as you approach. Most mammals are less easy to deceive, however, and it is sometimes better to wait until you are very near before firing. The aim is to secure a series of photographs between the time you catch the subject's attention to the time it runs off. Sometimes, even without a motordriven camera, the sound of a shutter firing just once will be sufficient to startle many subjects when working at close range.

Though many seabird colonies contain the same variety of species, not all are easily accessible and it may be necessary to visit several different sites to obtain good views of each. Once found, however, birds like this puffin are often so tame that they may be photographed in close-up with short telephoto or zoom lenses within the 100–300mm range.

Every wildlife subject has a certain distance to which it will allow you to approach before it will flee. This feral goat proved to be a prime example, and though it would not allow me to get any nearer than 40m (130ft), its relatively large size meant that I could easily take this portrait using a 600mm lens. Unfortunately, many smaller subjects have similar or even greater 'flight distances' and, if large enough images are to be obtained, they must be approached without them realising you are there.

In really poor lighting it is often preferable to support a long lens by lying it along the ground. In this photograph the camera is actually supported on two separate points—the base of the motordrive, and the front of the lens; it is therefore much more stable than if mounted on a tripod. In adopting this technique I can consistently get photographs which are free from camera shake with shutter speeds as slow as 1/15sec with a 600mm lens. Also, from the subject's viewpoint, a low camera position will always render the photographer less noticeable.

I came across this siskin feeding on the dead seed-head of a nettle by the side of a footpath one winter's afternoon. After attaching my camera with 300mm lens onto a tripod I began to edge my way forwards, 1 or 2 metres at a time—by moving very slowly, and only when the bird was feeding, I was able to approach to within 4m (13ft). Taking photographs all the while helped to accustom the bird to the sound of the camera shutter.

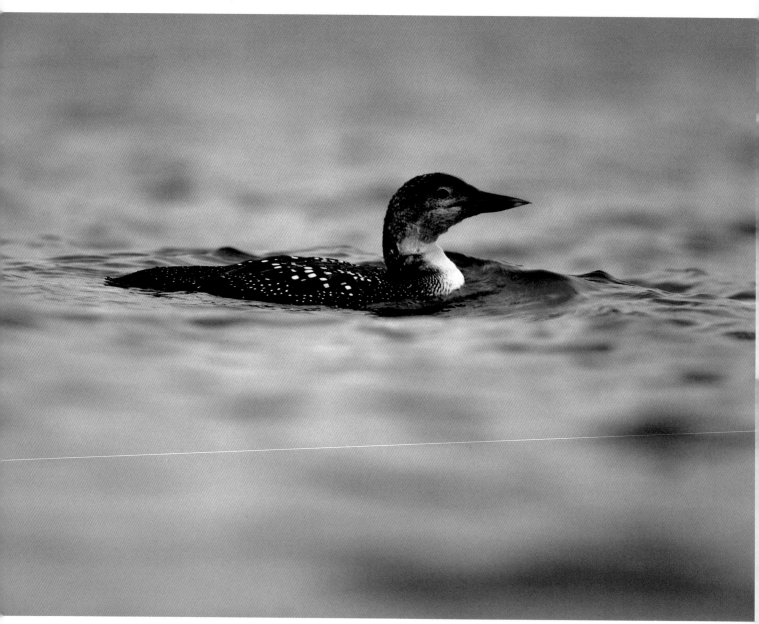

This diver in winter plumage was also stalked in stages, but on this occasion speed was of the essence because I had to get from one boulder to another (which I was using for cover along the seashore) whilst the bird was underwater.

After crawling down to the seashore to hide behind some boulders, I succeeded in attracting this grey seal to within camera-range by gently waving a white handkerchief in the air. This technique relied on the animal's poor eyesight and worked by arousing its natural curiosity, but it was essential to have the wind in my favour and not to show myself completely.

Sufficient cover in the form of juniper bushes and boulders allowed me to approach on all fours to within 15m (50ft) of this mountain hare. Suddenly, it noticed the front of my lens appearing over one last tussock, and from then on I had only a few seconds in which to focus and shoot before it ran off. As always, using a motordriven camera provided the best means of securing a series of photographs within such a short space of time.

Both the distance to which you are able to approach, and the size of your subject, will determine the focal length of the lens you must use. Generally, a lens of at least 300mm will be needed for stalking the majority of birds and mammals, though in situations where it is desirable to include some background, or where, say, a flock of birds is being photographed, then a shorter focal length may suffice.

Finding an adequate means of supporting longer lenses is a constant problem when stalking, particularly when working in poor light where slow shutter speeds will be inevitable. There are various methods which may be used, and some are more suited to a particular situation than others. Monopods and shoulder grips, for example, work best from a standing position and may therefore prove useless where it is necessary to keep a low profile. Conversely, in a woodland habitat, where trees are being used as cover, they may be ideal especially if they are braced against the side of a tree trunk. On level ground, however, a tripod may allow you to work from a lower level, and once set up it can be moved forward in stages. In any event, always make use of natural camera supports such as boulders, walls or tree stumps, and try to plan your line of approach so as to include as many of these obstacles as possible—they will also serve to hide your progress.

Once you are ready to begin stalking, move forward slowly—and only when the subject appears to be relaxed and engaged in some sort of activity. If at any time you think you have been noticed, then keep perfectly still, and wait for as long as it takes for the subject to settle down and continue whatever it was doing. In open country it is generally advisable to keep low to the ground, and avoid showing yourself against the sky; a silhouetted, upright human form will be instantly recognisable to any animal, regardless of how poor its normal vision may be.

Try to move quietly by laying your feet down gently—with practice you should be able to feel the twigs underfoot before you break them. On rocky ground or on shingle, step only on the larger stones to avoid crunching the smaller ones together.

In locations where no natural cover exists and where the subject is accustomed to seeing people, it might be possible simply to approach slowly, pretending all the while that you are not paying it any attention—the subject will probably be less disturbed than if you were appearing to 'behave unnaturally' by, say, crawling forwards on all fours.

An indirect method of stalking can be used successfully with subjects which are moving along an obvious route, for example, ducks which are working their way along the edges of a lake or river when feeding. Rather than trying to keep up with them it is often better to make a wide detour so that you can position yourself ahead, and then lie in wait until they move towards you. This process can be repeated several times, though this will depend on how well you can conceal yourself.

15 HIDES

Though stalking can sometimes yield good results, the senses of many subjects are such that it is often difficult to approach very closely and remain undetected for long periods of time. In many instances you will have no alternative but to work from within a hide which has been introduced into the area where the subject is likely to appear. Permanent hides, such as those found on many nature reserves, offer the most comfortable conditions in which to work and have the advantage of already being accepted by the local wildlife. Garden sheds, outbuildings, and even your house can also be used for photographing the wildlife in your garden, particularly if they overlook a bird-table, a nest-box or a pond.

There will, of course, be other times when you may wish to conceal yourself at some other location which you know to be regularly visited by a particular subject—wader roosts, song posts, or favourite feeding and drinking areas are all possibilities. At many of these sites it may be possible to construct a hide from whatever natural materials are available locally. Rocks, dead branches, and driftwood, for example, can all be piled together to form a screen which can then be covered with finer materials like grass,

bracken or seaweed. In wet weather a roof can be made by adding a ground sheet or some heavy canvas, though polythene materials are best avoided because they tend to make too much noise in wind and rain. Where the structure is intended to be semi-permanent, you should also take along some rope, string, and a hammer and nails to help fasten everything in place.

The effectiveness of any improvised hide is usually decided by the senses of your subjects and the range from which you are likely to be working. While many such hides may be adequate for photographing, say, water voles at 4m (13ft), most birds have much better eyesight and are likely to see through the smallest of

Lying on the ground covered with a camouflage net provides the simplest and quickest form of concealment. However, quite apart from the discomfort, there are two further disadvantages: firstly, it is important to keep very still to avoid detection; and secondly, the low viewpoint makes it very difficult to attempt photographs of nearby subjects which are more than I or 2m (6½ft) above ground level. In this photograph the camera is resting along a rucksack.

gaps, and notice the slightest movement from behind all but the very best screening. Since many small birds and keener-sighted mammals often have to be photographed at close range, and as it may not always be convenient to construct a makeshift hide, it follows that an effective portable version will be useful which is quick and easy to erect.

One versatile and widely used design consists of an upright, rectangular-shaped tent, with a floor area of about 1sq m (10sq ft) and sufficient height to allow the photographer to sit comfortably on a folding camp chair. Although such hides can be bought readymade, they often require some modification to suit individual needs, so it is often better to make your own. Begin with the framework which will support the covering: the simplest method is to use four upright poles driven into the ground to form a square, linked together with heavy gauge wire at the roof. If you intend to work on very hard or soft ground, then it may be necessary to build a self-supporting frame from sectional aluminium tent poles; these are available from any camping supply shop.

The covering can be sewn from any dull-coloured material which is heavy enough not to reveal your outline to the subject, especially when working with the sun shining from behind. It should also be waterproofed, and must fit snugly over the frame with no large areas of excess cloth which might flap around and scare off potential subjects. Make the covering slightly longer than necessary so the material along the bottom edge can be turned up and stitched at intervals to form shallow pockets; these can be filled with rocks or earth for extra stability. In very windy weather it may also be necessary to have guy ropes attached to each corner of the roof.

A slit running from the bottom of one wall provides access, which can be closed with cord ties, safety pins, zip-fasteners or strips of Velcro. At a convenient height along each wall a series of small peep-holes should be cut to give a clear all-round view to the outside. Camera ports should be positioned towards the centre of each wall, and can be made by sewing half a leg from an old pair of trousers into a suitably-sized hole, thereby forming a sleeve that may be secured around the front of the lens with an elastic band.

As time goes on, you may encounter situations where a conventional hide cannot easily be used. When waiting for deer, for instance, you must be at least 3 or 4m (10 to 13ft) above the ground to take your scent over their heads. This may involve building a platform in a tree, or even erecting a hide on top of four stilts which have been sunk into the ground

and braced with cross-members and guy ropes. Such high-level hides will also be needed for photographing birds that nest in trees, or feed on berries on the tops of tall shrubs.

Special preparations are also required for subjects which live on marshy ground, or on water. In some situations a hide can be built onto a platform supported by stakes driven into the bed of a river or lake, while in deeper water, you may be forced to work from a suitably camouflaged boat or raft.

Whatever the location, your final design should also make some provision for your own comfort, so that lengthy sessions are more tolerable. The longer you are prepared to wait, the more you are likely to see.

USING A HIDE

Having decided on the type of hide you wish to use, the next step is to introduce it to the subjects you intend to photograph. With subjects which return to a particular area to raise young or feed, it is important not to erect the hide in one operation at the final working distance. Nesting birds in particular will almost certainly abandon eggs or young if unduly disturbed, so special care must be taken to ensure that the hide is either moved into position gradually, or built in stages to enable them to become accustomed to it (see p 129).

Even at less sensitive sites, which are only visited periodically, disturbance should be reduced by working mainly when the subject is absent. A hide for

I built this hide at the edge of a Scottish pinewood, using locally gathered materials including heather, branches, and dead birch trees. I had originally intended to use it for photographing black grouse, but was prevented from doing so one spring when a pair of redstarts took up residence and built a nest inside—presumably after deciding it was just another part of the landscape!

This photograph shows a de-luxe version of a collapsible hide which I constructed from thin sheets of plywood, braced by a lightweight pine frame. Due to its weight (a little under 20kg/44lb) it is really only usable at short distances from a vehicle. Nevertheless, it has the advantage over a conventional hide in that it can be erected on almost any type of terrain, including sand, shingle, mud, and on one occasion, in the middle of a stream! In addition, the weight of the photographer is transferred to the side walls via a folding wooden seat, thus increasing its stability in windy weather.

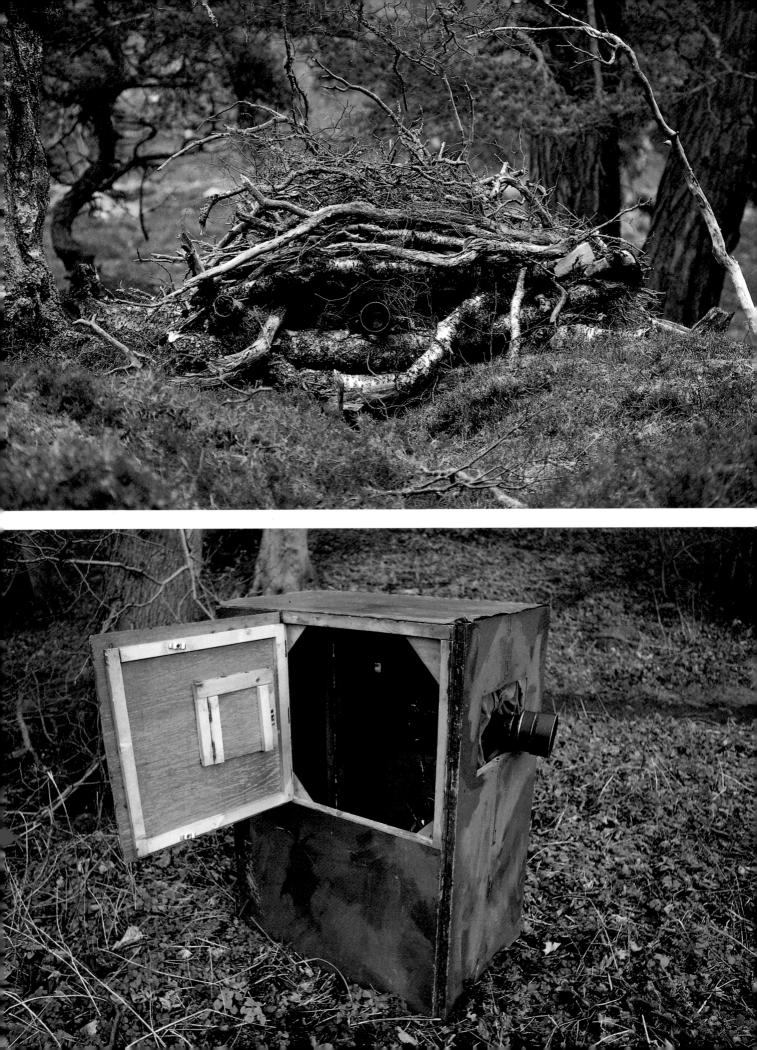

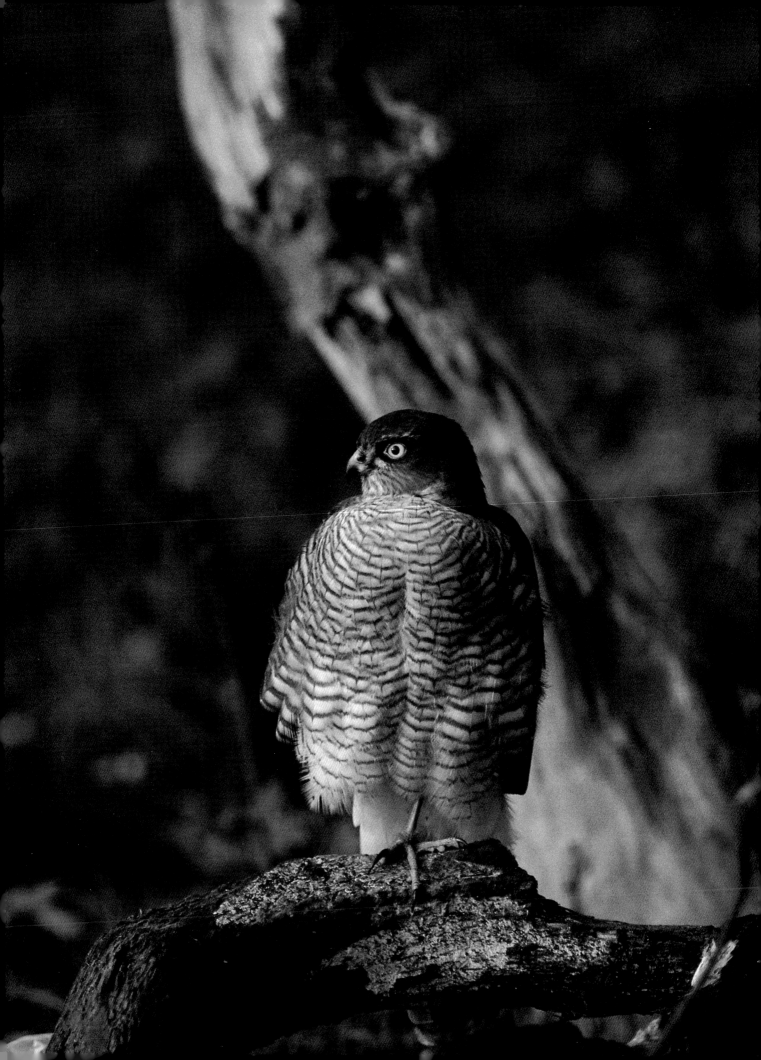

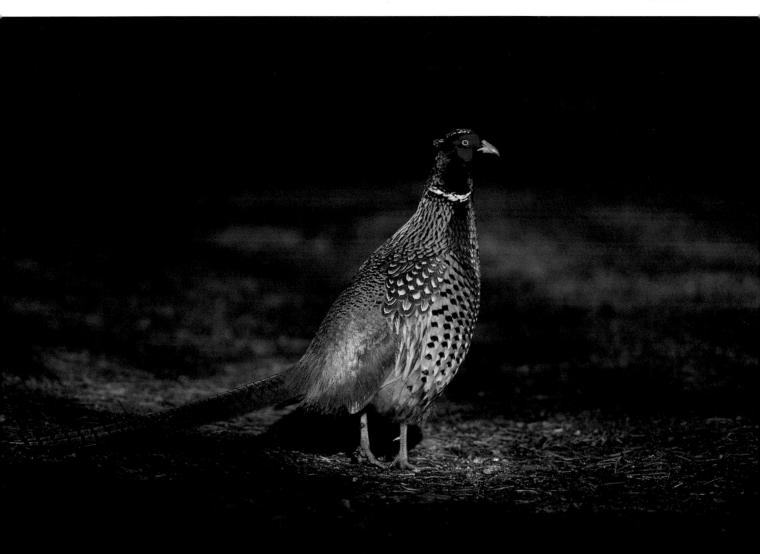

This cock pheasant was a regular visitor to a feeding station which I had in fact set up to entice red squirrels. My main problem in obtaining this photograph was ensuring the bird would pause while in one of the few pools of sunlight which filtered down between the trees; I achieved this through arousing its curiosity by whistling quietly while remaining unseen in my hide.

One of the joys of working from a hide is that you never know what is going to turn up next. On the day I took this sparrowhawk I had actually been photographing some goldfinches feeding on some nearby thistleheads—only their alarm calls and sudden disappearance caused me to look around and notice the hawk from another side of the hide. I then had to spend 15 minutes slowly re-positioning the camera and tripod beside the appropriate lens opening, being careful not to disturb it.

127

photographing wading birds feeding, for example, could be built at high water beside a mudflat, whereas one to photograph them at their high-tide roost site could be built at low water, when they are feeding. A hide is also likely to be more acceptable if some effort is made to break up its outline. Very often this can be achieved by siting it beside a wall, a tree, or by some other established, natural feature. If none is available, then try adding natural débris or camouflage netting; this will also help to avoid attracting the unwanted attention of curious human visitors.

Hides built in flat, open country are often the most difficult to conceal, though they can sometimes be made less conspicuous by sinking them into a shallow pit to reduce their height. On completing the hide, leave an empty glass bottle protruding from one of the camera ports. This will make your subjects less anxious about the sudden appearance of a camera lens when you actually come to use the hide.

Choosing the final site for a hide deserves special consideration, and where an elaborate structure is necessary it is vital to get it right first time. Select one which affords the clearest view and a pleasing background. If you are uncertain about either, then preview the scene by setting up your camera and tripod with the lens you hope to use, while sitting on your usual hide chair. This will immediately reveal any problems you may encounter with foreground obstructions, or with distant buildings, electricity pylons, and so on. Remember also to take into account the position of the sun at the time of day you anticipate your subjects will be active.

When it comes to actually using a hide, try to enter and leave when the subjects are not in the vicinity, or when it is still too dark for them to see you. If you cannot avoid being seen, arrange for someone to walk up to the hide with you, and then depart once you are settled inside—this will fool most birds into thinking the hide is vacant, though intelligent species like ravens are notoriously difficult to deceive, and several helpers will be needed. At a pre-arranged time or signal, your helpers can then return from a safe distance so that the process can be reversed, and you can leave without upsetting the subjects by your sudden emergence. This technique

should be standard practice when photographing birds at the nest because it is usually impossible to know whether or not your movements are being watched from afar.

Once inside the hide, prepare your equipment quickly, and unpack extra film and any other items of equipment which you may need later, to save time and avoid further disturbance. Noisy food wrappers should also be removed. Sit quietly, and try not to lean or brush against the walls of fabric hides, or put your eye directly against a peep-hole. At all times imagine that your subject is just outside, even though it may be nowhere to be seen. When it does appear, give it time to settle down and only begin to take photographs once you are quite satisfied that it appears relaxed and is behaving normally.

After taking one or two initial exposures, check to see if it has been disturbed by the noise of the camera shutter. If this is the case, then give it time to relax before trying again. As time goes on, most birds will come to ignore such sounds and you may even find it useful to attract their attention by introducing a slightly different one, for example, by whistling quietly. However frequently you use a particular hide, you are unlikely to accustom any subject to the movement of your lens as you follow its progress. The general rule is to pan or tilt the camera very slowly, and preferably only when the subject is preoccupied, usually with feeding or drinking.

When working at close range it may also prove impossible to change lenses quickly and quietly without scaring off the subject completely. Using a teleconverter or a zoom lens to change magnification provides the most effective solution to this problem, though even zooms can sometimes arouse suspicion if they are adjusted too rapidly, as the subject may notice the groups of individual elements moving around inside the lens.

While some of the above measures may seem unnecessary for certain species, it is always better to be over-cautious. The most important thing is to build up the confidence of your subjects, so that you can then experience the satisfaction of photographing them going about their daily lives, unhindered by your presence.

16 BIRDS AT THE NEST

No matter how well it is conducted, photographing birds at their nests will inevitably subject them to some degree of disturbance, and in order to keep this down to an acceptable level it is essential to abide by certain guidelines. There are also legal restrictions regarding the photography of rarer species which should be observed at all times.

Unless you are planning to photograph very tame species, such as swans or certain seabirds, then it will usually be necessary to work from within a hide, and all the recommendations already discussed concerning hides will be especially relevant. Your first priority should be to find a nest in an area where you are unlikely to be disturbed, and which cannot be seen from a public right of way. Begin with a common species, which normally nests close to the ground, as this will avoid having to build an elaborate hide. Also important is to find a nest near the beginning of the breeding cycle to allow sufficient time to introduce the hide. Not all nests will fulfil these requirements, and you may have to locate several before you find one which is suitable for photography.

With species like robins and other birds whose young stay in the nest until they are fully fledged, the best time to begin work will be three or four days after the eggs have hatched. Even if you allow a week to position a hide, this should still give you ample time to photograph the young being fed by their parents before they leave the nest. As fledging times vary, it is wise to check those for the species in question.

Other birds have young which are capable of leaving the nest very soon after hatching—so if you wish to photograph this happy event, you will have to introduce the hide while the adults are still incubating. Although the behaviour of the parents can often indicate when hatching is about to occur, it may still involve watching and waiting for days on end to be sure of recording it.

Another problem, and one which applies to all species, is that nests containing only eggs are more likely to be abandoned as a result of disturbance, because the parental instincts of the adult birds are always stronger after hatching. For this reason it is advisable—at least to begin with—to concentrate only on those species whose young stay in the nest after hatching.

Hides must be introduced to the nesting area gradually to give the adult birds time to become accustomed to their presence, and there are two ways of doing this. The first entails erecting the hide fully at a distance, then moving it closer over several days. With small birds you should aim to begin at about 10m (33ft) away, working down to an eventual position some 2 or 3m (6½ to 10ft) from the nest. Larger species, and especially those which nest in open country, are usually less confiding and may need to be worked from at least 30m (100ft) with a final shooting distance of 4 or 5m (13 to 16ft). Although these distances can only serve as an approximate guide, it is seldom possible to reduce them. In the case of very timid species, such as herons or birds of prey, they will even have to be increased, though the exact amount can only be judged safely after spending several seasons working with more familiar species.

The timescale over which the hide should be moved forward must never be hurried, and progress is largely dependent on the temperament of the subject. With small birds, think in terms of making one move a day for three or four days; each move should only be attempted in fine weather and must be completed as quickly as possible. After each move, retreat to a safe distance and check through binoculars that the birds have accepted the hide. If they appear distressed and are reluctant to return to the nest, then move the hide further back; you must be prepared to abandon the project if the hide is rejected for a second time.

The other way of introducing a hide is to build it in stages at the final working distance. This practice is more appropriate for sites which are in dense cover, or require a special platform to be constructed. Where a conventional portable hide is to be used, the process could begin by simply laying the folded hide on the ground where it is to be erected. On the second day, part of its framework could be set in position, while on the third a section of covering could be draped over one corner, and so on, until the structure is complete.

Like the previous method, each stage must be carefully pre-planned and completed quickly and quietly. Loose material should not be left to flap around and acceptance by the parents must be confirmed before you leave. More elaborate hides will take longer to complete, so it is essential to spread their construction over more days rather than try to work for longer periods—twenty minutes should be the maximum

duration of any one building session. Even after a hide has been successfully established, birds can still be upset by the subsequent addition of shiny flash units and the tripods used to support them. This problem should be anticipated early on so that 'dummy' units can be made and moved into place alongside the hide.

Because several trips are often needed just to get everything into place, great care must be taken not to trample the vegetation leading to the nest site as this is likely to attract the attention of predators or inquisitive humans. Similarly, the vegetation surrounding the nest should never be removed because it also provides the brood with protection against predators and the weather. On some occasions, however, it may be desirable to tie back leaves or grasses to give a clearer view of the nest; this procedure is known as 'gardening', and requires great care—it should never be attempted once the young are nearly fledged because it can easily cause them to leave the nest prematurely. The effects of any 'gardening' must always be reversed each day at the end of the session so that the site is restored to its original state.

Once you are ready to begin photography, try to avoid visiting the site too often. Remember, too, that the duration of your sessions will often be determined by the frequency of the visits made by the adults to feed their young. Robins, for example, are convenient subjects in that they will return with grubs and insects every few minutes, while a kestrel may only visit once every three or four hours since it brings more substantial prey.

Once you have obtained the photographs you require, do not suddenly remove the hide as this could distress the parents who will have grown used to its presence. Either withdraw it gradually, or leave it in position until the young have fledged. Always return at a later date to tidy up the site and remove any trace of your occupation.

To photograph this nesting black-headed gull at the edge of a large colony on a freshwater marsh, I worked from a portable hide at a distance of 12m (39ft). Due to the difficult location, I attached the hide to a makeshift raft built from a wooden pallet and four large plastic drums. After tying bunches of reeds to the whole contraption, over a period of five days I then floated it into position.

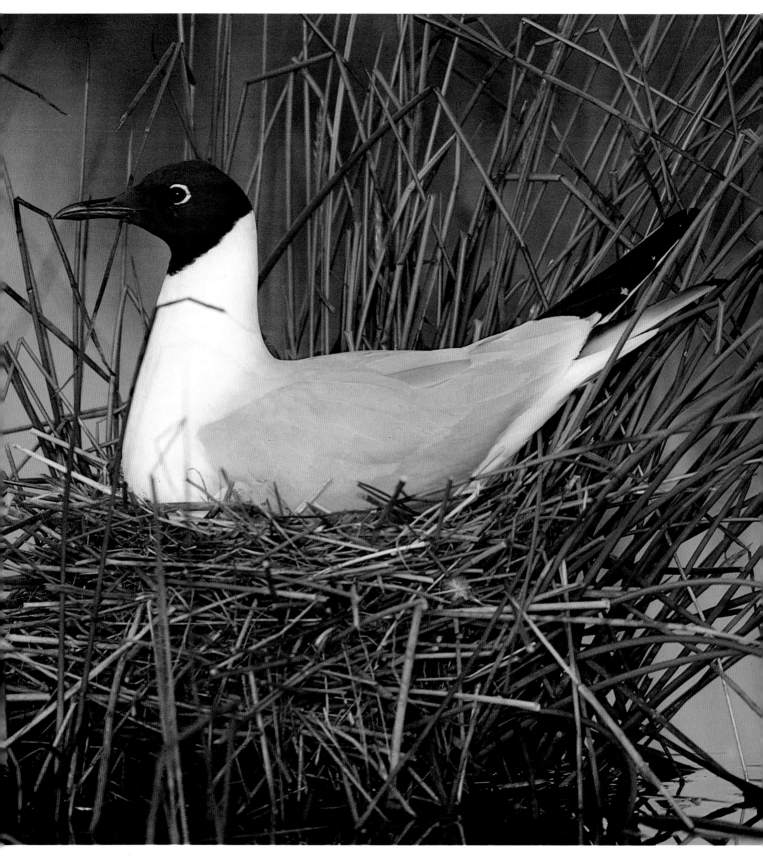

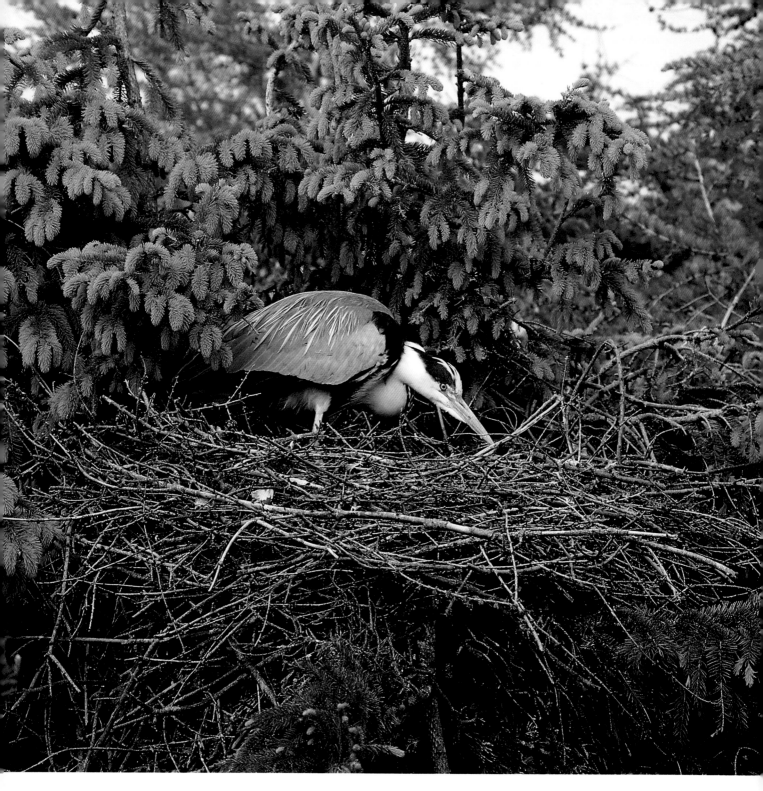

Although these two photographs of grey herons at the nest were taken over a month apart, they show how effective a zoom lens can be for varying the framing of a subject when working from a hide. Had I been using fixed focal lengths, then it would have been very difficult to change lenses without alerting the birds, which were only 10m (33ft) from my treetop hide.

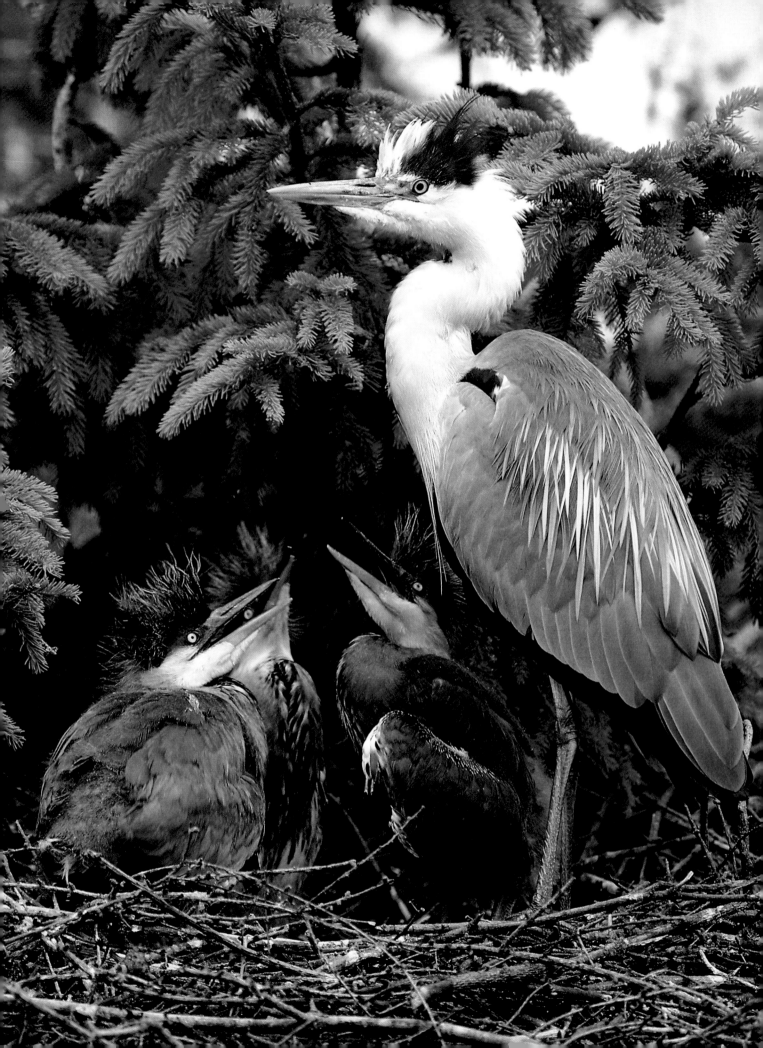

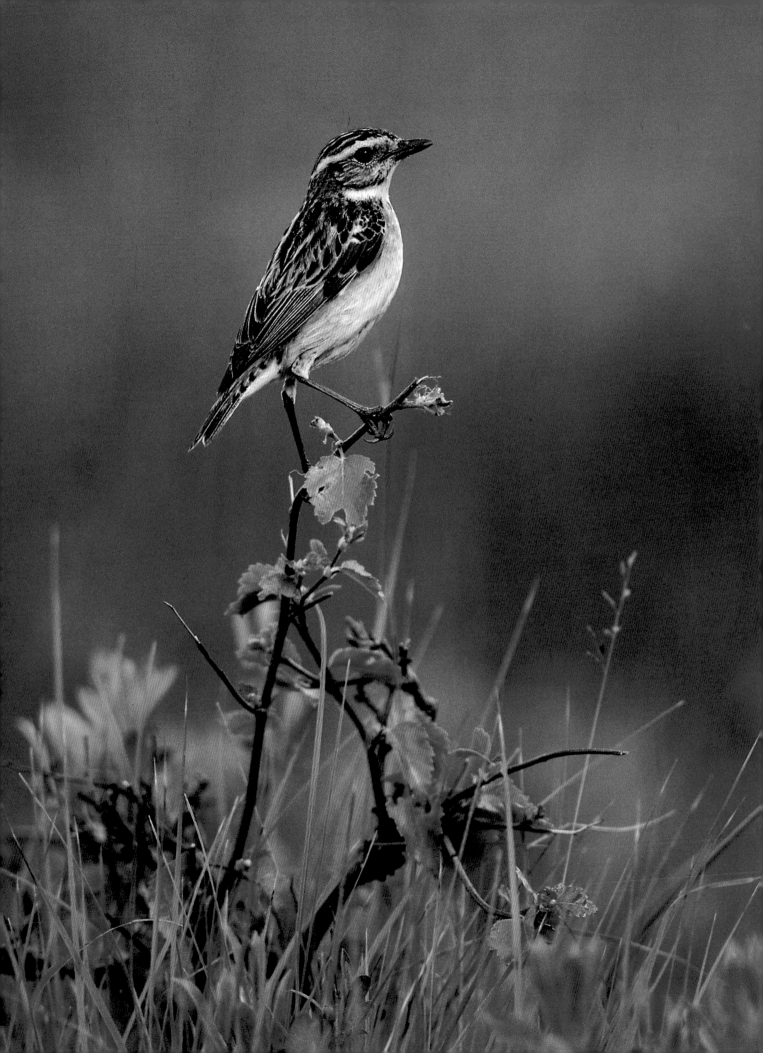

17 WORKING FROM A VEHICLE

Because few birds and mammals associate cars with people, it is quite possible to use one as a form of mobile hide. Apart from the obvious advantage of being able to alter camera positions, you will have the benefit of working in a weatherproof environment with the facility to use a wider range of equipment than could normally be carried into the field. The most suitable types of vehicle for this kind of work include those with a good ground clearance and which have four-wheel drive, though even these features are not really necessary since a surprising amount can be accomplished without ever having to leave a public road.

The simplest way of using a vehicle as a hide is to park by a likely spot, then wait quietly for your quarry to appear. It is important to have your camera already held in position, preferably by a special window mount, because if you suddenly poke a lens through an open window, wary subjects are unlikely to stay for long. Most cars will have room for a tripod or monopod to be wedged between the seat and the door. Some form of screening is also necessary and this can be improvised by taping a suitable piece of cloth to the door frame so that it hangs down around the camera.

Another method of working involves seeing your subjects in advance whilst driving along, then drawing up alongside to photograph them. This form of stalking is actually more difficult than it sounds, because all animals will immediately become suspicious of any vehicle which comes to a halt beside them, especially if it does so abruptly. The best solution is to approach very slowly, and preferably with the engine in neutral and the ignition switched off. You should also have the window rolled down and your camera to hand with an appropriate lens fitted so that you are ready to begin taking photographs the moment you arrive.

On those occasions where you come across a subject without warning it is best to drive on, then turn and go back better prepared, even to the extent of having the exposure pre-set on your camera. In the interests of road safety use this technique only on quiet byways, and take along a sympathetic friend to drive so that you are free to devote all your attention to watching for likely subject matter, and to photographic matters. This will also enable you to stay in the back of the vehicle where you will have easy access to the windows on each side.

Where it is dangerous to wait for any length of time it is sometimes possible to get out of the vehicle unseen if it is parked for a minute or two beside, say, a bush or a wall which is between yourself and the subject. The ploy here is to obtain your photographs while the subject's attention is focused on your companion driving off. As with any other stalking technique, this is more likely to prove successful where there is only a single pair of eyes to avoid.

Small birds, such as this female whinchat, often have favourite perches which they use as 'look-out posts' before taking food to their young at the nest. Because such vantage points may be up to several metres away, they can provide an ideal way of obtaining close-ups, while keeping disturbance at the nest to a minimum. A hide is, of course, essential.

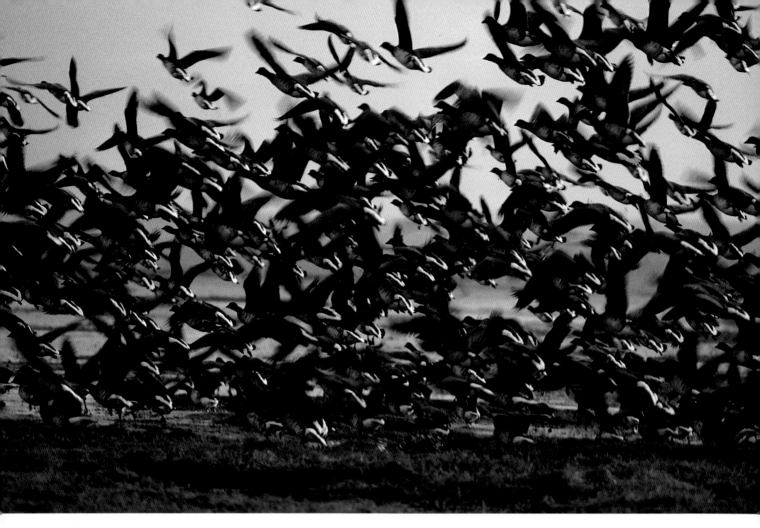

Moments before I took this photograph from my car window these brent geese had been grazing peacefully on this saltmarsh. Their rapid exit was caused by the occupant of another car deciding to get out to have a 'closer look'.

A convenient way of supporting a camera when working from a vehicle is to use a beanbag. The example shown below is homemade and is actually filled with rice. The general idea is to create a broad base which can be moulded to the shape of the camera or lens. When using very long lenses, it is helpful if the vehicle can be parked just before the subject is reached so that the camera can be supported lengthwise for greater stability.

Roadside fenceposts and telegraph poles provide convenient perches for many birds in open country. I photographed this short-eared owl in just such a location using a 600mm lens resting on a beanbag over a car roof. As this involved getting out of the car I had to be careful to emerge very slowly, on the side opposite to the bird.

18 REMOTE CONTROL

An alternative way of taking close-ups of animals is to place the camera near to a site where they are expected to appear, then to operate it from a distance by remote control. This technique is particularly suitable for situations where it would be impractical to build a hide, either because it would attract attention from passers-by, or simply because the site is inaccessible. Or you may wish to try this method as a means of using a short focal length lens from a close viewpoint in order to obtain a more interesting perspective. Either way, you will still be faced with the difficulty of having to familiarise your subject with the equipment.

Sensitive subjects like nesting birds will not tolerate the sight or sound of a hastily introduced camera, so you must disguise its appearance and move it into position gradually while noting their reaction on completion of each stage. Obviously, it will not always be practical to leave valuable equipment lying around outdoors while your subjects are becoming accustomed to it, so you may have to devise a convincing substitute which can be replaced by the camera proper once you are ready to begin taking photographs.

Another possibility would be to build a sort of mini-hide for the camera which could be moved forward in the normal way. It could take the form of a sound-proofed wooden box which need only be large enough to accommodate the equipment you hope to use. It should have a removable lid, an opening in one side for the lens, and be painted a drab colour. A glass bottle could be used as a substitute for the lens whilst it was being moved into position along the ground. If a higher viewpoint were required, then a suitable bracket could be attached to the underside to allow it to be secured to a tripod.

I photographed this badger at its sett by remote control, though before I could do so I had to spend several evenings sitting up a nearby tree to determine which of the many entrances were in regular use. On making my selection, I returned early one evening and set up my tripod at a distance of 5m (16ft). After attaching a motorised camera with flash units, plus an infra-red trigger, I pre-set all of the controls and retreated to my original vantage point in the tree. To avoid disturbing the badgers I used a low-powered flashlamp fitted with a red filter to check their position before firing the camera via an infra-red flash transmitter.

138

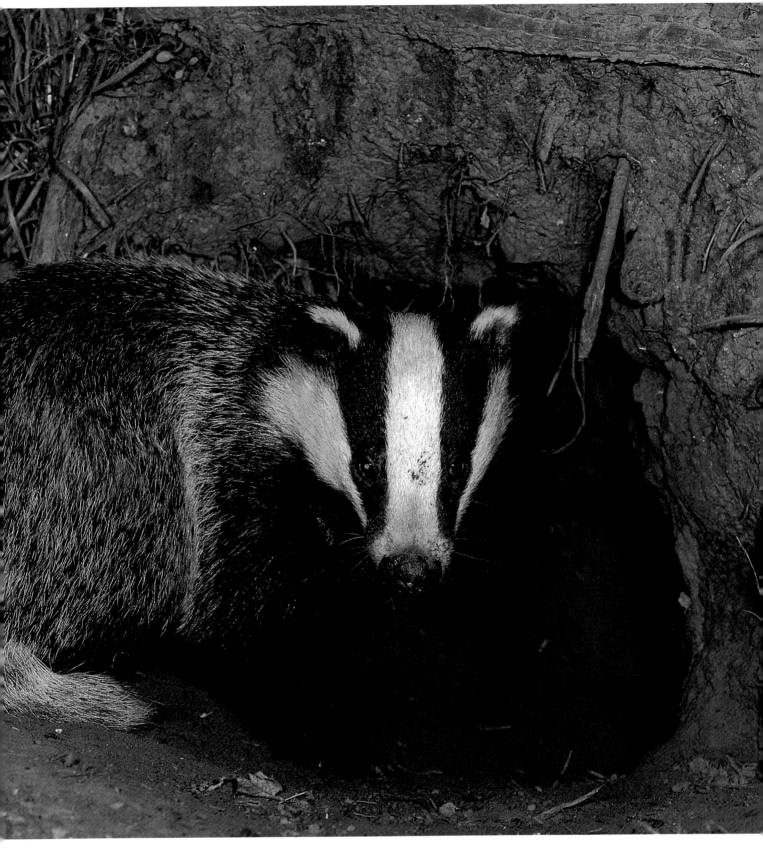

With a little imagination, any number of applications could be found for such an accessory. Think, for example, of the pictures you could obtain if one were left near to the entrance of a rabbit burrow, or on the ground beside a puddle where birds come to bathe. In either case, an auto-exposure camera would be ideal for coping with fluctuating light levels.

Whatever the location, you should never underestimate the difficulty of determining whether or not the subject is within view of the camera. The best approach is to place a marker—a stick or a pebble—at either side of the field of view covered by the camera, and level with the point on which the lens is focused. Each of these references should also be clearly visible from your vantage point, though a pair of binoculars will usually be necessary if you are working over a great distance.

Even when your subject is in place, it is seldom possible to know exactly what you are getting, so you should aim to take lots of photographs to be sure of getting a few which are worthwhile. Indeed, much of the thrill of this way of working will be had when you come to view the processed films for the very first time.

19 BAITING

All the techniques described so far have shown ways of moving a camera nearer to a subject. Yet by laying down a suitable bait in a time of natural shortage, you may be able to encourage your subjects to come to the camera. The main advantage of this is that you can have control over where they are to appear and can therefore pick a site which has a suitable background and where the lighting will be at its best. Of course you will need to begin in an area where your quarry is already present, and to know about the habits and preferred diet of the species in question.

Grain can be used to attract mice or seed-eating birds, while blackbirds, thrushes and voles will prefer apples. Robins are particularly fond of mealworms which can be bought from a petshop, and foxes, crows and magpies can often be enticed with scraps from a butcher or even a rabbit which has been found dead on a road.

If you wish to photograph your subjects feeding, then use a bait which occurs naturally, otherwise hide it from view by wedging it into a crevice, or by placing it behind a rock or log. Large items of bait left on the ground should be tethered in some way, to prevent them being moved out of view or carried off completely. Mid-winter is often a good time to begin baiting because this is when prolonged periods of frost and snow can make it difficult for wildlife to find enough natural food. Remember, however, that once you have started to leave food, some subjects may well come to depend on your artificial supply and therefore may suffer if it is suddenly cut off.

In hot weather and in times of drought you can use water as a means of attracting wildlife into an area where it is scarce. One way of doing this is to construct a small pond: dig a hole and line it with heavy-duty polythene; use earth or rocks to hold the edges in place and then plant several tussocks of grass to make it appear natural. Birds tend to find water more easily if it is moving, so it will be advantageous to rig up a drip-feed system: for example, attach a large canister of water to a tree then siphon it through a plastic tube and restrict the flow with a clamp.

There are other less obvious baits you can try, though to discover them will require a deeper understanding of the behaviour of your intended subject. Imagine, for instance, creating a muddy puddle in a prolonged spell of dry weather to allow swallows or house martins to gather mud to enable them to continue building their nests. Similarly, you could help many garden birds line their nests by putting out a handful of feathers from an old pillow.

If it is to be successful, any form of baiting must be carried out regularly and to a set pattern. You should not expect to get results right away, however. Some of the more wary species seem to take forever to get used to an idea; these can sometimes be put at ease by laying out a different bait to attract tamer species which will then act as decoys. And if this fails to work, at least you will have something to photograph while you are waiting!

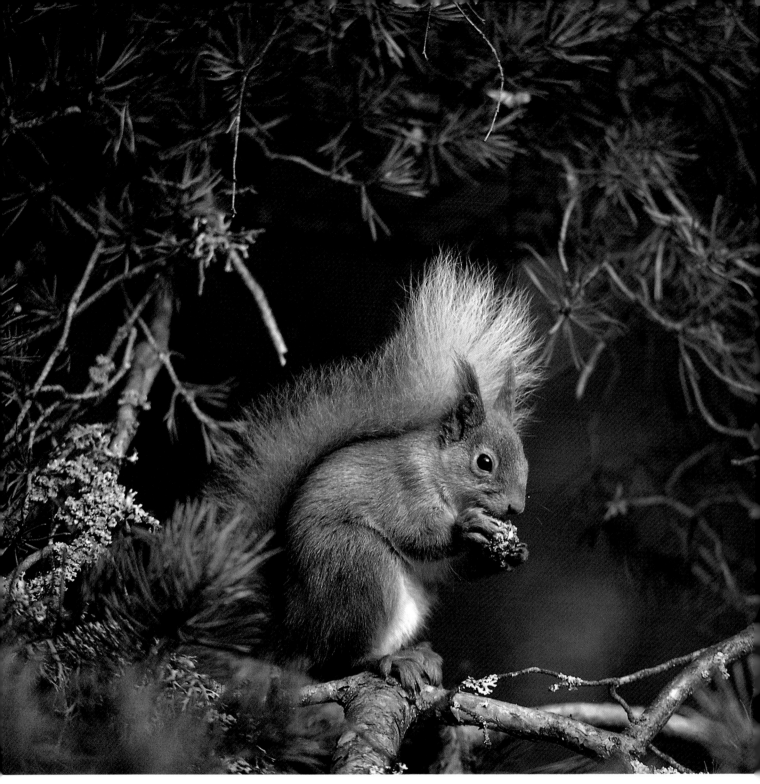

This red squirrel frequently visited a bird-table to feed on peanuts. To entice it into this more attractive pine-tree setting, I attached a small tin filled with peanuts onto the opposite side of the branch on which it was sitting, and reduced the supply at the bird-table. Then, so that it appeared to be feeding on a more natural food supply, I gradually substituted the peanuts in the tin for pine cones which had been smeared in peanut butter!

20 PHOTOGRAPHING ACTION

Attempting to record the actions of rapidly moving birds and animals is perhaps one of the most difficult areas of nature photography in which to work. To succeed will require complete familiarity with the controls of your camera, fast reactions, and a willingness to use plenty of film in order to secure only a handful of results which are really worthwhile. Ultimately though, the success of any action photograph will rely heavily on your ability to decide when the best moment will be to release the shutter.

This skill, which should become instinctive, may be learnt by carefully observing the actions of your subject so that the decisive moment can be anticipated, then seized. When stalking many birds, for example, it is often possible to judge by their reactions when they are about to take to the air. Flocks of geese on stubble will stop feeding, raise their heads and begin calling. From this moment on you may only have a few seconds in which to prepare your camera to capture the initial lift-off. Other birds will crouch down just prior to take-off in order to spring upwards to launch themselves into the air. Again, after bathing or preening, most waterfowl will rear upwards to outstretch, then flap their wings, thereby offering dramatic poses.

Any of these moments will be easier to record if you use a motordrive or an auto-winder because the uninterrupted view they provide allows more time to be spent concentrating on the subject. Without a motorised camera, valuable opportunities can be missed each time you take your eye away from the viewfinder to advance the film manually. Despite manufacturers' claims, however, no motordrive can be relied upon to capture all the action even when they are operating at their maximum firing rates, and it is still possible to miss the best chances between exposures. Consequently, it is best to use motor-driven cameras selectively and only fire them in short bursts, or even a single frame at a time, while watching how the action develops. Working in this way also helps to reduce film wastage, with the result that fewer opportunities are likely to be missed since films need to be changed less frequently.

Choice of shutter speed will also affect the impact of an action picture. By using a very fast speed of 1/1000sec or less, for example, you should be able to arrest practically all the movement of most birds and animals in full flight. Large birds like swans and herons, however, beat their wings more slowly than,

say, a puffin or an oystercatcher, and may therefore only require a shutter speed of 1/500 or 1/250sec. Again, you may be able to obtain a sharp photograph of a gannet 'hanging' in the air by a cliff-top on a windy day by using a speed as slow as 1/125sec.

The proximity and the direction from which the subject is approaching are two other important factors to consider when choosing a shutter speed. A subject which is crossing the frame from one side to another at close range will require a faster shutter speed than one which is more distant. Again, those moving directly towards, or away from the camera, will only appear to be increasing or decreasing in size slowly, and may therefore be photographed with a slower shutter speed.

Whenever the direction of flight allows, you should always pan the camera with the subject. Apart from allowing more precise framing, this will mean that slower shutter speeds can be used since the speed at which both camera and subject are moving will then be constant. With shutter speeds slower than 1/250sec this can sometimes result in the head and body of the bird or animal remaining sharp, while the legs or wings, which are generally moving more rapidly, will appear blurred. Panning the camera at slow shutter speeds will also reduce the background to a series of blurred streaks, thus further implying the sensation of movement.

Considering the number of variables involved, a fair amount of practice is needed before the likely effect of a given shutter speed with a particular subject can be predicted with any degree of accuracy.

This photograph of an oystercatcher with its chick is one from a sequence taken with a motordrive set onto its single frame advance mode. It illustrates a typical situation where the uninterrupted view given by a motordrive was essential. Had I been winding the film on manually it would have been so easy to have missed this attractive pose between exposures.

I used a shutter speed of 1/500sec to freeze the movement of this black-headed gull which had lost its balance while alighting on the surface of a frozen pond in a city park. The surrounding snow and ice boosted the light levels on this already sunny day to allow me to use a 600mm lens at an aperture of f8 with ISO 64 slide film.

142

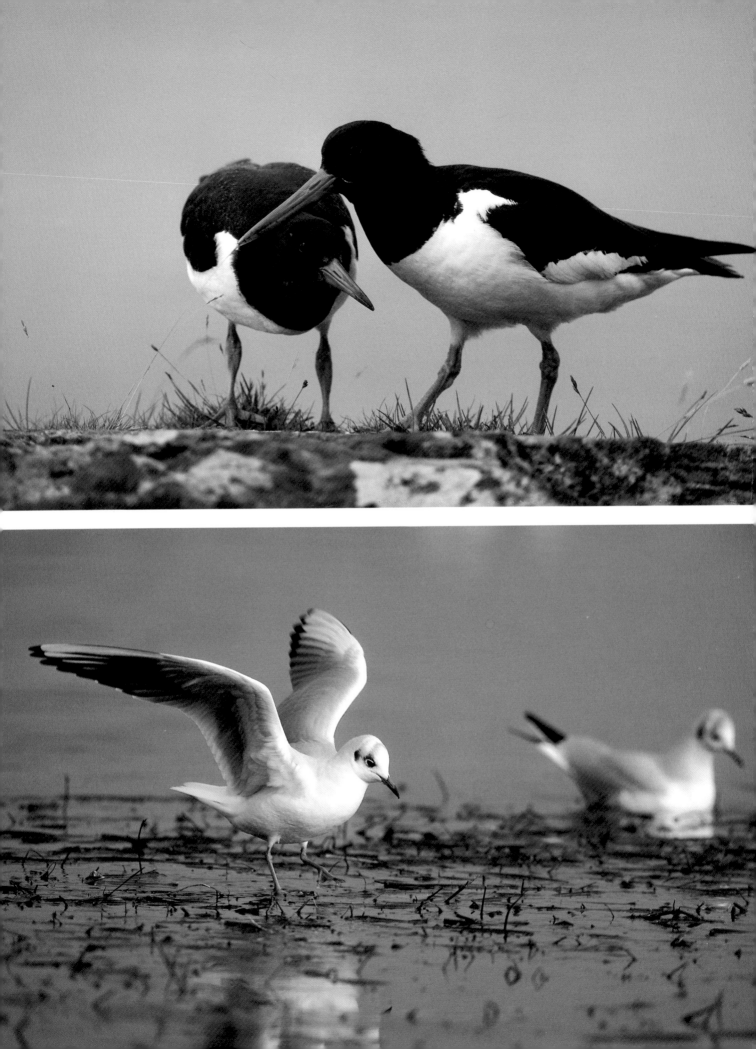

Since most action photography demands the use of fast shutter speeds, it is often necessary to use the widest possible aperture on the lens to allow sufficient light to reach the film. It should be noted that because this also reduces depth of field, accurate focusing becomes essential.

With manually operated equipment there are two basic methods of focusing on a moving subject, and the one to choose will depend on its speed and direction of travel. The first technique is known as 'follow-focusing', and involves panning the camera while continually adjusting the focusing ring in an attempt to keep the subject in sharp focus. This method is best suited to slow-moving subjects, or ones which are likely to remain at a fairly constant distance from the camera. Rapidly moving subjects are more difficult to keep up with and to achieve reliable results it is better to pre-set the focus on a point ahead of them, then wait until they move into this zone before firing. This method works particularly well when observing seabird colonies where many birds will use the same flight-paths time and again, thus allowing plenty of opportunities to determine the focusing distance.

In either instance, using telephoto lenses which

On the day I photographed this whooper swan at a wildfowl trust refuge, the light levels were so low that my camera's meter only indicated an exposure of 1/30sec at f5.6 with my ISO 64 film. Rather than change to a faster film, I decided to make do with the one I was using and take advantage of the slow shutter speed to blur the bird's wing movements, thus creating an impression of movement.

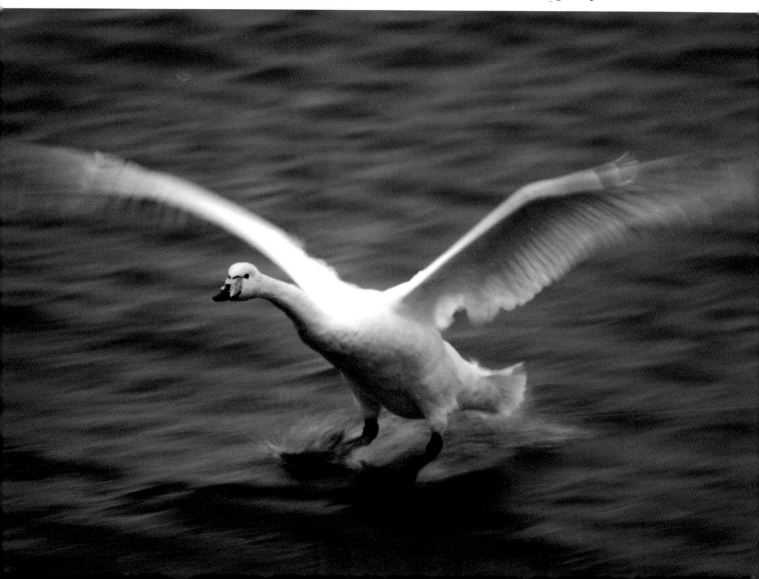

focus internally will be a great help, since these tend to be more compact and to focus faster than conventional designs. The most suitable focal lengths for action and flight photography lie in the 200–400mm range. Such lenses often have reasonably wide maximum apertures which allow slow-speed, fine-grained films to be used with fast shutter speeds in all but the poorest of lighting conditions. Another advantage of using shorter focal length lenses is that their wider angles of view make it easier to home-in on and compose the subject within the frame. Using a monopod or a rifle grip will also aid composition by supporting the weight of the camera and so allowing it to be panned more smoothly.

Large flocks of birds or groups of animals in motion at close range are often awkward to photograph because depth of field cannot be controlled and it is difficult to know which individuals to concentrate on. The solution here is to focus on a single subject toward the centre, but at the edge of the group nearest the camera. Then, by staying with this one subject, all those nearest the camera will remain in focus while the others should fill all, or most, of the rest of the frame and form an effective background to the shot.

This flock of barnacle geese on the island of Islay provided a reasonably large target on which to focus while panning with a motorised camera and 600mm lens. Had I chosen to try and fill the picture with only two or three birds, then the problems of framing and focusing would have been greatly increased, due to the necessary closer viewpoint. Even at a range of 50m (165ft) the depth of field was much too shallow to keep all of these birds in sharp focus.

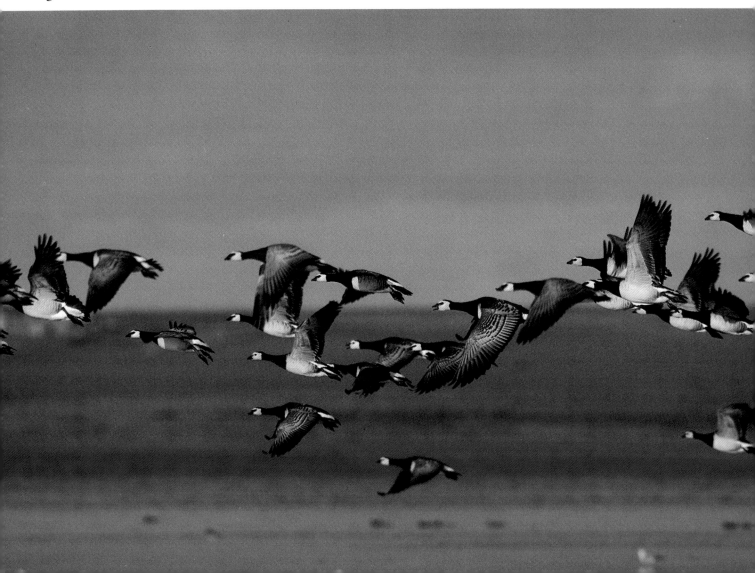

APPENDIX

NATURE PHOTOGRAPHY
AND THE LAW

Many of the wild animals, birds and plants to be found in Britain are protected by the Wildlife and Countryside Act of 1981. Understandably, there are special restrictions regarding the photography and handling of certain rarer species. With rare breeding birds, for example, the law forbids intentional disturbance of any species contained in Schedule 1 of the Act while it is nest building, or on or near a nest containing eggs or unflown young. It is also an offence to disturb intentionally dependent young of Schedule 1 birds even if they have left the nest.

To visit such nests lawfully you must first apply for a licence from the Nature Conservancy Council. These licences are not easily obtained and you may be asked to submit existing examples of your work with birds at the nest, with names and addresses of referees who are suitably qualified in this field.

Rare animals are also vulnerable to disturbance, but may be photographed freely provided they are away from their place of shelter, and that it does not involve removing them from their habitat. A licence would therefore be required if you intended to photograph a red squirrel and disturb it at its drey, or wanted to capture a sand lizard or natterjack toad and take it away to photograph it in a vivarium. As far as plants are concerned, unless you are an authorised person it is an offence to uproot any wild plant, or intentionally pick or uproot any wild plant in the list on page 149.

When applying for licences or requesting information about restrictions on specific species, correspondence should be sent with a stamped addressed envelope to: The Licensing Section, The Nature Conservancy Council, Northminster House, Peterborough, PE1 1UA.

Whilst observing the legal restrictions you should impose your own moral ones, too. Never put your desire to obtain a photograph before the welfare and safety of the subject. And remember that public opinion generalises: the thoughtlessness of one nature photographer may damage the reputation of others.

When visiting a puffin colony early in the breeding season, I noticed this group of birds on a rocky ledge near to a cliff-top. Every now and then one would take off, circle around two or three times, then hover momentarily above the ledge on a strong updraught before touching down gently to re-join the others. Because their flight-path was fairly constant I decided to set my camera on a tripod and pre-set the composition and focusing on the ledge, while allowing sufficient room at the top of the frame for the birds to fly into. Having the camera prepared in this way enabled me to take my eye away from the viewfinder to watch out for the next arrival. A cable release was used to trip the shutter at the precise moment.

Wildlife Protected under the Wildlife and Countryside Act of 1981

Common name (*scientific name*)

PROTECTED BIRDS
(Birds which are protected by special penalties and which may not be photographed at or near a nest without a licence.)
Avocet (*Recurvirostra avosetta*)
Bee-eater (*Merops apiaster*)
Bittern (*Botaurus stellaris*)
Bittern, Little (*Ixobrychus minutus*)
Bluethroat (*Luscinia svecica*)
Brambling (*Fringilla montifringilla*)
Bunting, Cirl (*Emberiza cirlus*)
Bunting, Lapland (*Calcarius lapponicus*)
Bunting, Snow (*Plectrophenax nivalis*)
Buzzard, Honey (*Pernis apivorus*)
Chough (*Pyrrhocorax pyrrhocorax*)
Corncrake (*Crex crex*)
Crake, Spotted (*Porzana porzana*)
Crossbills (all species) (genus *Loxia*)
Curlew, Stone- (*Burhinus oedicnemus*)
Divers (all species) (*Gaviidae*)
Dotterel (*Charadrius morinellus*)
Duck, Long-tailed (*Clangula hyemalis*)
Eagle, Golden (*Aquila chrysaetos*)
Eagle, White-tailed (*Haliaeetus albicilla*)
Fieldfare (*Turdus pilaris*)
Firecrest (*Regulus ignicapillus*)
Garganey (*Anas querquedula*)
Godwit, Black-tailed (*Limosa limosa*)
Goldeneye (*Bucephala clangula*)
Goose, Greylag (in Outer Hebrides, Caithness, Sutherland and Wester Ross only) (*Anser anser*)
Goshawk (*Accipiter gentilis*)
Grebe, Black-necked (*Podiceps nigricollis*)
Grebe, Slavonian (*Podiceps auritus*)
Greenshank (*Tringa nebularia*)
Gull, Little (*Larus minutus*)
Gull, Mediterranean (*Larus melanocephalus*)
Gyrfalcon (*Falco rusticolus*)
Harriers (all species) (genus *Circus*)
Heron, Purple (*Ardea purpurea*)

Hobby (*Falco subbuteo*)
Hoopoe (*Upupa epops*)
Kingfisher (*Alcedo atthis*)
Kite, Red (*Milvus milvus*)
Lark, Shore (*Eremophila alpestris*)
Merlin (*Falco columbiarius*)
Oriole, Golden (*Oriolus oriolus*)
Osprey (*Pandion haliaetus*)
Owl, Barn (*Tyto alba*)
Owl, Snowy (*Nyctea scandiaca*)
Peregrine (*Falco peregrinus*)
Petrel, Leach's (*Oceanodroma leucorhoa*)
Phalarope, Red-necked (*Phalaropus lobatus*)
Pintail (*Anas acuta*)
Plover, Kentish (*Charadrius alexandrinus*)
Plover, Little Ringed (*Charadrius dubius*)
Quail, Common (*Coturnix coturnix*)
Redstart, Black (*Phoenicurus ochruros*)
Redwing (*Turdus iliacus*)
Rosefinch, Scarlet (*Carpodacus erythrinus*)
Ruff (*Philomachus pugnax*)
Sandpiper, Green (*Tringa ochropus*)
Sandpiper, Purple (*Calidris maritima*)
Sandpiper, Wood (*Tringa glareola*)
Scaup (*Aythya marila*)
Scoter, Common (*Melanitta nigra*)
Scoter, Velvet (*Melanitta fusca*)
Serin (*Serinus serinus*)
Shrike, Red-backed (*Lanius collurio*)
Spoonbill (*Platalea leucorodia*)
Stilt, Black-winged (*Himantopus himantopus*)
Stint, Temminck's (*Calidris temminckii*)
Swan, Bewick's (*Cygnus columbianus*)
Swan, Whooper (*Cygnus cygnus*)
Tern, Black (*Chlidonias niger*)
Tern, Little (*Sterna albifrons*)
Tern, Roseate (*Sterna dougallii*)
Tit, Bearded (*Panurus biarmicus*)
Tit, Crested (*Parus cristatus*)

Treecreeper, Short-toed (*Certhia brachydactyla*)
Warbler, Cetti's (*Cettia cetti*)
Warbler, Dartford (*Sylvia undata*)
Warbler, Marsh (*Acrocephalus palustris*)
Warbler, Savi's (*Locustella luscinoides*)
Whimbrel (*Numenius phaeopus*)
Woodlark (*Lullula arborea*)
Wryneck (*Jynx torquilla*)

PROTECTED ANIMALS
Adder, in respect of section 9(5) only, (*Vipera berus*)
Bats, Horseshoe (all species) (*Rhinolophidae*)
Bats, Typical (all species) (*Vespertilionidae*)
Beetle, Rainbow Leaf (*Chrysolina cerealis*)
Burbot (*Lota lota*)
Butterfly, Chequered Skipper (*Carterocephalus palaemon*)
Butterfly, Heath Fritillary (*Mellicta athalia*, otherwise known as *Melitaea athalia*)
Butterfly, Large Blue (*Maculinea arion*)
Butterfly, Swallowtail (*Papilio machaon*)
Cat, Wild (*Felis silvestris*)
Cricket, Field (*Gryllus campestris*)
Cricket, Mole (*Gryllotalpa gryllotalpa*)
Dolphin, Bottle-nosed (*Tursiops truncatus*, otherwise known as *Tursiops tursio*)
Dolphin, Common (*Delphinus delphis*)
Dormouse (*Muscardinus avellanarius*)
Dragonfly, Norfolk Aeshna (*Aeshna isosceles*)
Frog, Common, in respect of section 9(5) only (*Rana temporaria*)
Grasshopper, Wart-biter (*Decticus verrucivorus*)
Lizard, Sand (*Lacerta agilis*)
Lizard, Viviparous, in respect of

Common name (*scientific name*)

section 9(5) only (*Lacerta vivipara*)
Marten, Pine (*Martes martes*)
Moth, Barberry Carpet (*Pareulype berberata*)
Moth, Black-veined (*Siona lineata*, otherwise known as *Idaea lineata*)
Moth, Essex Emerald (*Thetidia smaragdaria*)
Moth, New Forest Burnet (*Zygaena viciae*)
Moth, Reddish Buff (*Acosmetia caliginosa*)
Newt, Great Crested, otherwise known as Warty newt (*Triturus cristatus*)
Newt, Palmate, in respect of section 9(5) only (*Triturus helveticus*)
Newt, Smooth, in respect of section 9(5) only (*Triturus vulgaris*)
Otter, Common (*Lutra lutra*)
Porpoise, Harbour, otherwise known as Common porpoise (*Phocaena phocaena*)
Slow-worm, in respect of section 9(5) only (*Anguis fragilis*)
Snail, Carthusian (*Monacha cartusiana*)
Snail, Glutinous (*Myxas glutinosa*)
Snail, Sandbowl (*Catinella arenaria*)
Snake, Grass, in respect of section 9(5) only (*Natrix n. helvetica*)
Snake, Smooth (*Coronella austriaca*)
Spider, Fen Raft (*Dolomedes plantarius*)
Spider, Ladybird (*Eresus niger*)
Squirrel, Red (*Sciurus vulgaris*)
Toad, Common, in respect of section 9(5) only (*Bufo bufo*)
Toad, Natterjack (*Bufo calamita*)

PROTECTED FLOWERS
Alison, Small (*Alyssum alyssoides*)
Broomrape, Bedstraw (*Orobanche caryophyllacea*)

Broomrape, Oxtongue (*Orobanche loricata*)
Broomrape, Thistle (*Orobanche reticulata*)
Calamint, Wood (*Calamintha sylvatica*)
Catchfly, Alpine (*Lychnis alpina*)
Cinquefoil, Rock (*Potentilla rupestris*)
Club-rush, Triangular (*Scirpus triquetrus*)
Cotoneaster, Wild (*Cotoneaster integerrimus*)
Cow-wheat, Field (*Melampyrum arvense*)
Cudweed, Jersey (*Gnaphalium luteoalbum*)
Diapensia (*Diapensia lapponica*)
Eryngo, Field (*Eryngium campestre*)
Fern, Dickie's Bladder (*Cystopteris dickieana*)
Fern, Killarney (*Trichomanes speciosum*)
Galingale, Brown (*Cyperus fuscus*)
Gentian, Alpine (*Gentiana nivalis*)
Gentian, Spring (*Gentiana verna*)
Germander, Water (*Teucrium scordium*)
Gladiolus, Wild (*Gladiolus illyricus*)
Hare's-ear, Sickle-leaved (*Bupleurum falcatum*)
Hare's-ear, Small (*Bupleurum baldense*)
Heath, Blue (*Phyllodoce caerulea*)
Helleborine, Red (*Cephalanthera rubra*)
Knawel, Perennial (*Scleranthus perennis*)
Knotgrass, Sea (*Polygonum maritimum*)
Lady's-slipper (*Cypripedium calceolus*)
Lavender, Sea (*Limonium paradoxum, Limonium recurvum*)
Leek, Round-headed (*Allium sphaerocephalon*)
Lettuce, Least (*Lactuca saligna*)
Lily, Snowdon (*Lloydia serotina*)

Marsh-mallow, Rough (*Althaea hirsuta*)
Orchid, Early Spider (*Ophrys sphegodes*)
Orchid, Fen (*Liparis loeselii*)
Orchid, Ghost (*Epipogium aphyllum*)
Orchid, Late Spider (*Ophrys fuciflora*)
Orchid, Lizard (*Himantoglossum hircinum*)
Orchid, Military (*Orchis militaris*)
Orchid, Monkey (*Orchis simia*)
Pear, Plymouth (*Pyrus cordata*)
Pink, Cheddar (*Dianthus gratianopolitanus*)
Pink, Childling (*Petroraghia nanteuilii*)
Sandwort, Norwegian (*Arenaria norvegica*)
Sandwort, Teesdale (*Minuartia stricta*)
Saxifrage, Drooping (*Saxifraga cernua*)
Saxifrage, Tufted (*Saxifraga cespitosa*)
Solomon's-seal, Whorled (*Polygonatum verticillatum*)
Sow-thistle, Alpine (*Cicerbita alpina*)
Spearwort, Adder's-tongue (*Ranunculus ophioglossifolius*)
Speedwell, Spiked (*Veronica spicata*)
Spurge, Purple (*Euphorbia peplis*)
Starfruit (*Damasonium alisma*)
Violet, Fen (*Viola persicifolia*)
Water-plantain, Ribbon leaved (*Alisma gramineum*)
Wood-sedge, Starved (*Carex depauperata*)
Woodsia, Alpine (*Woodsia alpina*)
Woodsia, Oblong (*Woodsia ilvensis*)
Wormwood, Field (*Artemisia campestris*)
Woundwort, Downy (*Stachys germanica*)
Woundwort, Limestone (*Stachys alpina*)
Yellow-rattle, Greater (*Rhinanthus serotinus*)

BIBLIOGRAPHY

ANGEL, H. *Nature in Focus*, Pyramid
BLACKLOCK, C. and N. *Photographing Wildflowers*, Airlife
FREEMAN, M. *Wildlife & Nature Photography*, Croom Helm
HILL, M. and LANGSBURY, G. *A Field Guide to Photographing Birds in Britain and Western Europe*, Collins

HOLMASEN, I. *Nature Photography*, Cassell
IZZI, G. and MEZZATESTA, F. *The Complete Manual of Nature Photography*, Witherby
SHAW, J. *The Nature Photographer's Complete Guide to Professional Field Techniques;* and *John Shaw's Close-ups in Nature*, Amphoto

ACKNOWLEDGEMENTS

In writing and producing the photographs for this guide I have received much help, advice, and useful information from many people. I would especially like to extend my thanks to the following for their help with the photography: Robin Dunbar, Norris Gold, Fred Marr, Jimmy Oswald, Mike Richards, Billy Shiel, Ian Watt.

To my wife, Margaret, and mother, Norma Campbell, for typing the manuscript and generally assisting and supporting me in my work over the years.

Special thanks are also due to Jane Rowe at David & Charles, and to Sylvia Sullivan of The Royal Society for the Protection of Birds for their help, patience and kindness throughout.